Merry Christmas to My Darling Daughter Jeanette,

With all good wishes and hopes for
a wonderful visit to this "far-away place."
With a heart full of love for you now
and always,
Mother
1985

P9-CEK-386

Festival of India
in the United States 1985–1986

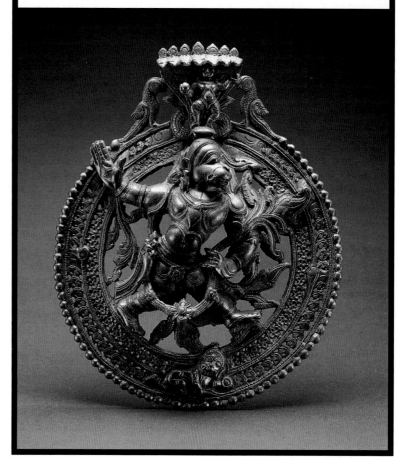

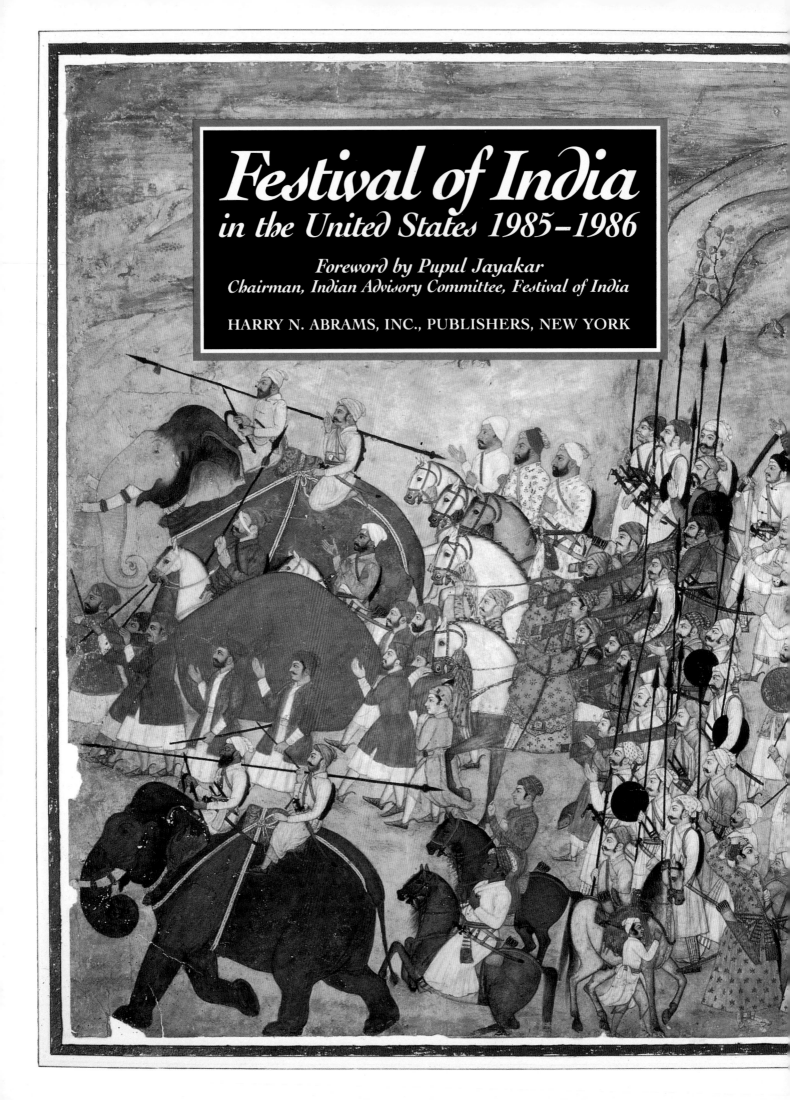

Festival of India
in the United States 1985–1986

Foreword by Pupul Jayakar
Chairman, Indian Advisory Committee, Festival of India

HARRY N. ABRAMS, INC., PUBLISHERS, NEW YORK

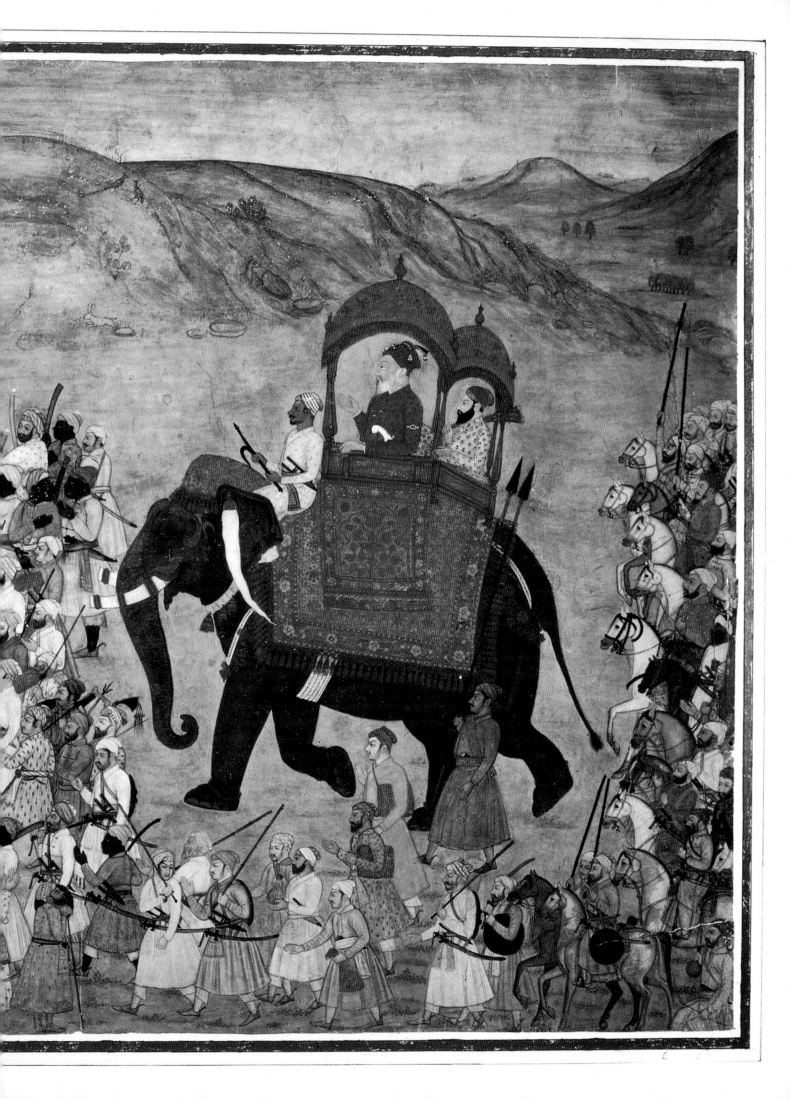

Page 1: *Hanuman Carrying Herbs to Heal the Wounded Lakshmana.* Karnataka, 19th century. Bronze, 8½×7". All India Handicrafts Board, Crafts Museum, New Delhi. Photograph courtesy the Smithsonian Institution, Washington, D.C.

Pages 2–3: *Bahadur Shah on a Royal Progress.* Mughal, c. 1700–1707. 14½×23⅜". The Ehrenfeld Collection. Photograph courtesy the American Federation of Arts, New York

Project Director: Leta Bostelman
Editor: Lory Frankel
Rights and Reproductions: Eric Himmel
Designer: Gilda Hannah

Library of Congress Cataloging in Publication Data
Main entry under title:
Festival of India in the United States 1985–1986.
 Includes index.
 1. Festival of India in the United States (1985–1986)
2. Arts, India. 3. India—Civilization. I. Harry N.
Abrams, Inc.
NX430.I4F4 1985 700'.954'074013 85–7349
ISBN 0–8109–0937–5

Copyright ©1985 Harry N. Abrams, Inc.
Published in 1985 by Harry N. Abrams, Incorporated, New York
All rights reserved. No part of the contents of this book may
be reproduced without the written permission of the publishers
Printed and bound in Japan

Contents

A Foreword

An ancient Indian text extolls the culture of the pathways. Addressing the journeyer it says:

> There is no happiness for him who does not travel, Rohita! Thus we have heard. Living in the society of men, the best man becomes a sinner. . . . Therefore, wander!
>
> The feet of the wanderer are like the flower, his soul is growing and reaping the fruit; and all his sins are destroyed by his fatigues in wandering. Therefore, wander!
>
> The fortune of him who is sitting, sits; it rises when he rises; it sleeps when he sleeps, it moves when he moves. Therefore, wander!
>
> The wanderer finds honey and the sweet Adumbara fruit; behold the beauty of the sun, who is not wearied by his wanderings. Therefore, wander, wander!
>
> *The Aitareya Brahmanam,* 7.15

In India when the harvest is in and the sun commences its auspicious journey to the northern hemisphere, people lay down their burdens and travel to participate in fairs and festivals, held at the confluence of rivers, around lakes, and amidst dense forests. This travel of discovery and adventure has sacred sanction; it is the ground for observation, for learning and teaching; a coming together of vast numbers of people.

Millions move; walking centuries-old paths, traveling in gaily decorated carts drawn by bullocks or camel, journeying by train in carriages, on roofs, or on footboards, or traveling by bus. Irrespective of caste and creed they converge on the sacred soil where festivals are held. Along this route for centuries have traveled mendicant and storyteller; dancer and musician; seer, philosopher, and wiseman; social worker; magician; the great *Mahants* of religious sects who set up their *Akhadas* or clearly demarcated arenas at the sacred site. Along with this moving countryside travels the merchant and the shopkeeper, to build tiny bamboo booths, decorated with brilliant-colored paper or cloth buntings or lithographs of the gods; the trader whose merchandise includes sun-dyed cloths, brass utensils, beads for human beings, camels, cattle. Amongst them is the *Halwai*, the maker of sweetmeats, sitting before mountains of round sugar balls covered with very fine silver foil or sweet-

meats shaped as animal, bird, or flower. Here you find a seller of glass bangles, parrot-colored or red as the circular marks that adorn the foreheads of the women who sit before him. Here for the child are paper toys, dolls, carts, lacquered cooking utensils, or kits. And, of course, there is the astrologer reading horoscopes and at propitious moments arranging marriages. Moving in between the brilliantly clad women and children are the acrobat, the juggler, the monkeyman, and the man with the performing bear.

Processions, pageantry, ornament, color, delectable food, sound of drumbeat and song, the chiming bells of dancing feet, of bells that hang around the necks of camel and cattle, fragrance of flowers and Indian perfumes, movement of people and dust—all these create a festival.

In the late summer of 1982, President Ronald Reagan of the United States and Prime Minister Indira Gandhi of India decided that their two countries would collaborate on a massive cultural exchange, and the Festival of India in the United States resulted—a unique cultural encounter.

To be inaugurated in Washington in June 1985, in New York in September–October 1985, and the West Coast in 1986, the Festival will continue across the United States for a year and over.

Brought together by many minds and hands in India, working in close collaboration with the major cultural and academic institutions in the United States, masterpieces of Indian art will be juxtaposed against artifacts of rural and tribal communities. Exhibitions of the ancient and new sciences will coexist with the craft technologies of textile and terracotta. The magnificence of costume and artifact of great courts will coexist with projections of vernacular perceptions. Performing arts, films, theater, poetry readings will reveal the vitality and energy of an emergent India. Dialogue and seminar will bring together the academic and cultural profiles of the two countries.

Indira Gandhi was assassinated on 31 October 1984. An era ended. To Indira Gandhi culture was an enchanted ground, the alchemy that transforms a society. She quickened to seasons, to color, to artifact, to textiles, to music. Above all, she delighted in dance. She participated in many of the festivals of India—journeying to distant village or tribal homeland, donning local costumes, stretching her arms in a gesture of epiphany to complete the magical, energy-charged circle of barefoot dancing feet.

She was to tell me that there were two attitudes to walking barefoot. Gandhiji used to say, walk barefoot because the poor have no shoes. Then there was a dancing barefoot to get a direct tactile feel of the earth, to feel it become one with the body. In a rare but intense moment of laughter, she had lifted her head and said, "If I had not been in politics I would have been a dancer."

India is a mirror of many cultures and many centuries, coexisting in the same space and time. Continually transforming herself, she reveals herself to those who look at her anew, with eyes free of conditioned reflexes. To view her with a static imagery of a culture crystallized in time, to contain her in any known crucible of word or symbol, is to fragment and deny her; for, like her rivers emerging from snow-fed glaciers flooding vast territories, making verdant the field and riverbank, she is in movement and constant flux.

Muharrum Festival, *Tazia* procession, Delhi

For centuries India was perceived as the land of fabulous riches, of wisdom, of magic and fantasy. In recent times, the image has blurred, and India has come to be regarded as a land of teeming populations, backward, poor. Statistics prove that vast developments have taken place since the independence of India; they also reveal pockets of poverty, ignorance, and overpopulation. But statistics do not quicken a country and bring it to life. The observer with his predilections determines the area and focus of his vision.

Opposite, above, left: Festival at Madurai, Tamil Nadu

Opposite, above, right: A *Kathakali* dancer's face made from flowers at Onam Festival, Kerala

Opposite, below: Folk dancers, Maharashtra

Below: Onam Festival, Trivandrum, Kerala

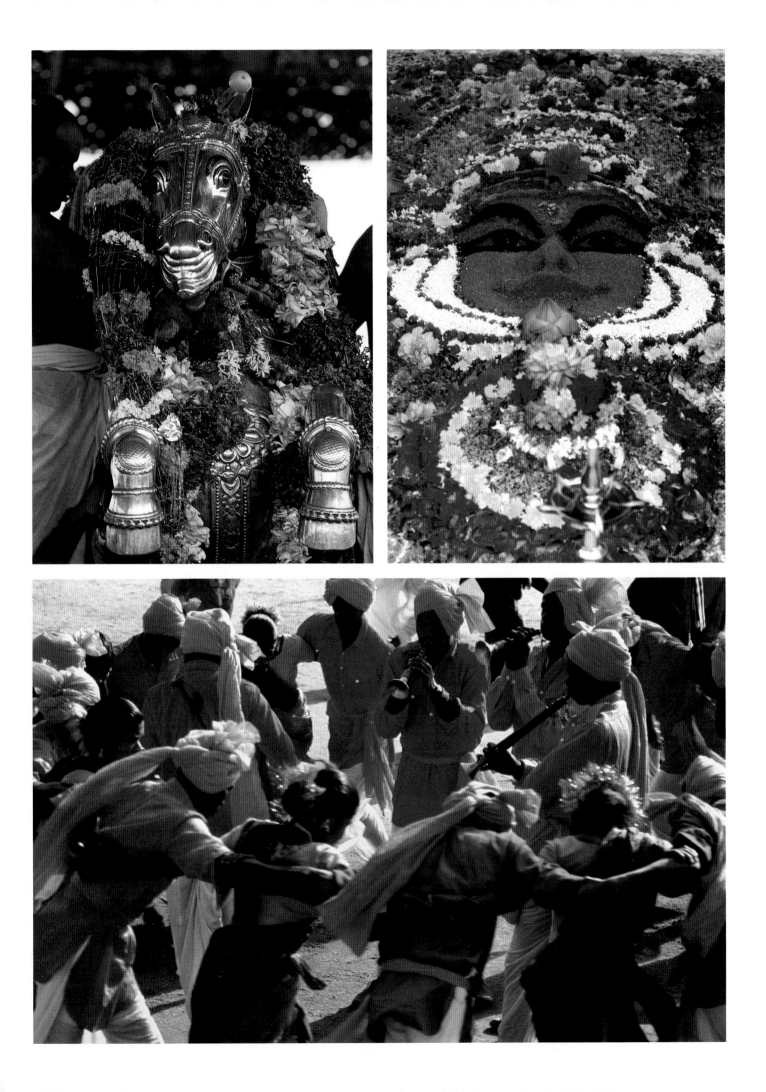

India gained independence on 15 August 1947. The young freedom-loving minds of the people of the United States had extended a hand of friendship to India in her struggle for freedom. With independence, the Indo-American dialogue assumed new dimensions and underwent dramatic change. Since then, distances of space, knowledge, and attitude have divided the men and women of the United States from the Indian experience. India today as a country has little actuality to a child in the United States except as a land mass on the globe. No bridges so far have been adequate to facilitate the flow of understanding, to communicate a vital sense of India's heritage, her values, her ways of life, her problems, the energy of her thrust into the modern age.

Few people in the United States are aware of India's immense adventure in democracy—that India is the largest democracy in the world. In December 1984, India went to the polls in an election based on universal franchise. Two hundred million men and women voted. Rajiv Gandhi, elected prime minister of India by massive mandate, is forty years old. The postulates of power and the future have passed to the hands of the young, and with this transition India enters a new age. The stability and ease of this passage mirror India's commitments, her strength and resilience.

Major challenges lie before India. An ancient culture in swift transformation is being catapulted into a new century. India has to sustain and nourish the new sciences, attune the minds of the young to an education based on observation, inquiry, doubt—attributes of the scientific culture. It has to generate creative impulses, to sustain artifacts of technology without a diminishing of her ancient heritage and the values that she has cherished over centuries. This has to be possible.

Prime Minister Rajiv Gandhi's youth, his courage and his capacity for direct decisive action, has in it the explosive energy of a new beginning. What comes in contact with this energy will bear the imprint of the new.

With frontiers receding under the thrust of modern science and its tools, no country can remain isolated. Indian thinkers, scientists, businessmen, poets, musicians, and dancers have enriched the American canvas. There is a growing interest in Indian art, fabrics, food, religious cults, serious or ephemeral. The United States and its equally composite and vibrant frontier culture, its new sciences probing the vast galaxies of outer space and seeking to unlock the secrets of life, has fired the minds of the young in India and has added brilliant new threads to the Indian tapestry.

The Festival of India will provide to the people of the United States a new and, we hope, a rewarding discovery. When the Festival ends, as all festivals must, will India leave behind a footprint?

Pupul Jayakar
Chairman, Indian Advisory Committee, Festival of India

The Sculpture of India
3000 B.C.–1300 A.D.

This exhibition at the National Gallery of Art, Washington, D.C., was organized with the intention of showing how Indian sculpture has contributed to the common artistic heritage of mankind. The inaugural event of the Festival of India, the show includes approximately 110 objects, which have been brought together to convey a sense of Indian sculpture as a whole and to reveal the rich diversity of styles that flourished in the ancient regions of the subcontinent. Executed in stone, ivory, and bronze, the works range in size from the miniature to the colossal.

Until the nineteenth century Indian sculpture was largely misunderstood and often denigrated by Westerners. The common belief was that the works depicted horrific figures of seemingly bizarre religions. Supported by distorted accounts of travelers to the region and by books illustrating the marvels of the world, this negative perception of Indian sculpture soon became ingrained in the Western mind and influenced the thinking of scholars, most of whom had no firsthand acquaintance with Indian art and could only attribute any of its excellent qualities to Greek or Roman influence. This Hellenocentric attitude persisted into the twentieth century, when it was changed by new Western intellectual attitudes and an altered perception brought about by modern art. Since midcentury, a growing number of collections and several loan exhibitions held throughout the world have contributed to the eventual acceptance and appreciation of Indian art.

The works are arranged chronologically, divided into six periods. This system avoids dynastic appellations and division of the works by religion, emphasizing instead that time and place are the elements that determine the character of a work of Indian art, the style being influenced primarily by the traditions of the area in which it was produced.

The Protohistoric Period

Many of the earliest pieces come from the sites of the Harappan culture located in the Indus River Valley, where archaeologists found a well-planned system of streets and houses. Among the works from this period are three seals inscribed with animal motifs and a miniature bronze *Chariot* (c. 2000–1500 B.C.) driven by a bronze charioteer and drawn by oxen. It was cast in the lost wax technique (the use of a wax model to form a mold into which molten metal was poured), and is a rendering in bronze after a wooden original.

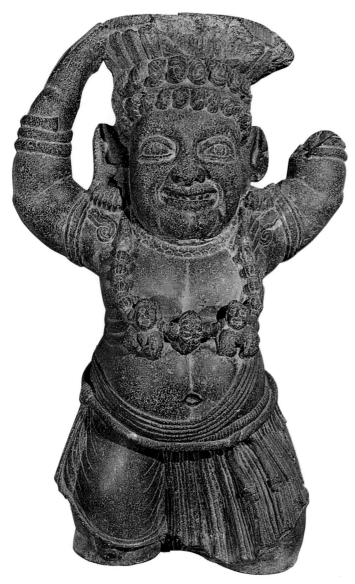

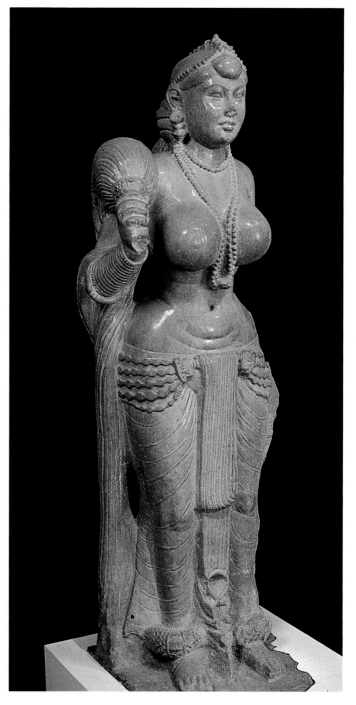

Above: Kanhadasa. *A Dwarf Yaksha*. Pi-
talkhora, Cave 3, Maharashtra, early 1st
century B.C. Gabbro, 40½ × 23⅝ × 14½"
(103.2 × 60 × 37.2 cm). National Muse-
um, New Delhi
Literature: Deshpande 1959

Right: *Goddess Holding a Fly Whisk*. Di-
darganj in Patna, Bihar, probably 3rd cen-
tury B.C. Polished sandstone, head to
pedestal: 62½" (158.8 cm); including ped-
estal: 82½" (209.6 cm). Patna Museum
Literature: Spooner 1919; and frequently
thereafter

Opposite: *Shiva in the Form of a Dwarf*.
Mansar, Maharashtra, late 5th century
A.D. Sandstone, 33½ × 25⅝ × 15¾"
(85.1 × 65.1 × 40 cm). National Museum,
New Delhi
Literature: Sivaramamurti 1976; London 1982

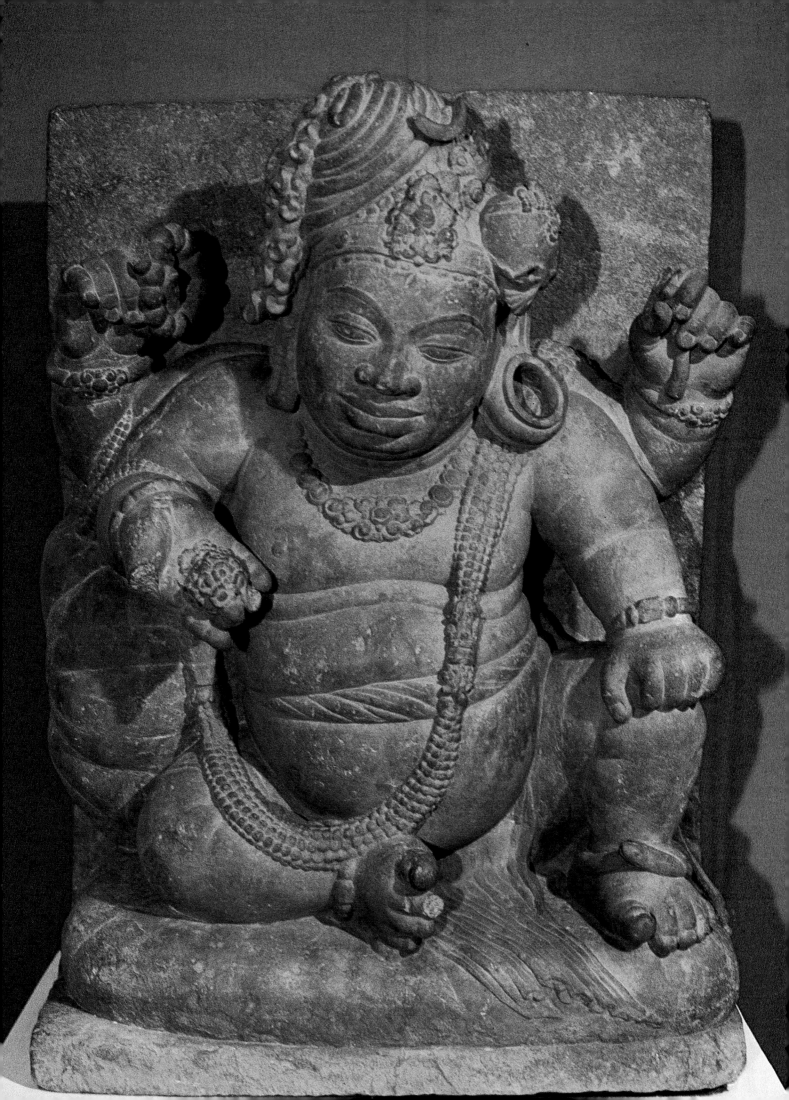

Third Century B.C.

The circumstances that brought about the end of the Harappan civilization remain the subject of much speculation, but there is evidence that it was succeeded by a number of essentially rural cultures. An age of great social and cultural ferment followed. Political struggles among city-states led to the establishment of the Maurya empire (c. 321–185 B.C.), which encompassed the entire subcontinent.

The sculpture of this period is largely associated with this dynasty. It is characterized by a remarkable maturity. A very important work is the *Goddess Holding a Fly Whisk* (probably third century B.C., Patna Museum), which is a life-size image of a *yakshi*, or fertility goddess. Extremely rare, it is one of the earliest visual statements of the Indian ideal of female beauty—wide hips and full breasts, characteristics that are constantly expressed in Indian art and literature.

Second Through the First Centuries B.C.

The *Dwarf Yaksha* by the artist Kanhadasa dates from the next period in Indian sculpture. Kanhadasa carved a happy grin on the figure's face, possibly the first attempt in Indian art to endow an image with vivid emotional expression. The sculpture is inscribed with the artist's name, which was a very rare practice.

First Through the Third Centuries A.D.

In north India, the school of art centered at Mathura, an ancient city about eighty miles south of Delhi, was responsible for the greatest artistic development during this period. Female figures appear to be more unified and coordinated entities. Emotions are no longer confined to the face but are expressed by the entire body. For the first time, Indian sculptors produced an anthropomorphic image of the Buddha, adopted from the *yaksha* divested of adornments and presented in monastic robes.

Contemporary with the school of Mathura was the Gandhara school (located in what is now Pakistan), known for its naturalistic style. Inspired by Greco-Roman art, the Gandhara artist portrayed the image of the Buddha in more humanistic, emotional terms.

Fourth Through the Sixth Centuries A.D.

The works of these centuries, considered to be the classical phase of Indian art, focus on the realm of the spirit, adopting that contemplative and spiritual aspect with which Indian art is frequently associated. This period marks a clear watershed in the history of Indian sculpture. The rise of the Gupta dynasty in north India coincides with the transformation from the earthy, extroverted forms of early Indian sculpture to forms expressive of a meditative, inward nature.

Seventh Century Onward

This is often referred to as the medieval period. Regional idioms flourished and a more ornate style emerged, as seen in numerous elaborately decorated works created to adorn stone temples. This stylistic development progressed into the tenth century, with forms that became tighter, flatter, and more angular. Ornamentation grew increasingly obtrusive until, in the eleventh century, geometric elements took precedence over sculptural ones and ornamentation overpowered form.

Kushan Sculpture
Images from Early India

For the first exhibition devoted to Kushan sculpture, the Cleveland Museum of Art assembled more than one hundred pieces. The Kushans, one of the most prominent of the Indian dynasties, were of Scythian descent. Known in India as *Sakas*, these tribesmen originally occupied the territory around the Oxus River, until they were forced by other nomadic tribes to move southward. They attacked Bactria and reached northwest India by the middle of the first century B.C. For almost a century the area was ruled by more or less autonomous tribes, until control was consolidated in the hands of Kujula Kadphises of the Kushan tribe. His successor, Wima Kadphises, established Kushan rule, and Kushan culture grew in significance during Kanishka's reign and that of his successors, Havishka and Vasudeva. Kanishka extended his kingdom to the area of present-day Uttar Pradesh, with Mathura (some sixty miles south of Delhi) as an important cultural center.

The art created under the auspices of these rulers in Mathura represents some of the highest achievements produced by the Mathuran school, which flourished for almost ten centuries, a span impossible for any other center of Indian culture to match. Mathuran sculpture of Kushan times provided a model upon which all the later schools of sculpture in India were based.

Mathuran sculpture of the Kushan period is conceptual in character, based on the artist's vision of the object rather than a direct copy from nature. The main features of Mathuran sculpture are volume and mass: the figures are solid and fleshy, with voluptuous female divinities as symbols of fertility and male deities reflecting their authority in bulk, weight, and robustness.

These features are all present in the *Torana Bracket with Salabhanjikas*. The rhythmic, melodious vitality of movement in the posture of these two voluptuous *yakshis* recalls a dance pose and is characteristic of Indian sculpture at its best. In truly indigenous fashion, there are no angular forms; the curvilinear outline of the upraised arms is echoed by the gently curving branches of the Asoka trees.

This *Torana Bracket* is a fragment of a stupa gateway; only the upper part remains of the full, life-size female figures that composed it. The sculptured figures are carved in such deep relief that they give the impression of free-standing sculptures. They represent the tree goddesses known as *salabhanjikas*, traditional fertility symbols; the maidens touch the tree and cause it to bloom. Each female figure holds the branch of a flowering Asoka tree; even in modern folk traditions it is believed that

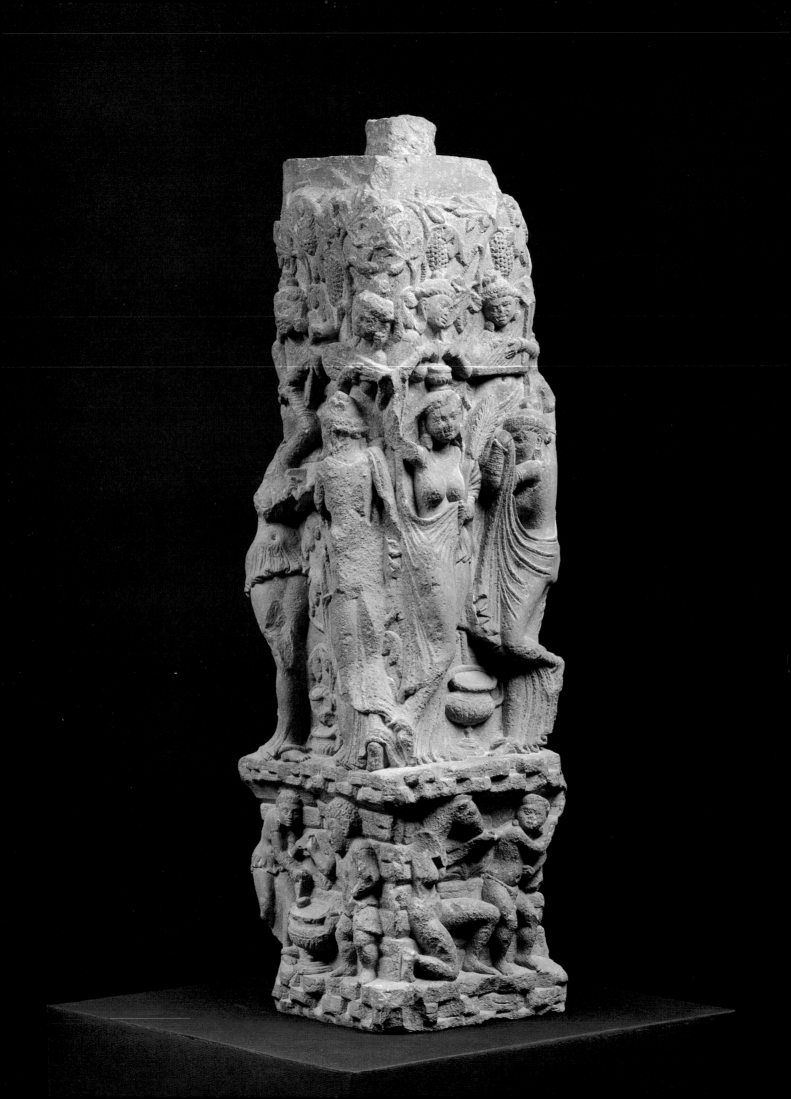

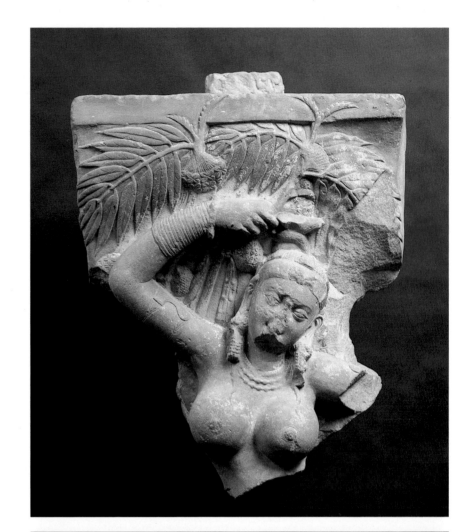

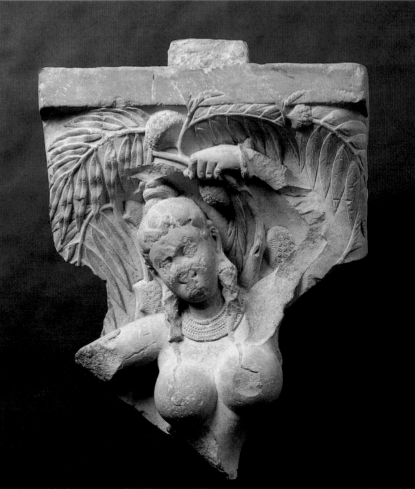

Torana Bracket with Salabhanjikas. Two views. Mathura, second half of 2nd century A.D. Pink spotted chunar sandstone, height 28″ (71.1 cm). The Cleveland Museum of Art. Purchase, John L. Severance Fund

Opposite: *Railing Pillar.* Mathura, late 2nd century A.D. Sikri sandstone, height 31½″ (80 cm). The Cleveland Museum of Art. John L. Severance Fund

this tree will bloom only if touched by a young woman. The Indian ideal of feminine beauty centers on woman as symbol of fertility: full, rounded breasts; large hips; slim, curving waist. Even in its fragmentary form, this architectural detail is a true representative of the ideal sensuously rendered in stone.

At the far western end of the Kushan empire—which at its height stretched from the Ganges to the Oxus—there flourished another important sculptural tradition, that of Gandhara. It was to Gandhara (now primarily Pakistan and Afghanistan) that Alexander the Great's legions extended their farthest reach in Asia in the fourth century B.C., and there that the Greco-Roman world inspired a distinctive art. The sculpture of Gandhara, which is basically an art of crisp outline, has a tendency toward realism and a keen "observation of life." Its ultimate aim is to capture the perfection of the human body, as established by Greco-Roman standards, though on occasion this physical beauty might be sacrificed for the sake of drama.

In this area, which had long been the primary route into India from Asia and the Mediterranean, there had been a succession of religious and artistic traditions. Gandharan art quickly absorbed and replaced these artistic styles, which were less deeply rooted than the indigenous ones the Kushans found in Mathura. As the Kushans were strong patrons of Buddhism, and as Gandhara remained the major passage between India and the rest of Asia, it is not surprising that Gandharan art was, with few exceptions and unlike Mathuran art, almost exclusively Buddhist.

The *Railing Pillar* is an unusual blend of stock Hellenistic elements combined with the ripe, rounded volumes of early Mathuran sculpture. It is very likely the creation of an Indian sculptor of the Mathuran school who chose non-Mathuran elements of pose, costume, drapery treatment, and proportion, and additionally emphasized their exoticism with foreign musical instruments, vessel forms, and, above all, the grapevine itself, which was found only on India's northwest frontiers. Such Greco-Roman features must certainly have been borrowed from Kushan Gandhara. It seems clear, however, that this is no Gandharan work. Not only do the type of stone and the pillar's shape reflect a Mathuran origin, the stylistic essence is Mathuran. The unusual mingling of the two traditions can be traced to the subject: the cult of the Greek god Dionysus transformed into voluptuous Indian bacchantes.

Like Dionysus and his cortege, the *yakshas* of ancient popular Indian folk religion were essentially primitive lords of all "wet and gleaming" nature: rain, dew, sap, blood, semen, and spiritous liquor. It seems probable that the Mathuran sculptor who executed this work used Gandharan imagery in order to depict more authentically the exotic *yaksha* paradise far away among the snowy peaks of the northwest where grapevines flourished.

These two arts of the Kushan empire, the Western-influenced Gandharan and the indigenous Mathuran, reflected the new interests of Kushan society and its rulers. The Kushan period is the formative period of Buddhism, when for the first time sculptors produced an iconic image of Buddha as well as royal portraiture. While the Buddha image glorified the religion, royal portraits proclaimed the might of the Kushan rulers, and both served the purpose of unifying and glorifying the Kushan empire.

STANISLAW CZUMA
Curator of Indian and Southeast Asian Art, The Cleveland Museum of Art

From Indian Earth

4000 Years of Terracotta Art

Indian terracottas are improvisational, spontaneous, and often experimental forms of expression; these objects are frequently endowed with a high degree of technical sophistication and rich artistic variety, combining sophisticated modeling techniques and rich inspiration. Indian terracotta art reflects a diverse range of cultural patterns and ideas which are frequently liberated from the usual stylistic and iconographic conventions. Yet the terracotta art of India remains less well known than the Indian sculptural representations in other mediums.

In view of the importance of terracottas in Indian art and archaeology, the Brooklyn Museum has organized a comprehensive exhibition, "From Indian Earth: 4000 Years of Terracotta Art." This exhibition explores the variety of treatments and attitudes characteristic of the many regional traditions inherent in Indian terracotta art.

In the history of Indian art, the terracotta figurine stands out as the only type of object that has a continuous archaeological record from the sixth century B.C. to the present. Numerous terracottas have survived from the formative period of Indian art, circa 2300 B.C., a period of which our knowledge is otherwise fragmentary. In later periods, where the record is more complete, we find that the development of terracotta art does not always parallel that of other mediums. Unlike stone and bronze, clay is abundant, inexpensive, and easily modeled, and terracotta artists have therefore had, on the one hand, greater liberty to improvise and experiment, and, on the other hand, greater ability to focus on the everyday and mundane facets of Indian life as well as on the princely or religious subjects of more formal mediums.

Although the precise function of many terracottas is still a matter of speculation and dispute, the multiple uses of terracotta art in Indian religious and secular life are an established fact in India. Whether intended for worship and shaped in the form of propitious deities, or for architectonic elements, or for decorative objects and toys, these clay objects represent a variety of approaches, not only stylistic but also symbolic.

Rare examples of antiquity unearthed from several excavations as well as a number of terracottas of artistic value and significance have been brought together for the first time so that we may appreciate this continuous tradition and investigate other questions of particular interest, such as the themes represented and how they relate to aspects of Indian culture.

The Brooklyn Museum, New York

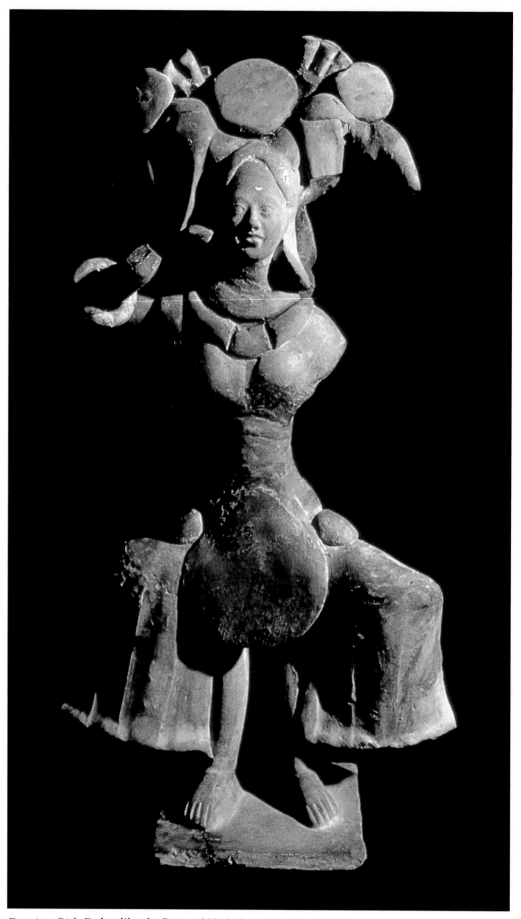

Dancing Girl. Bulandibagh, Patna, 300–200 B.C. Height 10¾″ (27.5 cm). Patna Museum

The emergence of a rich middle class at Pataliputra (modern Patna) in the fourth century B.C. is demonstrated in the examples of secular terracotta figures found in the region. Several extraordinary hand-modeled figures from Bulandibagh in Patna are thought to represent female dancers. The faces are generally skillfully molded, but their individual costumes showing pleated skirts and jeweled girdles and their elaborate studded headdresses are hand-formed elements.

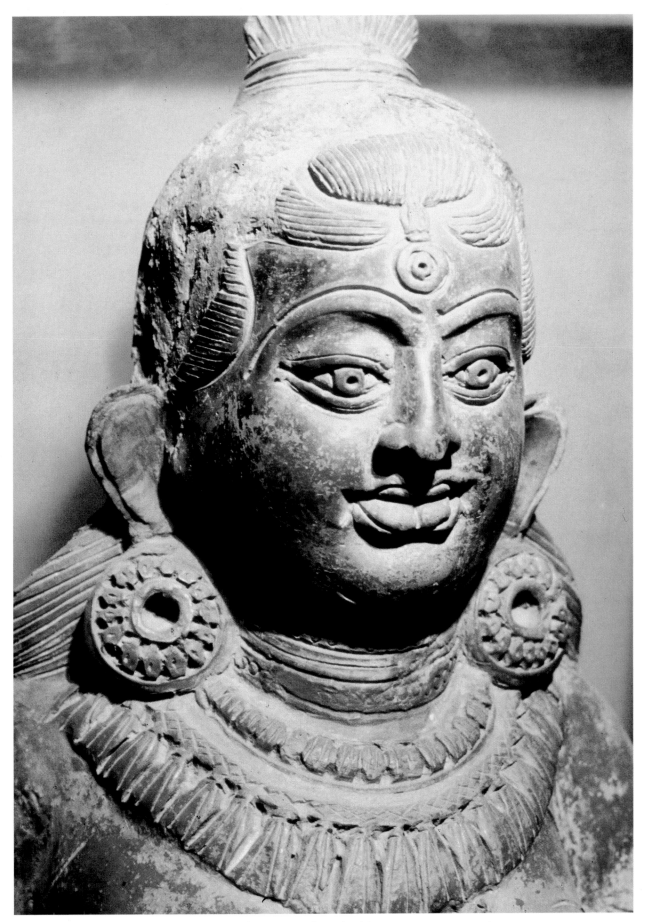

Seated Goddess Hariti. Excavated at Kausambi, Ghoshitaram Monastery, c. 1st century A.D. Allahabad University Museum

The religious function of terracottas is an interesting aspect of Kushan-period art. Among the clay images of deities, perhaps the greatest technical advance of the period is the modeling of monumental figures. This powerful image, identified as Hariti, was discovered with two other almost life-size cult images in a shrine of Kushan date at Kausambi, a site in the upper Gangetic Plain.

Over sixty outstanding terracottas have been loaned from Indian collections for this exhibition, and additional pieces from public and private collections in the United States and Europe have been selected to give an extensive picture of the role and function of Indian terracotta art. The objects come from the Indus and the Ganges river valleys in the north and from sites in Rajasthan, the Deccan Plateau, Karnataka, and Tamil Nadu in the far south, demonstrating at once the continuity of the themes and methods of production throughout India and the modifications developed by local traditions.

Clay, tempering material (such as ash, sand, and cattle dung), and color are the essential components of terracotta production. Although all types of clay are used for terracottas in India, the quality of the alluvium soil of the Indus and Ganges rivers was, as it still is, the finest, and the greatest quantity of ancient terracottas have been found in these areas. Examples of glazed and painted terracotta figures are also known throughout the subcontinent.

Techniques of manufacture differed over time, but not necessarily in a linear progression. For example, in northern India, the use of the mold reached a peak of refinement during the Sunga period (second century B.C.–first century A.D.) and Gupta period (circa A.D. 300–600), but fell into disuse in other periods.

Terracotta figurines by anonymous or little-known masters, whose archaeologically verified provenance has made them the focus of extensive research, stand out in an albeit obscure field. The occurrence of female figurines with accentuated breasts or splayed hips, seated male figures, and animal figures suggests that many of these objects were cult images. The universal female image representing the nurturing mother, goddess of prosperity and abundance, is the most common type, represented in terracotta in all periods. This vigorous, imaginative tradition suggests that terracottas may have more to tell us about Indian life than we can learn from any other single art form.

AMY G. POSTER
Associate Curator of Oriental Art, The Brooklyn Museum

Vistara
The Architecture of India

Man lives in a world of manifest phenomena. Yet, since the beginning of time, he has intuitively sensed the existence of another world: a nonmanifest world whose presence underlies—and makes endurable—the one he experiences every day.

The principal vehicles through which he explores and communicates his notions of this nonmanifest world are religion, philosophy, and the arts—music, poetry, painting, sculpture. Like these, architecture, too, is myth-based, expressing either explicitly or implicitly the presence of a reality more profound than the manifest world in which it exists.

Over the centuries, India has generated a truly extraordinary range of architecture. This exhibition presents some of the most significant examples, arranged in three sections so as to illustrate three principal mythic themes:

1. *Mandala:* architecture as an analogue of the cosmos;
2. *Manusha:* architecture as the measure of man; and
3. *Manthana:* the absorption of new myths into an existing construct.

In short, the first is concerned with the myth explicit; the second with the myth implicit; and the third with the internalization of outside interventions—changing myths.

Mandala

To the Vedic seers, the function of architecture was not just utility, nor even beauty, but something of much greater significance: it needs must constitute a model of the cosmos.

Since built form was perceived as an analogue of the nonmanifest world, design decisions were made not merely on the usual basis of form, structure, and materials but also on overriding metaphysical parameters—represented by the sacred geometry of the *mandalas*. These magic diagrams of the cosmos formed the underlying structure of Vedic architecture.

The form of the architectural *mandala* is generally a perfect square—since a square is generated by the four points of the compass, and hence symbolically represents Earth. Each *mandala* consists of a varying number of identical squares, ranging from 1 to 1,024. In the building of temples, the most commonly used *mandalas* are those of 49, 64, and 81 squares. But *mandalas* can also form the basis of other typolo-

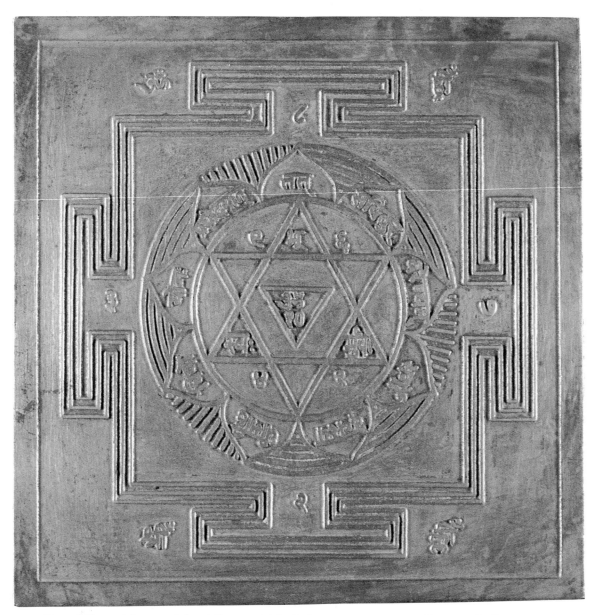

Gayatri Yantra (plate used for daily worship). Gujarat, contemporary. Bronze. Collection Mrs. Pravina Mehta

Gayatri Yantra is the geometric analogue of the *Gayatri Mantra*, the sacred chant inscribed within. Proceeding from the innermost triangle, it radiates outward in a clockwise direction. *Gayatri Mantra* is emblematic of the place of sun worship in daily life.

Opposite: The pillared entrance to the stepwell at Bundi, Rajasthan

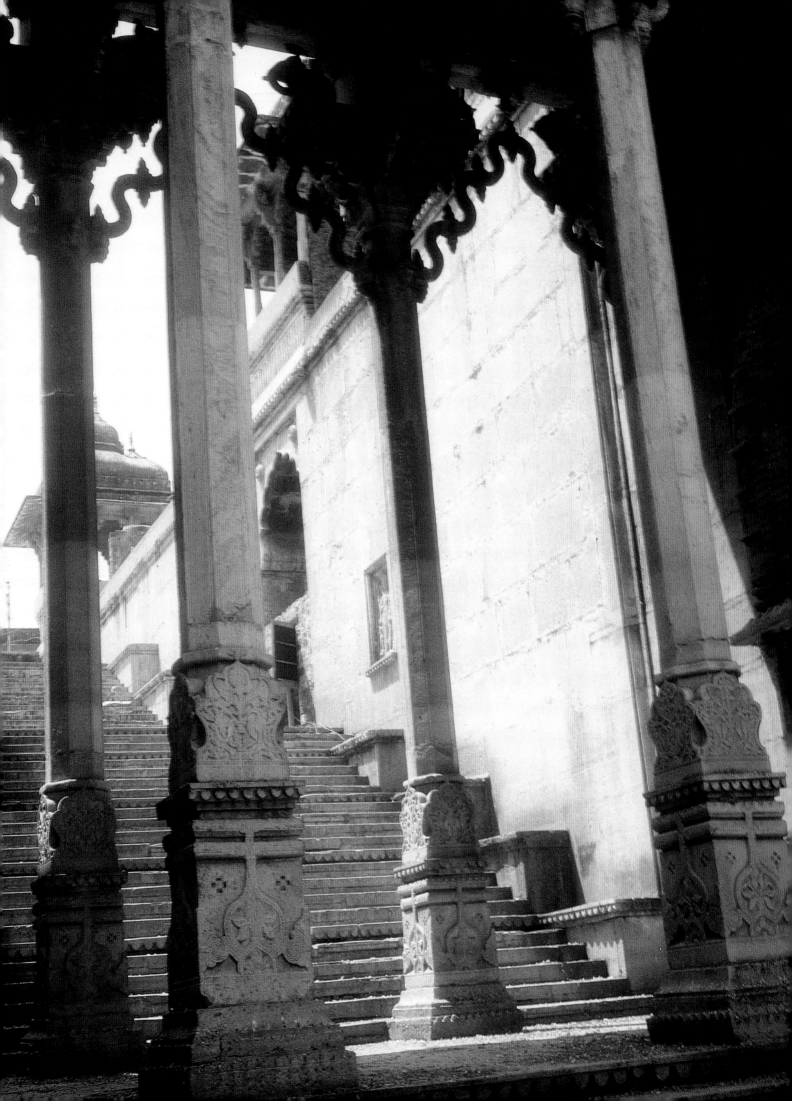

gies, including palaces and houses. They were even used as the generating order for the master plan of towns and cities. Examples include a Khajuraho temple, the Padmanabhapuram Palace in Trivandrum, the Sanchi stupa, and the master plan for the city of Jaipur.

The nonmanifest world was also modeled by subterranean architecture, that is, built form *within* the earth's surface, a concept with the most profound metaphysical connotations.

Wells, being the source of water, were particularly significant. For water, one of the five elements, is the giver of life as well as its taker. The wells became elaborate architectural constructs, and the path to the water a ritualistic pilgrimage. Going down into the earth was analogous to submersion in water, i.e., to rebirth. It is similar to the dissolving of the germinating seed into nothingness, into the world of unformed matter, before it reappears in the form of a plant. If the temple is a model of the cosmos, then this subterranean architecture could well be a model of the dissolution of the cosmos.

So powerful was the architectonic expression of these metaphysical concepts that they influenced the Muslim sultans of the fourteenth century who ruled in western India. Through them, they were metamorphosed into an Islamic architecture.

Manusha

Architecture as the measure of man *(Manusha)* deals with the organic and symbiotic processes through which human beings form their environment, as elegantly and naturally as birds build nests. The basic human need for shelter is, of course, primary. But transcending this is a set of overriding values intrinsic to the human condition: a concern for life, for beauty, for community.

Here again, India has an embarrassment of riches, ranging all the way from decorated mud villages to imposing trade centers along caravan routes. The examples shown here (the village of Banni in Kutch, the desert city of Jaisalmer in Rajasthan, a fishing community in the backwaters of Kerala, and a traditional urban neighborhood in Bombay) not only document the buildings and urban spaces but also illustrate the social relationships that underlie and generate the built form. Squatter colonies—and the myths and aspirations inherent in these urban typologies—are also examined.

Manthana

In history, various societies have accepted and absorbed interventions; the more pluralistic the society, the more easily—and creatively—this seems to happen. India is a prime example. It has had a unique capacity to interact vigorously with outside influences (*manthana* means "churning"), assimilating them through a process akin to osmosis. Examples in this section trace historic interventions from the Mughal and Lodhi periods and their absorption into the traditional architecture of Rajasthan. Other examples show the Muslim capital of Mandu in Madhya Pradesh; the imperial gesture of Sir Edwin Lutyens in New Delhi; the low-key, lifelong contributions of British architects like Claude Batley; and the buildings of Le Corbusier (from Chandigarh to its translation into a vernacular idiom). Finally there are examples of the work of contemporary Indian architects, which reveal both traditional and modern influences.

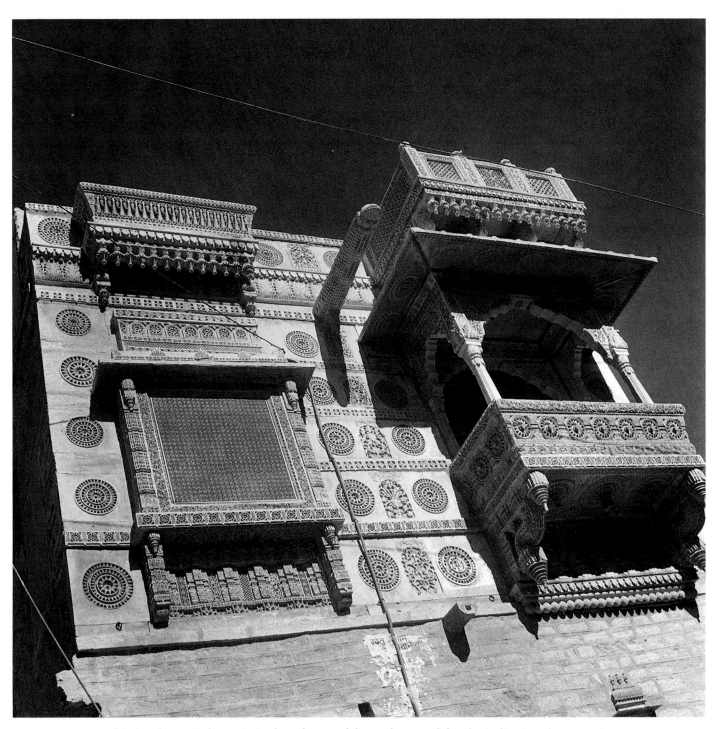

This *haveli* in Jaisalmer, Rajasthan, has an elaborately carved facade, indicating the owner's affluence. Within, a sense of order and rhythm prevails. The smallest detail seems to have received as much attention as the overall conceptual plan

What the various architectural examples in this exhibition have in common is that each opens up new perspectives, fresh vistas—without losing touch with centrality. It is this quality that binds together the conceptual framework of the exhibition "Vistara"—which means an expansion, an unfolding. It is through *Vistara* that one returns to the still point of the center that is highest reality.

CHARLES CORREA
Chairman, Architectural Committee for Festival of India

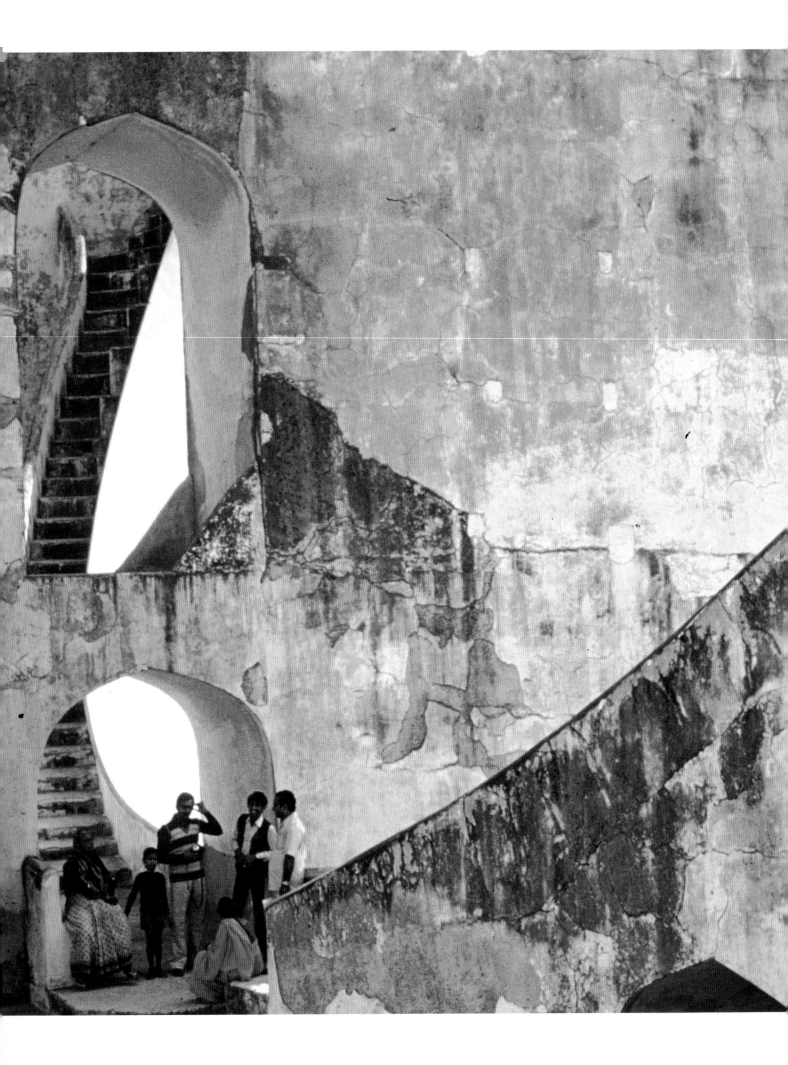

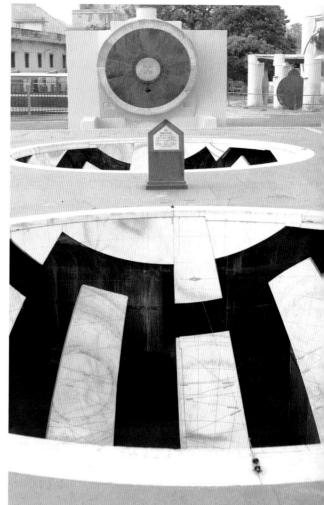

Above: Jaiprakash Yantra, Jantar Mantar,
Jaipur
Left: Jantar Mantar, Jaipur

Taking two emblematic shapes, the circle and the
square for heaven and earth, Sawai Jai Singh
(1686–1734) envisaged his master plan for the city
of Jaipur. His knowledge of astronomy, the
movement of celestial bodies, and cosmic con-
figurations led to the building of monumental ob-
servatories (Jantar Mantar) in Jaipur and Delhi.
Above, a view in silhouette of Jaiprakash Yantra,
a hemispherical cavity sunk into the ground and
used for marking the position of stars in the celes-
tial hemisphere. In the background is Nadiwala
Yantra, a sundial for telling time.

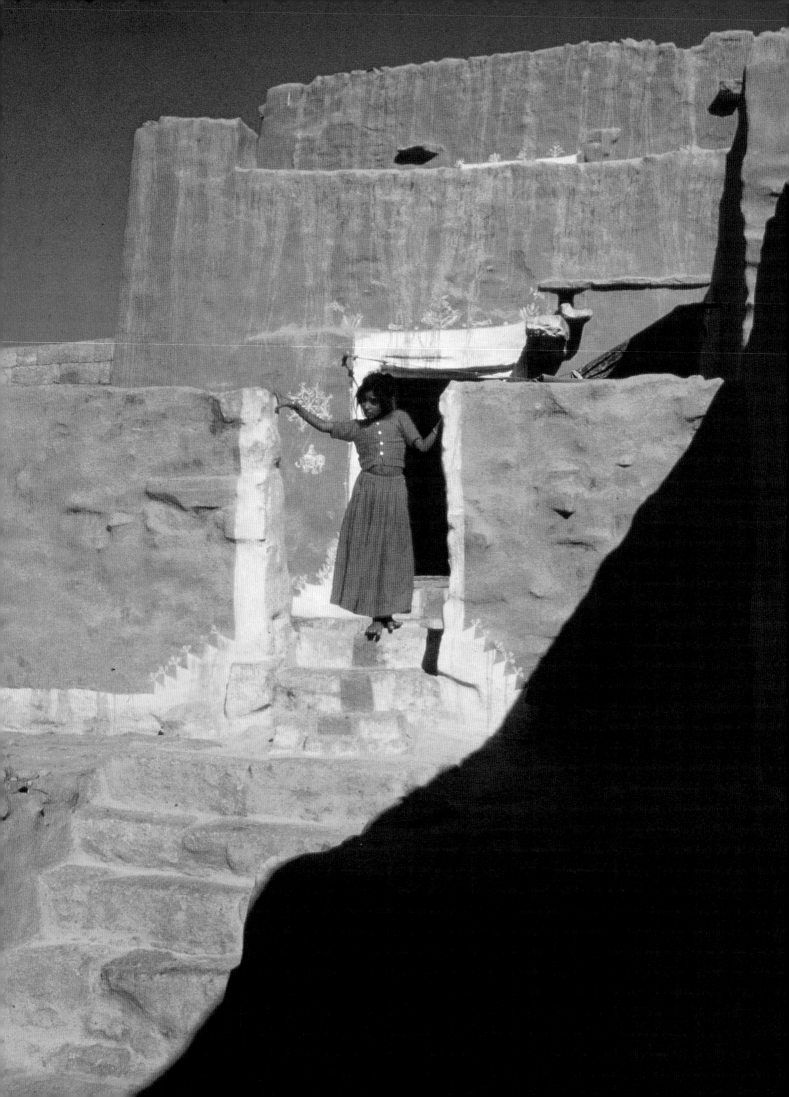

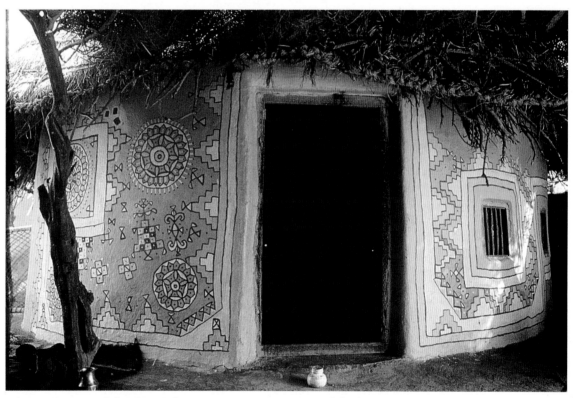

Above: A view of the City Palace in Jaipur. Sawai Jai Singh laid out Jaipur city on a grid of nine squares, based on the nine divisions of the universe. But the city's nine divisions are not perfectly shaped squares, because Jai Singh tempered architectural design with human considerations—for example, to integrate existing villages. The eventual city form expresses a constant concern for relating parts to the whole and the whole to its parts without the displacement of man

Below: Village of Banni, Kutch. This typical mud hut in the village of Banni has painted decorations on the walls, based on geometric forms like the circle and the square. Even in simple rural dwellings, the primary need for shelter is transcended by overriding human values: a concern for beauty, for life, for community

Opposite: Jaisalmer, Rajasthan, demonstrates the coexistence of two different architectural expressions—the imposing *havelis* of the merchant princes and their humbler counterparts in the homes of the people. This structure, called the guard's home, abuts the bastion of Jaisalmer fort

Monumental Islamic Calligraphy from India

In the Islamic world, calligraphy is regarded as the highest form of artistic expression, intrinsically meaningful in content, yet totally abstract in design. Perhaps the most uniquely Islamic use of calligraphy is to adorn large architectural monuments, like the famed Taj Mahal at Agra, each of whose four facades is framed by a vast calligraphic arch rising to a total height of more than one hundred feet. In addition to their decorative functions, such calligraphic inscriptions also contain valuable information about the religious or secular functions of the buildings—telling us who built them and why.

For obvious reasons, stone inscriptions from architectural monuments are rarely included in art exhibitions: most major examples of Indian architectural calligraphy are either still attached to the original buildings or their great size and weight preclude their shipment outside the country. The exhibition "Monumental Islamic Calligraphy from India," sponsored by the Islamic Foundation, Villa Park, Illinois—the first in the United States to focus entirely on architectural calligraphy—consists of full-size photographs and inked paper estampages lent from the extensive archives of Arabic and Persian inscriptions maintained by the Archaeological Survey of India at Nagpur, through the courtesy of Dr. Z. A. Desai, former Director of Epigraphy.

First published in the journals *Epigraphia Indo-Moslemica* and *Epigraphia Indica, Arabic and Persian Supplement*, the seventy-one exhibited inscriptions demonstrate the important artistic role of calligraphy in Islamic architecture of the Sultanate and Mughal periods (c. 1150–1750), during which most of India was ruled by Muslim dynasties. About half the inscriptions were originally installed on mosques, one-fourth on tombs, and one-fourth on secular buildings such as forts, gateways, caravanserais. Aside from numerous quotations from the Koran, the inscriptions contain historical information and, occasionally, Persian poetry or prose compositions that reflect the courtly literary taste of the times.

By the time the first permanent Muslim empire in India was established at the end of the twelfth century, the tradition of adorning Islamic monuments with large-scale calligraphy was already centuries old.

The Quwwat al-Islam mosque at Delhi was the most visible architectural symbol of the new Mamluk dynasty's imperial power. No expense was spared in making it one of the most grandiose monuments of the entire Islamic world. Around 1230, during the reign of the Emperor Iltutmish, the mosque's size was more than doubled, through two great extensions to the north and south. Now only the stumps of the great piers of the northern *qibla* screen extension still stand, but the surviving

University of Iowa, Iowa City

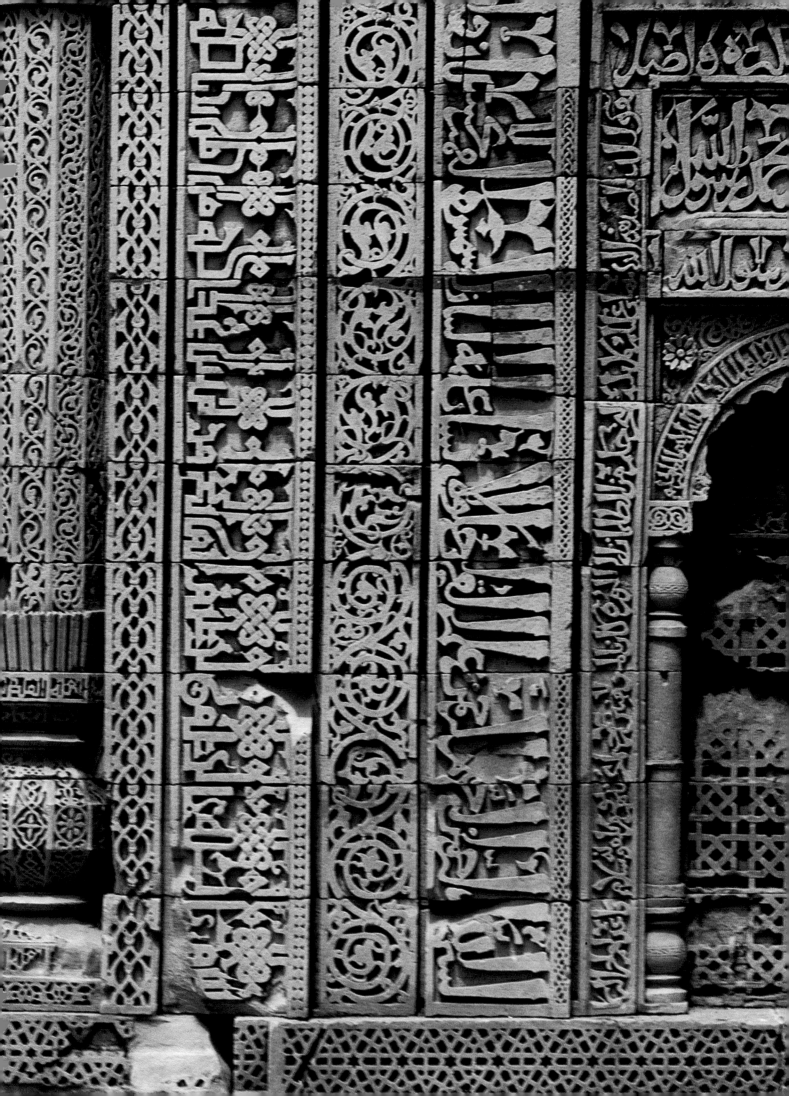

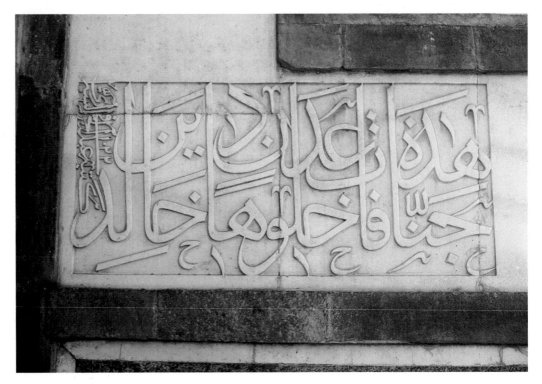

Above: 'Abd al-Haqq of Shiraz (Amanat Khan). Tomb of Akbar. Detail of Persian dedication eulogy and verses inscribed on south facade of main gateway. Mughal, Sikandra (Uttar Pradesh), calligraphy executed 1613 (1022). Overlapping Thulth script, exhibited portion approximately 48 × 96 ⅛" (122 × 244 cm)

Below and opposite: Amanat Khan ('Abd al-Haqq of Shiraz). Taj Mahal. Southern facade, part of Koranic inscription at lower left of arch. Mughal, Agra (Uttar Pradesh), completion of exterior calligraphy 1636–37 (1045). Monumental overlapping Thulth script, exhibited portion approximately 11'9 ¾" × 5'10 ⅞" (360 × 180 cm)

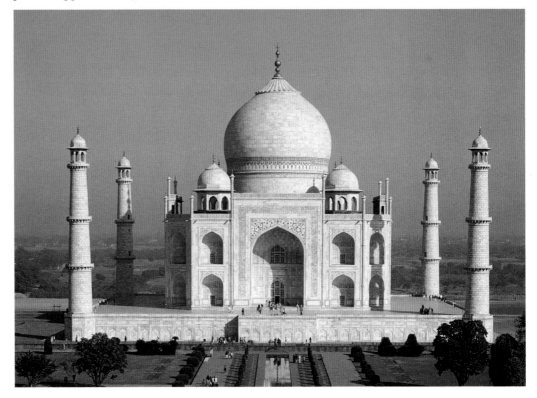

Preceding page: Quwwat al-Islam mosque. North extension screen of Sultan Iltutmish, part of Koranic passages inscribed on right pier of main arch. Mamluk, Mehrauli (Delhi), calligraphy executed probably 1230 (Hijri 627). Plaited Kufi and monumental Naskhi script, exhibited portion approximately 96 ½ × 72 ½" (244 × 184 cm)

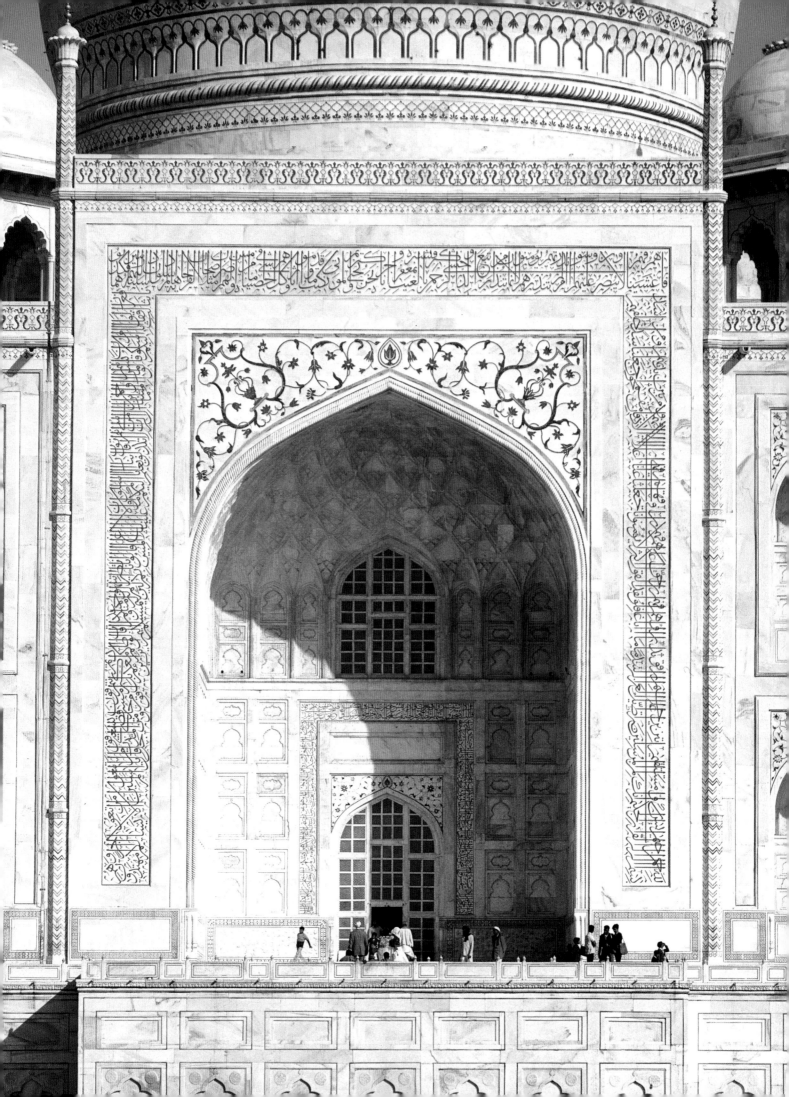

areas of ornately carved calligraphy convey some sense of the addition's original magnificence.

Two distinctly different scripts are used: angular Kufi and cursive Naskhi. In the illustration, the Kufi inscription contains the opening words of a Koranic passage (9.18) that is frequently inscribed on Indian mosques, since it conveys the concern of the Muslim community about the sanctity and purpose of a mosque:

> In the Name of God, the Merciful, the Compassionate. The mosques of God shall be visited and maintained by such as believe in God and the last Day, establish regular prayers, and practice regular charity and fear none except God. It is they only who can be considered among the rightly guided.

The large Naskhi inscription in the middle of the pier contains a few verses from a passage (55.1–5) urging that man recognize God's bounty in the harmonious universe he has created.

Relatively few signatures of calligraphers are found in inscriptions of the Sultanate period, but under the Mughal emperors, as appreciation of the art of calligraphy continued to increase, these became fairly common.

The most honored calligrapher in Indian history designed the calligraphy on India's most famous Islamic monument, the Taj Mahal. This was the great Persian master 'Abd al-Haqq of Shiraz, who was probably in his thirties when he immigrated to India around 1608 and entered the employ of the emperor Jahangir. His first major commission apparently was to both compose the Persian eulogy and inscribe the calligraphy on the main gateway of the late emperor Akbar's tomb at Sikandra.

The illustration shows part of a very long dedication inscription band in white marble, which frames the inner recessed arch of the gateway. Most of the eulogy is in prose, but the bottom marble panel, above the geometric patterned dado, contains three poetic couplets, exalting the magnificence of the tomb structure itself. The final couplet translates as follows:

> The pen of the architect of the Divine Decree has inscribed on its threshold: "These are the gardens of Eden, enter them to live forever."

Thus the inscription provides a clue to the symbolic meaning of the vast garden tomb complex as a metaphorical replica of the heavenly Paradise, which the faithful shall enter on the Day of Judgment.

Some twenty years after Akbar's tomb was completed, 'Abd al-Haqq was appointed chief calligrapher of the Taj Mahal, the tomb built by the emperor Shah Jahan for his beloved wife Mumtaz Mahal. As a reward for his brilliant designs for the Taj Mahal, 'Abd al-Haqq was appointed to a relatively high position in the Mughal nobility and awarded the title Amanat Khan. Approximately equivalent to knighthood, this distinguished honor apparently had never before been bestowed upon a calligrapher in Mughal India.

But then, Amanat Khan was no ordinary calligrapher. Entrusted with designing the Koranic inscriptions on the famed Taj Mahal, he produced monumental calligraphy that must rank as one of the great achievements of world art—as majestic and beautiful as the architecture of the tomb itself.

No.	Name	Separate Form	Transcription	Combined Forms Final Medial Initial	Numerical Value		No.	Name	Separate Form	Transcription	Combined Forms Final Medial Initial	Numerical Value
1.	Alif	ا	a,ā,etc.	ا ... ‍	1		17.	Ṣād	ص	ṣ	ص ... ص ... ص	90
2.	Bā' (Be)	ب	b	ب ... ب ... ب	2		18.	Ḍād (Ẓād)	ض	d (ż)	ض ... ض ... ض	800
(P) 3.	(Pe)	پ	p	پ ... پ ... پ	(2)		19.	Ṭā'	ط	ṭ	ط ... ط ... ط	9
4.	Tā' (Te)	ت	t	ت ... ت ... ت	400		20.	Ẓā'	ظ	ẓ	ظ ... ظ ... ظ	900
5.	Thā' (S̱e)	ث	th (s̱)	ث ... ث ... ث	500		21.	'Ayn	ع	'	ع ... ع ... ع	70
6.	Jīm	ج	j	ج ... ج ... ج	3		22.	Ghayn	غ	gh	غ ... غ ... غ	1000
(P) 7.	(Chīm,Che)	چ	(ch)	چ ... چ ... چ	(3)		23.	Fā' (Fe)	ف	f	ف ... ف ... ف	80
8.	Ḥā' (He)	ح	ḥ	ح ... ح ... ح	8		24.	Qāf	ق	q	ق ... ق ... ق	100
9.	Khā' (Khe)	خ	kh	خ ... خ ... خ	600		25.	Kāf	ک	k	ک ... ک ... ک	20
10.	Dāl	د	d	ل ...	4		(P) 26.	(Gāf)	گ	(g)	گ ... گ ... گ	(20)
11.	Dhāl (Ẕal)	ذ	dh (ẕ)	ذ ... ‍	700		27.	Lām	ل	l	ل ... ل ... ل	30
12.	Rā' (Re)	ر	r	ر ... ‍	200		28.	Mīm	م	m	م ... م ... م	40
13.	Zāy (Ze)	ز	z	ز ... ‍	7		29.	Nūn	ن	n	ن ... ن ... ن	50
(P) 14.	(Zhe)	ژ	(zh)	ژ ... ‍	(7)		30.	Hā' (He)	ه	h	ه ... ه ... ه	5
15.	Sīn	س	s	س ... س ... س	60		31.	Wāw (Vāv)	و	w(v)etc.	و ... ‍	6
16.	Shīn	ش	sh	ش ... ش ... ش	300		32.	Yā' (Ye)	ی	y,ī,etc.	ی ... ی ... ی	10

DIACRITICAL SIGNS

١ ٢ ٣ ٤ ٥ ٦ ٧ ٨ ٩
1 2 3 4 5 6 7 8 9 0

	Sign			Sign			Sign	
Fathah (Zabar)	´	a	Hamzah	ء	' (glottal stop)	Tanwin	˝	- an, etc. (suffix)
Kasrah (Zir)	ˏ	i (e)	Maddah	~	à (extended alif)	Shaddah (Tashdid)	˷	(doubled consonant)
Dammah (Pish)	˒	u (o)	Waslah	~	(unvocalized alif)	Sukun (Jazm)	˚	(unvocalized consonant)

Above: The Arabic and Persian alphabet

Below: Amanat Khan. Caravanserai (built by Amanat Khan). Mughal, Serai Amanat Khan (Punjab), calligraphy executed 1640–44 (1050). Monumental overlapping Thulth script, height of inscription panel approximately 50′ (15.24 m)

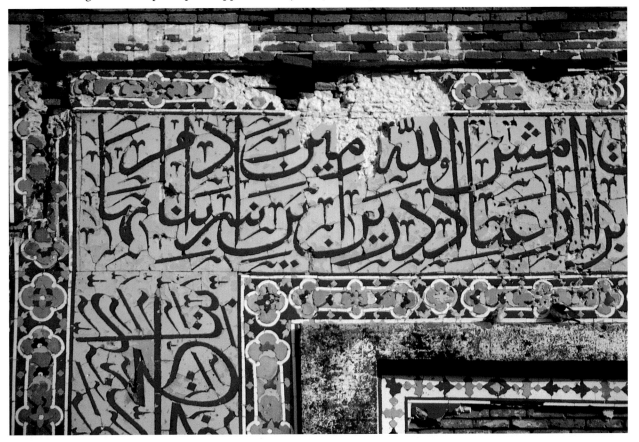

The grand linear sweep of the inlaid calligraphy dramatically articulates the gleaming surfaces of white marble, framing the recessed arches like vast heraldic banners. The formal organization is highly abstract, as we can see in the design of the Koranic passages inscribed on the framing panel of the southern facade. The entire panel contains the opening verses of the profound *Ya Sin* chapter (36.1–21), whose solemn grandeur and majestic rhetoric have caused it to be considered the "heart" of the Koran. Because of its content, the chapter is also traditionally recited at the time of death, since it powerfully affirms the vision of the final reward in the hereafter.

Amanat Khan was also a learned scholar, who apparently was personally responsible for the selection of the entire program of Koranic passages inscribed on the Taj, through which he sought to communicate the meaning of the monument on both the functional and symbolic levels. Like the Persian verses he apparently composed for the tomb of Akbar, the Koranic passages on the Taj also seem to have been selected to suggest that the tomb and its garden are to be understood as a kind of symbolic prefiguration of the celestial Paradise and its ultimate reward.

The last known calligraphic work of Amanat Khan was the vast and extravagantly decorated caravanserai he built with his own funds about a day's journey east of Lahore, on the old Mughal highway connecting that city with Delhi and Agra. Here the distinguished calligrapher went to live after retiring from public office in 1639, following the death of his brother Afzal Khan, Shah Jahan's highly honored prime minister.

Completed two years later, in 1640–41, the serai's most extraordinary feature is its use of glazed-tile calligraphy to adorn both of its mammoth gateways. No other Indian serai has such large and magnificent inscriptions; the lengthy Persian dedication they contain was both composed and written by the calligrapher himself. Building serais was considered an act of pious religious charity, and the conclusion of Amanat Khan's boldly written inscription on the west gateway confirms this motivation:

> . . . I have founded this serai in this land for the comfort of God's creatures, and having completed it on this date—the fourteenth year of the auspicious accession of His August Majesty [Shah Jahan], corresponding to the Hijri year one-thousand-and-fifty [1640–41]—[I wrote] this inscription with my own hand by way of a remembrance. . . .

Although Amanat Khan's calligraphy on the Taj Mahal will always be considered his supreme masterpiece, his inscriptions on the serai bearing his name constitute a moving, final aesthetic testament of a great artist nearing the end of his life.

Although the events and personages mentioned in the inscriptions on Indian Islamic monuments are often obscure and chiefly of interest to scholars, the beauty and majesty of the calligraphy should be comprehensible to everyone. In the words of the sixteenth-century Persian author Qadi Ahmad: "If someone, whether he can read or not, sees good writing, he likes to enjoy the sight of it."

W. E. Begley
Professor of Indian and Islamic Art History,
University of Iowa, Iowa City

Vijayanagara
Where Kings and Gods Meet

The exhibition "Vijayanagara: Where Kings and Gods Meet," at the American Museum of Natural History, introduces a significant archaeological project that is currently taking place in India. While India is celebrated for its many ruined sites, Vijayanagara, the "City of Victory," is unique, the best-preserved and most extensive of all medieval Hindu capitals. (Other earlier Hindu cities are well known from historical sources and isolated monuments, but little of their urban plans can be observed.) Vijayanagara presents the impressive remains of an extensive royal center from which Hindu monarchs manipulated the mundane and spiritual affairs of a vast empire. Not only a royal center, Vijayanagara was also a ritual center where kings interacted with the various gods and goddesses of Hinduism. Identified with Rama, the divine hero-god of the *Ramayana* epic, the kings of Vijayanagara engaged the divine, not only to maintain the power of the ruling dynasty but also to protect the welfare of the kingdom and its subjects.

Founded in the middle of the fourteenth century A.D.—in the wake of Muslim invasions of India and the subsequent disruption of many Hindu kingdoms—Vijayanagara rapidly emerged as the most effective focus of power for Hindus in the south. The rulers of this city successfully extended their influence over the whole of the peninsula, affirming Hindu culture and religion, and preventing Muslim expansion by maintaining substantial military forces. Named after its capital, the Vijayanagara empire endured until the seventeenth century as the last and greatest of all south Indian kingdoms.

In its day, Vijayanagara was one of the largest and wealthiest of all Asian cities, attracting numerous ambassadors, traders, and travelers. Contemporary Italian and Portuguese visitors described an impressive display of regal might at Vijayanagara. Life at the capital was dominated by the activities of the resident ruling dynasty, with their attendant governors, advisors, commanders, courtiers, officers, guards, wives, concubines, and handmaidens. Much of the cultural and intellectual talent of south India was concentrated at Vijayanagara; here the finest architects, sculptors, and artists of the period created a splendidly appointed palace-city. Here, too, priests, philosophers, and pilgrims came to worship in the many sacred temples nearby.

War was a constant preoccupation for the Vijayanagara kings, who were almost continually involved in intrigues against their Muslim neighbors and other Hindu rulers. Hardly a decade passed without some major encounter with the armies of the Muslim sultans. With their superior techniques of warfare, especially the use

American Museum of Natural History, New York

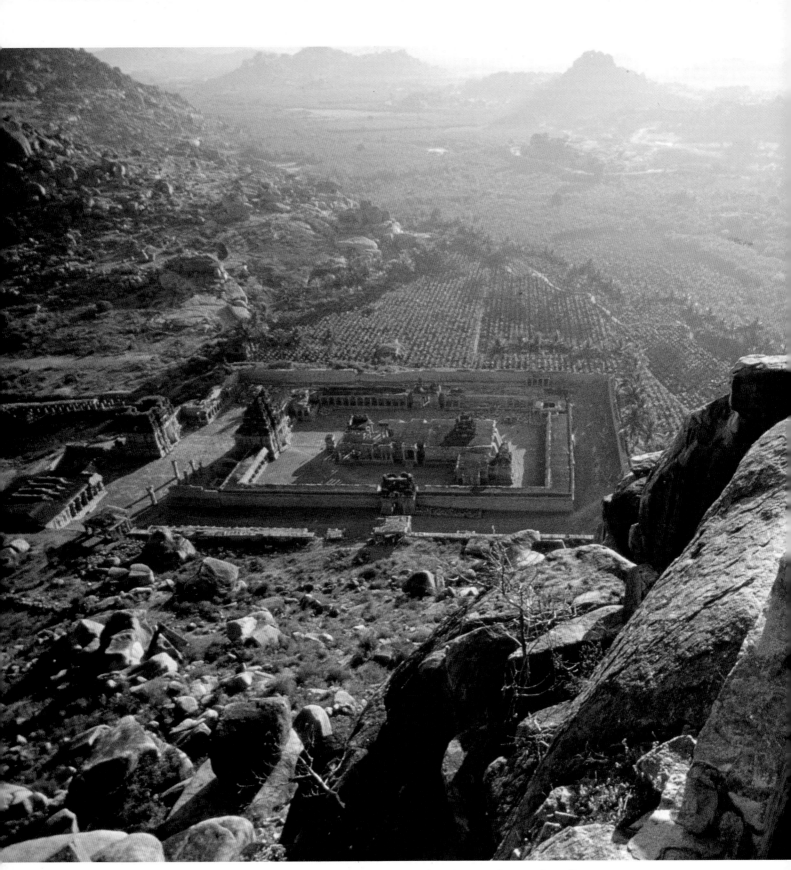

Above: Aerial view of the 16th century Tiruvengalanatha temple complex. Concentric rectangular-walled enclosures contain the principal shrine. The vast tract of cultivated land beyond was once irrigated by the temple authorities

Opposite, above: This monolithic granite sculpture of the man-lion (Narasimha) form of Vishnu is more than 20 feet high

Opposite, below: The friezes of elephants, horses, soldiers, and women on the outer walls of the Ramachandra temple illustrate the processions of the annual festivals within the royal center

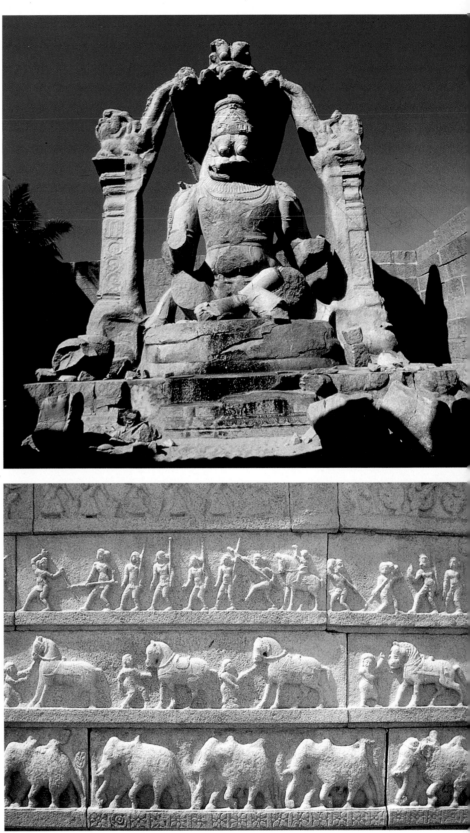

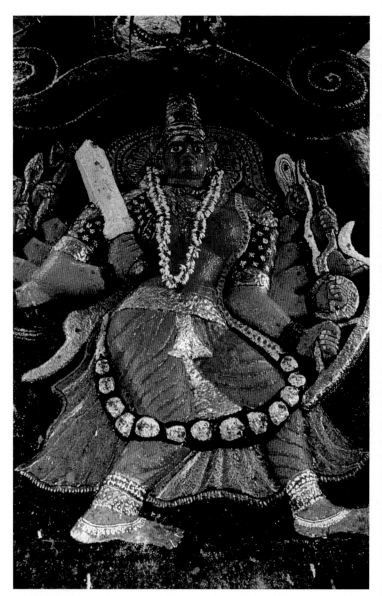

Above: This image of Kali carved onto a granite boulder is still worshiped

Right: The royal pavilion from the 16th century, known popularly as the Lotus Mahal, effectively blends Hindu and Islamic elements

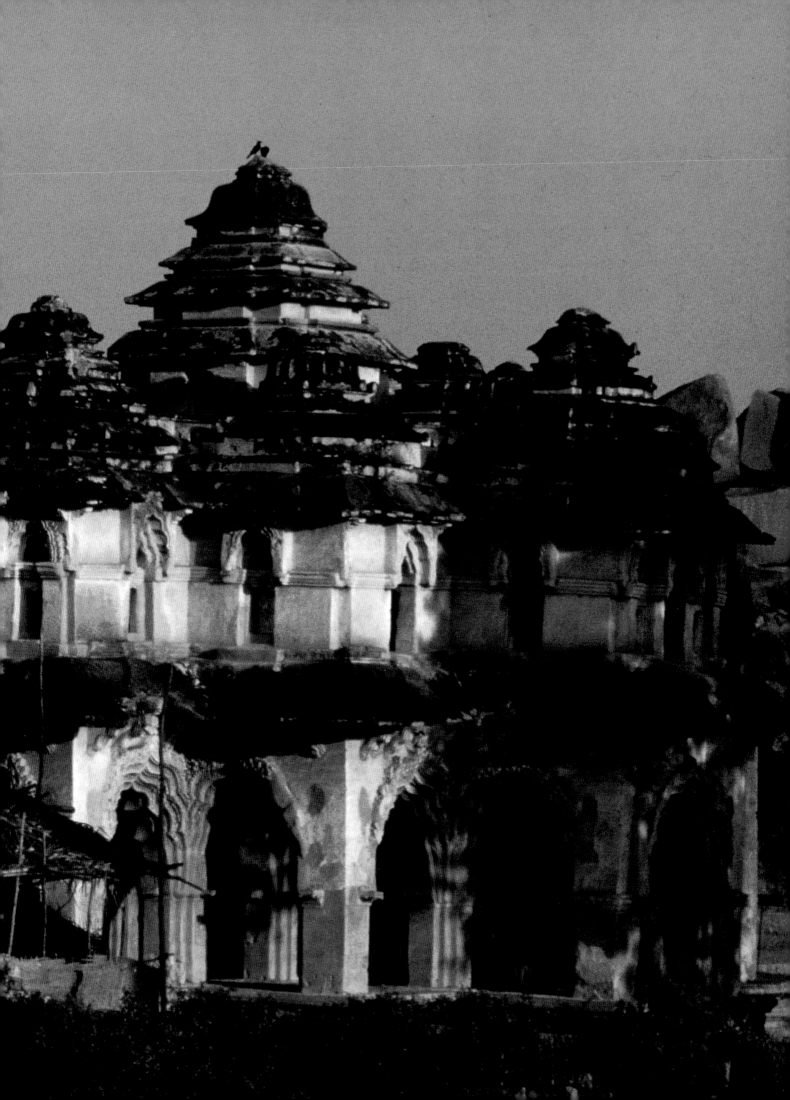

of cavalry, the Muslims eventually emerged as victors. In 1565 a consortium of Muslim armies defeated the Vijayanagara military commander and his vast retinue of elephants, horses, foot soldiers, and other warriors. The king, court, and army fled southward, leaving the capital undefended. For more than six months Vijayanagara was thoroughly sacked and burned. The ruined city was never again occupied or rebuilt; its great monuments, palaces, markets, and streets lay abandoned forever. Soon the site was a wilderness of jungle, infested with malaria and populated only by tigers.

Despite this devastation, the ruins of Vijayanagara are plainly visible, spreading over an area of more than twenty-five square kilometers in a rugged landscape with dramatic outcrops of granite ridges and boulders. Parts of the site are now irrigated with fields of rice, bananas, and sugar cane. Several villages on the periphery incorporate the remains of Vijayanagara-period settlements. The site presents a wide range of monuments—relatively well-preserved temples, pavilions, stables, treasuries, bathhouses, reception halls, and ceremonial platforms, in both Hindu and Islamic styles, as well as fragmentary remains of civic buildings, royal residences, and habitations, mostly buried beneath the accumulated soil.

Surrounding a large part of the site is a ring of massive fortifications following the granite hills wherever possible. These walls define the urban core of the capital, and are regularly broken by defensive gateways. The Tungabhadra River flows through a rocky gorge to the north of the urban core, overlooked by a series of great temple complexes. This "sacred center" predates the establishment of the capital. Within the fortified urban core a dense concentration of civic and royal structures comprises the "royal center." Here were focused most of the activities of the king, court, and army.

In the mid-1970s Vijayanagara was designated a "national project" by the government of India, and a program of clearing and excavating was initiated by the Archaeological Survey of India and the Department of Archaeology of the Government of Karnataka. This work continues today, and local teams of archaeologists are busily revealing palace architecture and other evidence of courtly life at the capital.

Our project of "surface archaeology" aims at documenting the observable architectural and archaeological features of the site. Since 1980 we have been working in India with an international team of archaeologists, architects, surveyors, and photographers, some of whom are students. We also collaborate with historians, epigraphists, and other specialists.

The exhibition at the American Museum of Natural History includes panoramic photographs of the landscape in which Vijayanagara is set as well as photographic studies of the principal monuments and sculptures in the "royal center" and "sacred center." Of particular interest will be a selection of measured drawings of buildings, both sacred and secular. These drawings demonstrate how Hindu and Islamic elements were incorporated into a courtly architectural style. Constructed within the gallery space will be full-size models of arches and entryways from Vijayanagara's palace-pavilions. Several bronze and granite sculptures typical of the period will also be displayed.

George Michell and John Fritz

The World of Jainism
Indian Manuscripts from the Spencer Collection of the New York Public Library

Among the Indian manuscripts in the Spencer Collection of the New York Public Library is a group of works pertaining to the Jain faith. In connection with the Festival of India, the library has planned an exhibition of forty to fifty of these works, which will provide a unique opportunity for an exhibition that will not be represented elsewhere in the Festival.

Jainism, a religion as old as Buddhism in India, encouraged the copying of its own texts; by the fifth century A.D., Jain libraries were established to house these manuscripts. Surviving illustrated Jain manuscripts date from the eleventh century onward and represent the biography of the Jain Savior and the lives of Jain saints, as well as cosmological diagrams and other religious themes. As Jain manuscripts have traditionally been housed in religious libraries accessible only to members of their own faith, it is only in recent times that many of these manuscripts have become available for study.

Although Jain manuscripts have been included in most major Indian painting collections, to date there has never been an exhibition devoted solely to Jain painting in the United States. The Spencer manuscripts, unknown to either the scholarly community or the public at large, provide a unique basis for such an exhibition. The collection includes painted palm leaf manuscripts, manuscripts painted on paper, painted hanging scrolls, and cloth paintings. These range in date from the fifteenth to the nineteenth centuries, and are characterized as a group by a brightly colored palette of reds, yellows, blues, and golds. Many of the manuscripts are complete and contain dated colophons at the end. Thus, they not only have aesthetic and religious merit but are invaluable documents to the study of Indian art.

Among the most exciting of these treasures are four pages of a *Kalpasutra* (Life of the Jain Savior), circa A.D. 1475–1500. These pages are part of the most important and highly prized *Kalpasutras* in India, the largest portion of which is housed in the Devasano Pado Bhandar (Library) in Ahmedabad. It is one of the most richly decorated of all known Jain manuscripts, showing both traditional western Indian style and Persian influences introduced through the Mughal courts of India.

A complete manuscript of the *Kalpasutra* and its companion text, the *Kalakacaryakatha* (Story of Kalaka), circa 1527, is richly illustrated in traditional western Indian style using intense blues and golds. The major themes in the life of the Jain Savior and the Saint Kalaka are represented in the forty-six miniature paintings, from which several works will be selected.

Paintings from a series of cosmological texts, known as *Samgrahanisutras*, are also well represented in the library's Spencer Collection. The finest of this group is a

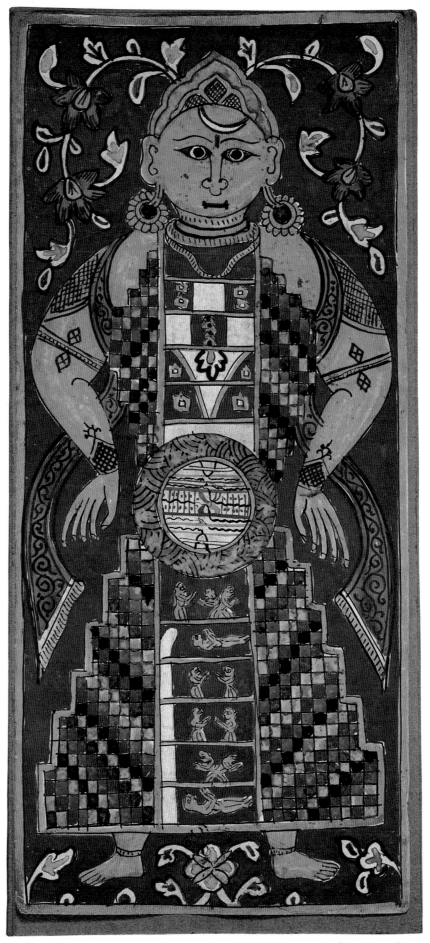

Cosmic Man. From a *Samgrahanisutra* dated 1604. Spencer Indian Ms. 48

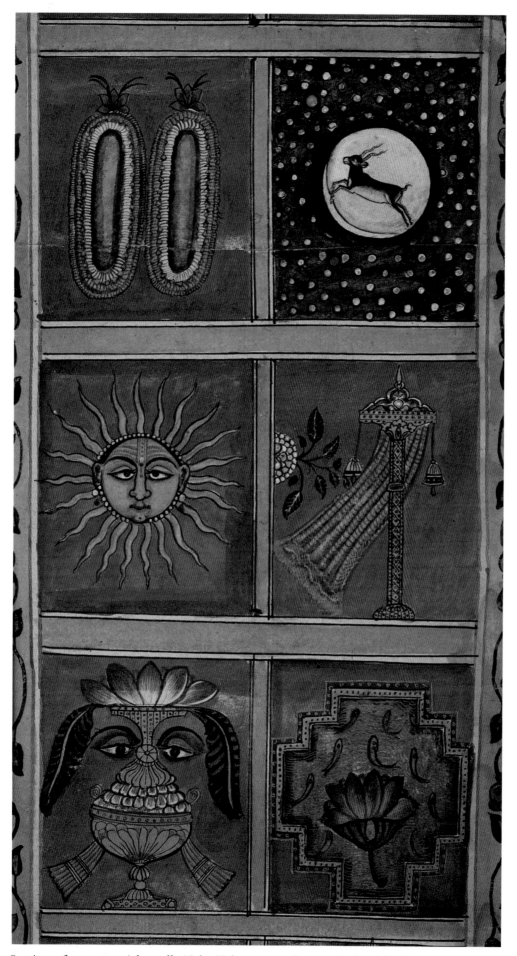

Section of a ceremonial scroll. 18th–19th century. Spencer Indian Ms. 69

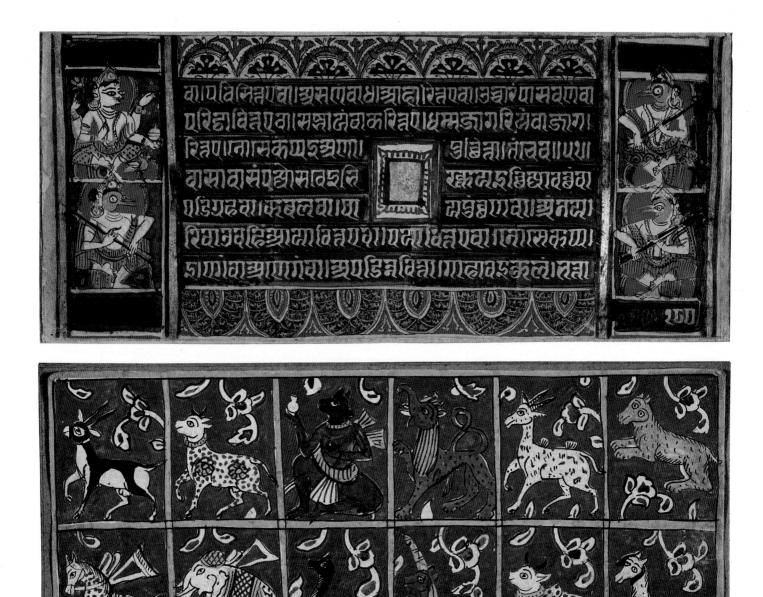

Above: Page from a *Kalpasutra*. c. A.D. 1475–1500. Formerly in the Devasano Pado Bhandar, Ahmedabad. Spencer Indian Ms. 4

Below: Symbols of the Twelve Lower Heavens. From a *Samgrahanisutra* dated 1604. Spencer Indian Ms. 48

work dated 1604. A lively and bold representation is that of the Triple World in the form of Cosmic Man. The central circle of his body represents the World with its mountains and rivers, while the upper and lower sections represent the Heavens and Hells respectively.

Other highlights of the exhibition will include a diagram of the cosmos, painted on cloth, circa 1550, and a group of hanging scrolls of the eighteenth century illustrating Jain rituals.

India!

Since "It would take . . . too long to describe the excellencies of each [painter] . . . my intention is 'to pluck a flower from every meadow.' " So reads the "Statutes" of Akbar (in Abu'l-Fazl 'Allami, *The A'in-i Akbari,* trsl. H. Blochmann), the greatest of the Mughal emperors. "India!," the exhibition held by the Metropolitan Museum of Art in celebration of the Festival of India, is a comparable assemblage of artistic "flowers"—not only from India's meadows, but from her mountains, valleys, plains, jungles, coast, and backwaters. To encompass Indian art in a single exhibition, however comprehensive, is even more challenging than deciding where to go in India during a short visit. To begin to understand her people and culture, one must also experience her shrines as well as palaces, forts, villages, towns, and cities. Representing their sacred spirit, "India!" opens with several superb bronzes of the great south Indian tradition, one of which, *Yashoda and Krishna,* a late Vijayanagar image, is movingly universal in its humanity.

Tribal and village Indian art—too often overlooked and underestimated—can be as splendid as that of the great religious institutions or courts. We include a small survey, therefore, of textiles, ornaments, bronzes, and bold sculptures, such as a tribal headdress from Nagaland, in which magically potent hornbill feathers, an elegantly shaped brass disk, human hair, wire, seeds, and natural fibers are assembled with dramatic inventiveness; even the recent repairs, in Day-Glo pink—legitimate aspects of the object's history—exude tribal majesty. It should be seen in action, of course—worn by a spinning warrior, one of hundreds similarly crowned, dancing in a field. But the best one can do in a museum is to sketch the setting through photographs and word-pictures.

Inasmuch as the exhibition is limited to later Indian art (1300 to 1900), several galleries are devoted to the court styles of the sultans and emperors. *The Leopard Explaining What the Lion Ordered,* an illustration to a sixteenth-century fable book probably from Gujarat, is both ornamental, with its textile-like arabesques, and suggestive of the unusual rapport in India between people and animals. Most Indians live in proximity to elephants, monkeys, or water buffaloes, which explains why so many of Aesop's and Jean de La Fontaine's amusingly moralistic tales originated in India.

The quintessence of a dedicated and creative royal aesthete, the Mughal emperor Jahangir was a patron of Medicean dimension who encouraged his artists and craftsmen

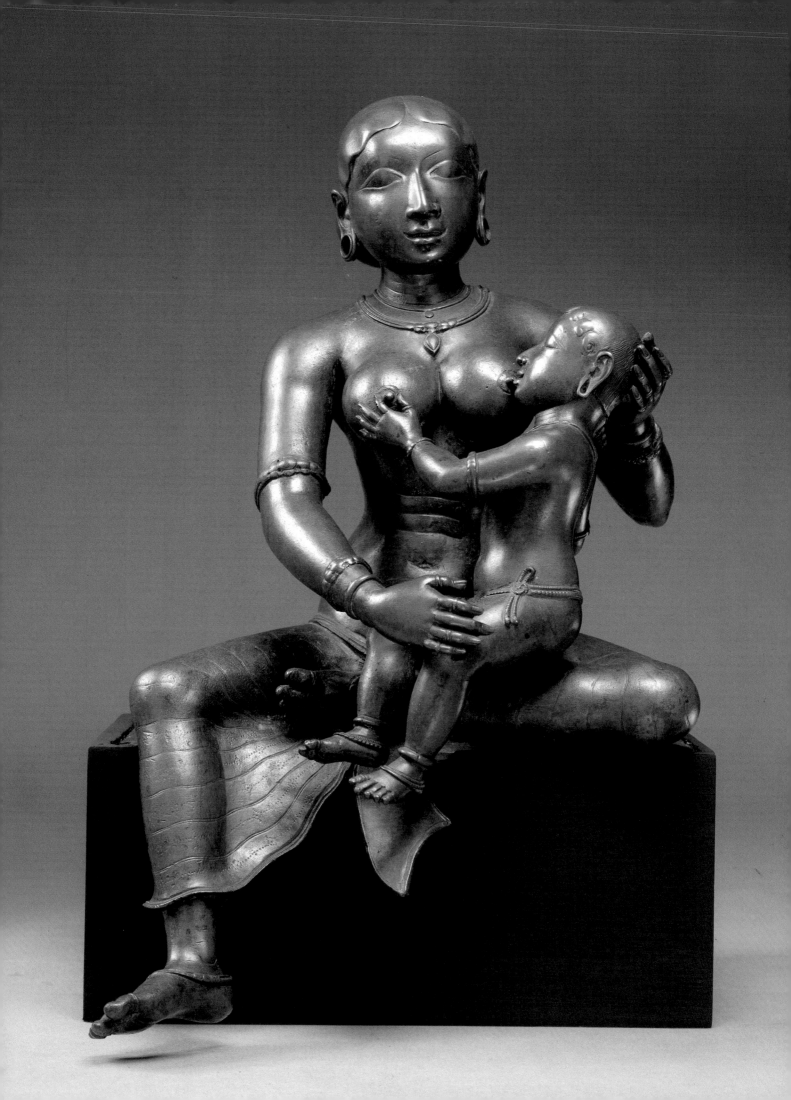

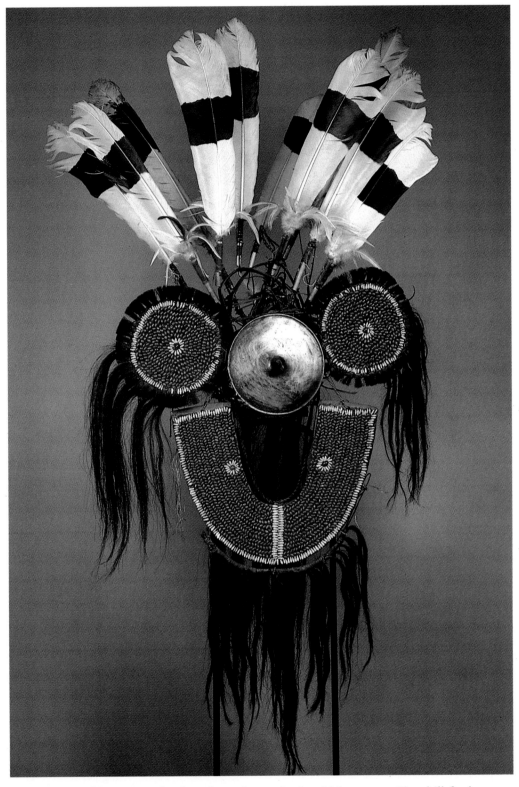

Feathered headdress. Nagaland, perhaps Angami tribe, 19th century. Hornbill feathers, brass, human and goat hair, white seeds of Wild Job's tears *(sikre),* unidentified red seeds, wood, basketwork, cotton thread, and copper wire, with recent Naga repairs in pink thread, 54¾ × 25⅝ " (139.1 × 65.1 cm). Private collection

Opposite: *Yashoda and Krishna*. Karnataka, 16th century or later. Copper, height 13⅛ " (33.3 cm). The Metropolitan Museum of Art, New York. Purchase, Lita Annenberg Hazen Charitable Trust Gift, in honor of Cynthia Hazen and Leon Bernard Polsky, 1982

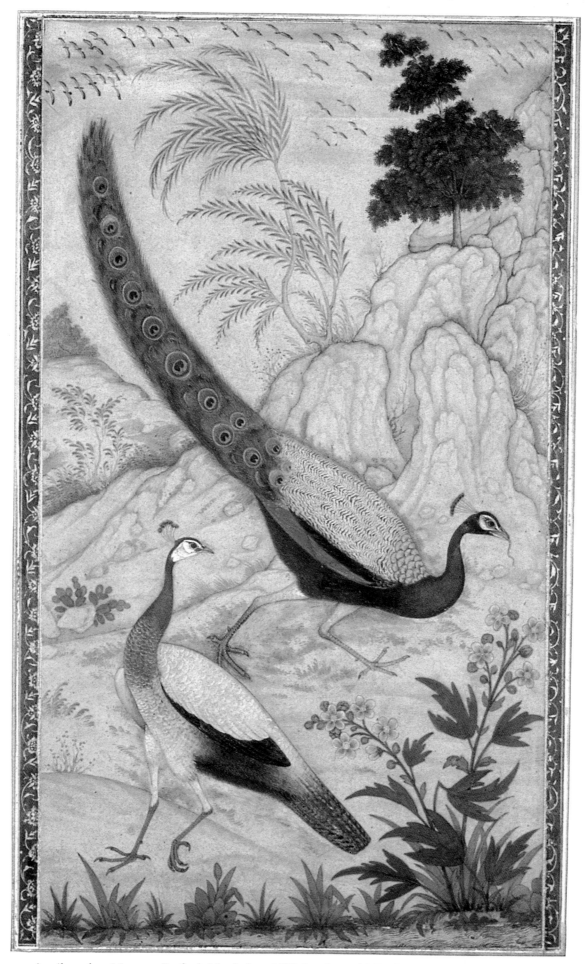

Attributed to Mansur. *Peafowl*. Mughal, c. 1610; border c. 1645. Opaque watercolor on paper, image 7½ × 4¼″ (19.1 × 10.8 cm); page 14⅜ × 9⅞″ (36.5 × 25 cm). Private collection

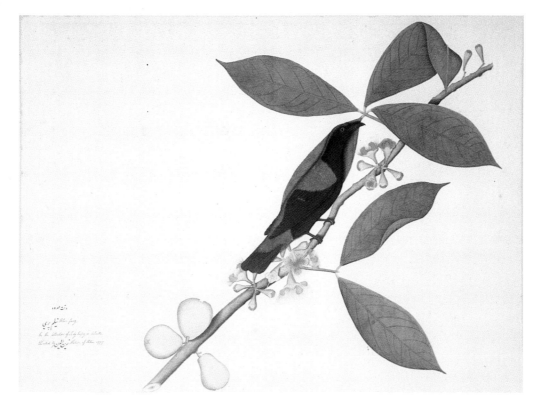

A Fairy Bluebird [*irena puella*]. Signed, lower left: "Zain ad-Din." Calcutta (Company School), dated 1777. Opaque watercolor on paper, 21 × 28⅞″ (53.3 × 73.4 cm). Private collection

to imbue all their work with seriousness and grandeur. Jahangir's *Peafowl*, probably the work of Mansur, his leading artist of flora and fauna, is a nature study suffused with vital painterliness. With the acuteness of a high-speed camera, all-seeing, all-knowing Mansur conveyed the birds' dashing grace as well as their hungry cruelty.

"India!" traces the rise and gradual fading away of many dynasties, including that of the Mughals, whose long rule (from 1526 until 1858) produced art that runs the gamut from works of surging power to those in exquisite decline. In the context of the exhibition, works of art too often demeaned as "ornamental" are revealed to be as profound as pictures and sculptures. A length of flowered silk made for Jahangir's son Emperor Shah Jahan, the builder of the Taj Mahal, is as lyrical as it is splendid. Even seeing it stretched out flat in a frame conveys something of the mood of the imperial court at Agra, where it was intended to cover a solidly comfortable bolster.

In the Deccan, the sultans of Ahmadnagar, Bijapur, and Golconda rivaled the Mughals, who were far more recent arrivals in India but who conquered their southern neighbors at the end of the seventeenth century. As builders, patrons of music, literature, and painting, rulers such as Sultan Ibrahim 'Adil-Shah II of Bijapur, a contemporary of Emperor Jahangir, encouraged their artists in moods of lyrical fantasy.

However compartmented India and her arts might seem, each section and style connects with and relates to others. Once the Mughal armies from the north had conquered the Deccan, Deccani artists countered by transforming many of the arts of the north. Among the prestigious officers of the imperial armies were Rajput princes from Rajasthan and other northern areas, who were eager to hire talented artists and craftsmen, many of whom they took back to their own ateliers.

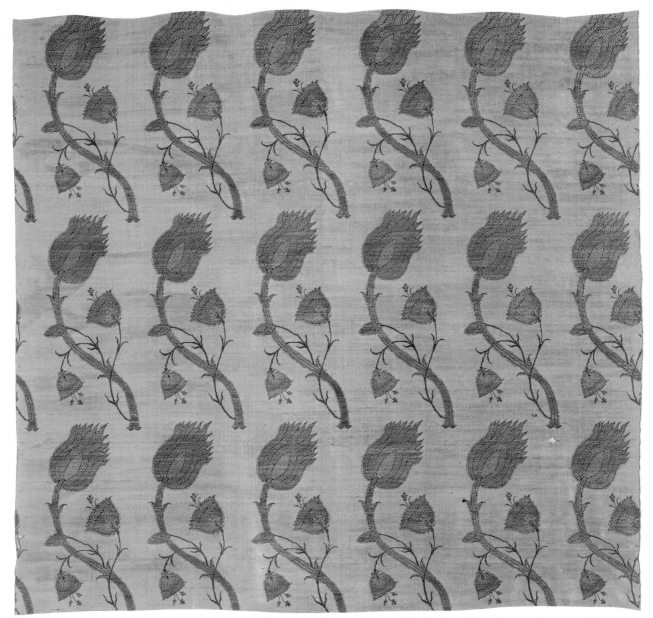

Length of flowered silk. Mughal, mid-17th century. Double cloth, silk and metal-wrapped yarns, plain weave, 27 ¼ × 29 ½" (69.2 × 74.9 cm). The Metropolitan Museum of Art, New York. The Nasli Heeramaneck Collection, Gift of Alice Heeramaneck, 1982

Reverence for scientific naturalism was expressed by Mary, Lady Impey, the English patroness of painting, who instructed her "native artists" in Calcutta at about the time of the American Revolution. For her, Shaikh Zain ad-Din, an artist trained in the Mughal tradition at Patna, painted a fairy bluebird on imported English paper. The sensitive, thoroughly Indian artist, aiming to achieve precise naturalism by delineating every feather exactly to scale, reveals not the frail body but the soul of a very shy bird with a frail body, hiding in a sinuous arabesque of greenery.

STUART CARY WELCH
Special Consultant in charge of the Department of Islamic Art,
The Metropolitan Museum of Art

Curator of Islamic and Later Indian Art,
Fogg Art Museum, Harvard University

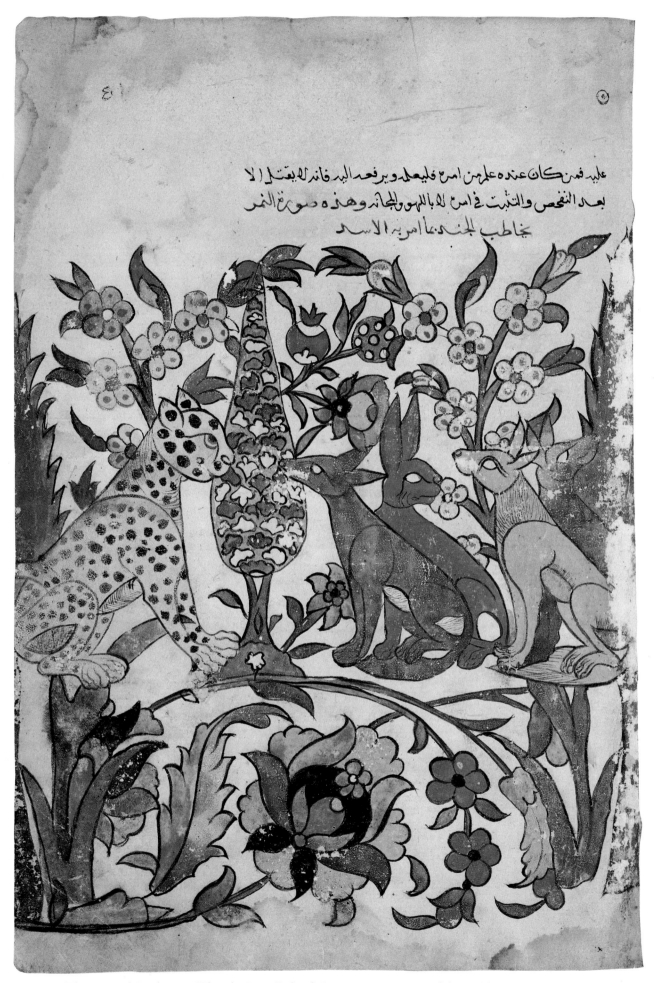

The Leopard Explaining What the Lion Ordered. From a manuscript of the *Kalila wa Dimna* of
Bidpai. Probably Gujarat, mid-16th century. Opaque watercolor on paper, 12 × 8 ⅞″
(30.5 × 22.5 cm). The Metropolitan Museum of Art, New York. The Nasli Heeramaneck
Collection, Gift of Alice Heeramaneck, 1981

The Arts of South Asia

The exhibition "The Arts of South Asia" is drawn completely from the permanent collections of the Freer Gallery of Art. The holdings are particularly strong in paintings made for the Islamic rulers of the Mughal dynasty (1526–1858), but also include superb examples of Buddhist and Hindu sculpture, Rajput (Hindu) and other paintings, and decorative objects.

For almost half a century after the beginnings of Buddhism in India—the mortal Buddha himself lived between about 563 and 483 B.C.—there was no explicitly Buddhist imagery. As the religious order grew, such pre-Buddhist deities and symbols as snake gods and lotuses began to be represented on Buddhist monuments. By this means, a wide range of existing sects within India could be associated with the new Buddhist order; a snake god in attendance at a Buddhist shrine, for example, encouraged his worshipers to acknowledge the Buddhist power as well.

Eventually, these symbols were given more specifically Buddhist meanings. In *King Vidudabha Visits the Buddha*, worshipers pay homage to a wheel that rests on a throne beneath a parasol. The wheel is one of the oldest and most potent symbols in India. For Hindus, it is the discus-like weapon of the god Vishnu, and a tool to conquer evil. (Even as late as the twentieth century, in the form of Mahatma Gandhi's spinning wheel, it became a symbol of resistance to the British.)

In this Buddhist relief, the wheel stands for the Laws of the Universe and the teachings of the Buddha, who was not himself represented in sculpture or painting until the first or second century A.D. The Buddha taught that Truth could only be realized by the annihilation of any sense of personal ego or distinct individual existence; therefore, to represent the Buddha as a historical mortal was antithetical. On the other hand, this sculpture is extraordinarily down to earth and explicit in other ways. The architectural representation, for example, is highly informative about buildings that have long vanished, and the horse that disappears beneath the entrance gateway to the left is carefully observed and placed in space. (The head of his rider is even visible beyond and above the gate.) To the right the king arrives in his chariot, and he is protected by a parasol similar to that which shelters the wheel of the World Ruler, the Buddha. The parasol was an enduring symbol of royalty and eminence. It is found also on a Mughal dagger made for the emperor Jahangir in 1620–21, where the shape is inlaid in gold on the steel and meteoric-iron blade.

This combination of highly symbolic references within a scene that otherwise seems wholly "realistic" recurs continually in the lavish output of artists in India. In

Freer Gallery of Art, Smithsonian Institution, Washington, D.C.

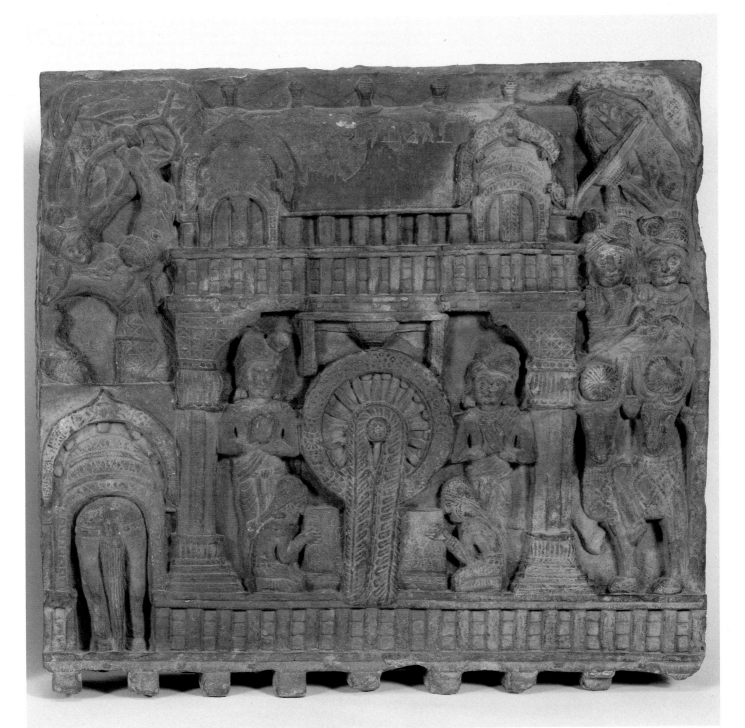

King Vidudabha Visits the Buddha. Relief from the railing of a Buddhist stupa. Bharhut, Shunga dynasty, 2nd century B.C. Red sandstone, height 18⅞″ (47.2 cm). Freer Gallery of Art (32.25)

A fragment of the decoration on one of the greatest Buddhist monuments, the stupa at Bharhut. Stupas were hemispherical funerary monuments that enshrined relics of the Buddha or, later, his major disciples. The scene here depicts a visit by Vidudabha, a vengeful king who was dissuaded from attacking the Buddha's followers by encounters with the Enlightened One. Vidudabha arrives at the right, but departs (to the left) after seeing the Buddha on his throne. Since images of the Buddha were not permitted at this time, he is represented by a wheel, the symbol of his teaching.

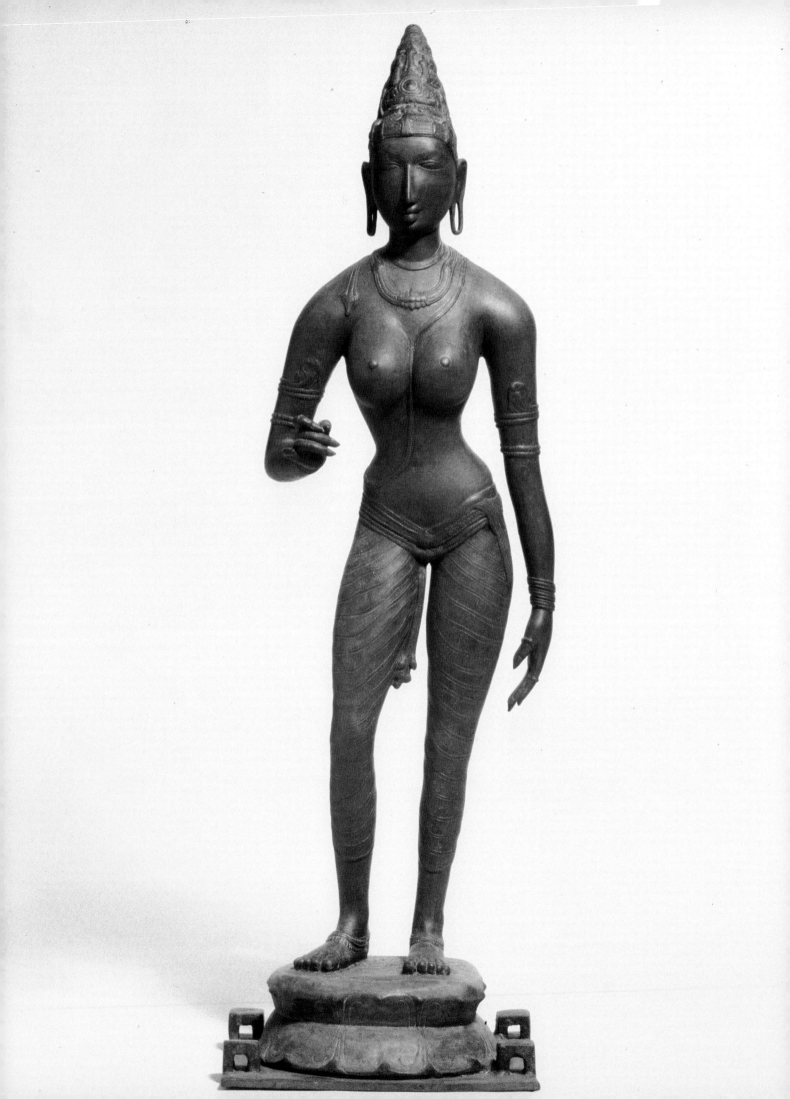

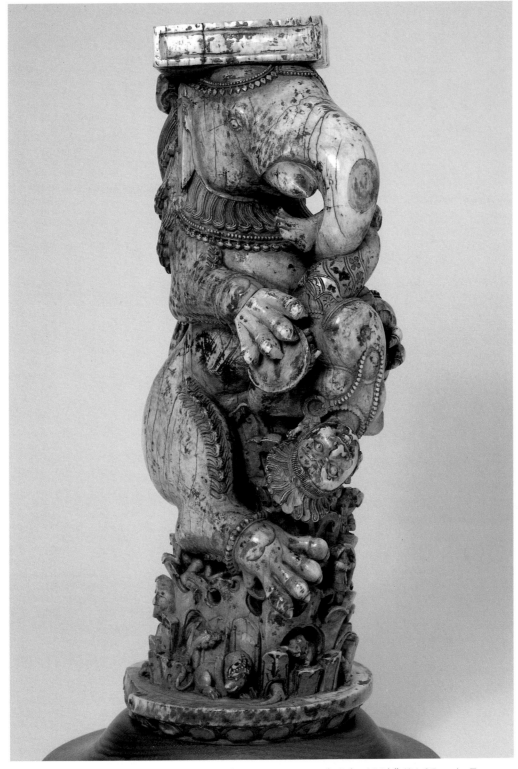

Throne leg. Orissa, Ganga dynasty, 13th century. Ivory, height 13 ¾″ (34.37 cm). Freer Gallery of Art (07.8)

In India, thrones frequently consisted of flat platforms, raised off the floor on elaborately decorated legs and covered with pillows. Here support was given by a mythical beast, half-elephant, half-lion. Fanciful creatures were frequently used in this context, and, as here, they often towered over dwarfish humans or attacked warriors. The original meaning has never been satisfactorily explained.

Opposite: *Parvati*. Chola dynasty, 10th century. Bronze, height 40″ (100 cm). Freer Gallery of Art (29.84)

Parvati, consort to Shiva, the Hindu God of Destruction, is considered to embody his *shakti*, or energy. She is shown as ravishingly beautiful, her fertility at once an embodiment of the creative powers of the universe and a complement to Shiva's destructive aspect.

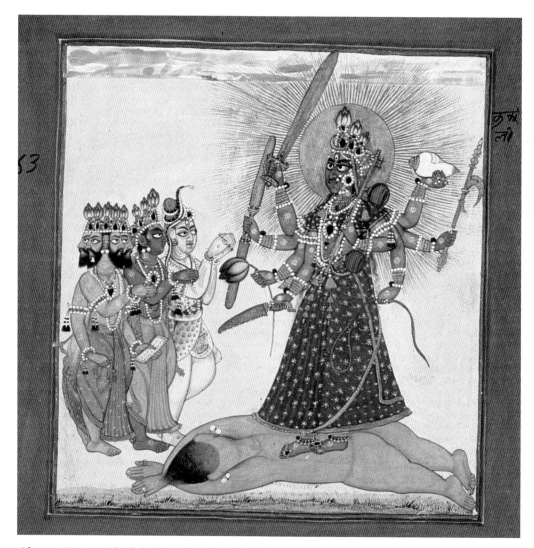

Above: *Devi as Bhadrakali, Worshiped by Brahma, Vishnu and Shiva*. From a *Devimahatmya* series. Punjab Hills at Basohli, Rajput, c. 1660. Gouache on paper, 7 × 6 ¾ ″ (17.5 × 16.87 cm). Freer Gallery of Art (1984.42)

This scene of homage to the Dark Goddess by the great male gods of Creation, Preservation, and Destruction is evidence of the potency of the maternal principle in Indian religious thought. (Statues of female fertility figures are profuse even at the earliest known stages of Indian imagery.)

Below: Pen box. Decoration by Rahim Deccani. Deccani, late 17th century. Lacquer, length 11⅛ ″ (27.8 cm). Freer Gallery of Art (59.5)

An inspection of the surface reveals that the paintings were made on paper, which was then cut and laid on the surface of the box and coated with lacquer. Such luxury objects were made for court use.

the imperial Mughal image of *Jahangir Embracing Shah Abbas*, the depiction of the monarch is no merely idealistic presentation. The artist, Abu'l Hasan, has probingly explored the emperor's character and convincingly depicted not merely the patterns of the clothing and ornaments he wears but also their material textures. If Jahangir stands on a lion and a globe—symbols of his power and world dominance—this in no way destroys our perception of him and Shah Abbas as flesh-and-blood beings. The power of this work, like that of *King Vidudabha Visits the Buddha*, resides in its ability to engage our interest at the most direct, human level, and then to reveal, through symbols or style, transcendent, unearthly spheres of meaning. In India, Earth is the realm of the gods. *Krishna and the Golden City of Dwarka*, from a *Harivamsa* (Genealogy of Vishnu) manuscript made for Jahangir's father, the Mughal emperor Akbar, places the palace of the god Vishnu within an appealingly rural landscape. Any Indian villager could identify with the setting, and would thereby be encouraged to feel the presence of the gods within his daily world.

Krishna and the Golden City of Dwarka illustrates a translation into Persian of a portion of the great Sanskrit epic *Mahabharata*. The text is Hindu in subject, but the volume was made for an Islamic ruler of north India. The painters of the illustrations in the manuscript, who were both Hindu and Islamic, were influenced by—among other things—the technique of prints and paintings arriving in India with European missionaries and adventurers. An understanding of the quite different cultural traditions and styles that are intermixed within such individual works enriches our comprehension of the arts in India, just as a knowledge of iconography adds to our appreciation of religious imagery.

Parvati, the consort of the Hindu god Shiva, for example, is represented here as a supremely beautiful woman. In truth, this is simply one aspect of the great goddess Devi. Another form is Bhadrakali, the fierce and destructive deity worshiped by the Hindu male trinity: Brahma (God of Creation), Vishnu (God of Preservation), and Shiva (God of Destruction). To know Devi in only her beautiful form as Parvati would limit the goddess's universality—her need to represent all aspects of woman. We can here recall *Jahangir Embracing Shah Abbas*, in which the emperor is presented to us as both human and divine. Within India, the divinization of mortal rulers was as necessary as the humanization of the gods, and artists in India were particularly skillful at creating a sense of universal power through such images.

Most Hindu and Buddhist works were made for ceremonial use: they were related to communal temple rituals. The Islamic arts, however, resulted from court patronage, and were intended for appreciation by specific individuals. Rather than ritual objects, these were more often simply opulent furnishings for a wealthy household. The courtly need for novelty, and for an increasing refinement of technique and artistic sensibility, was often irrelevant to Hindu traditions, in which art sought to represent the unchanging qualities of familiar gods. The richness of the arts of India lies in the variety of religions and social groups—from maharajas to villagers—from which it drew, and still draws, its sustenance, and to which it must, in turn, communicate.

Milo C. Beach
Assistant Director, Center for Asian Art, Arthur M. Sackler Gallery,
Smithsonian Institution, Washington, D.C.

Akbar's India
Art from the Mughal City

As its contribution to the Festival of India, the Asia Society Galleries will present "Akbar's India: Art from the Mughal City of Victory." This exhibition focuses on the years 1571 to 1585, when the Mughal emperor Jalal-ad-Din Akbar ruled India from his capital at Fatehpur-Sikri ("City of Victory"), twenty-four miles west of Agra. It is the first comprehensive examination of the arts at Akbar's capital. These years form a crucial period in the history of Indian culture, when Akbar extended his daring imagination, authority, and influence over the arts in the same manner that he did over the physical world of his capital. He created a court where his unique ideas about the nature and goals of artistic expression resulted in significant changes in the course of Indian art.

When Akbar issued the orders for work to commence at Fatehpur-Sikri, he was twenty-seven years old but had ruled the most important throne of northern India since the age of fourteen. By the time of this death in 1605, Akbar had extended his kingdom to include virtually all of the Indian subcontinent. The emperor's political and military feats, however, were matched by his patronage of the arts, and his years at Fatehpur-Sikri were among the most productive in this respect. The buildings of Fatehpur-Sikri and the various works of art that were created there between 1571 and 1585 reflect the emperor's vision of his world.

This exhibition will trace Akbar's impact on the arts at the same time that it displays a sampling of the greatest art produced at Fatehpur-Sikri in these years. Of the ninety items in the exhibition, most are paintings, but stone, bronze, jade, textiles, carpets, and ceramics are also included. The exhibition has been curated by Glenn Lowery, of the Freer Gallery of Art, and Michael Brand, of the Rhode Island School of Design, working in conjunction with Stuart Cary Welch, Special Consultant in Charge of Islamic Art at the Metropolitan Museum of Art.

A coordinate photographic exhibition, at Asia Society, "Fatehpur-Sikri Today," will consist of details of architectural elements and panoramic views of the buildings of Fatehpur-Sikri that remain standing, such as the majestic Panch Mahal, or Tower of the Winds. The exhibit will include photographs of locations depicted in manuscripts and described in the exhibition catalogue, in order to bring to life the imagery of Akbar's court.

DR. ANDREW W. PEKARIK
Director, The Asia Society Galleries, New York

Attributed to Baswan. *Anvari Entertains in a Summer House.* From an imperial copy of the *Divan* of Anvari. Completed at Lahore on 1 Dhul-qada 996 (September 22, 1588). Opaque watercolor on paper, 5½ × 2¾″ (13.97 × 6.98 cm). Fogg Art Museum, Cambridge, Massachusetts

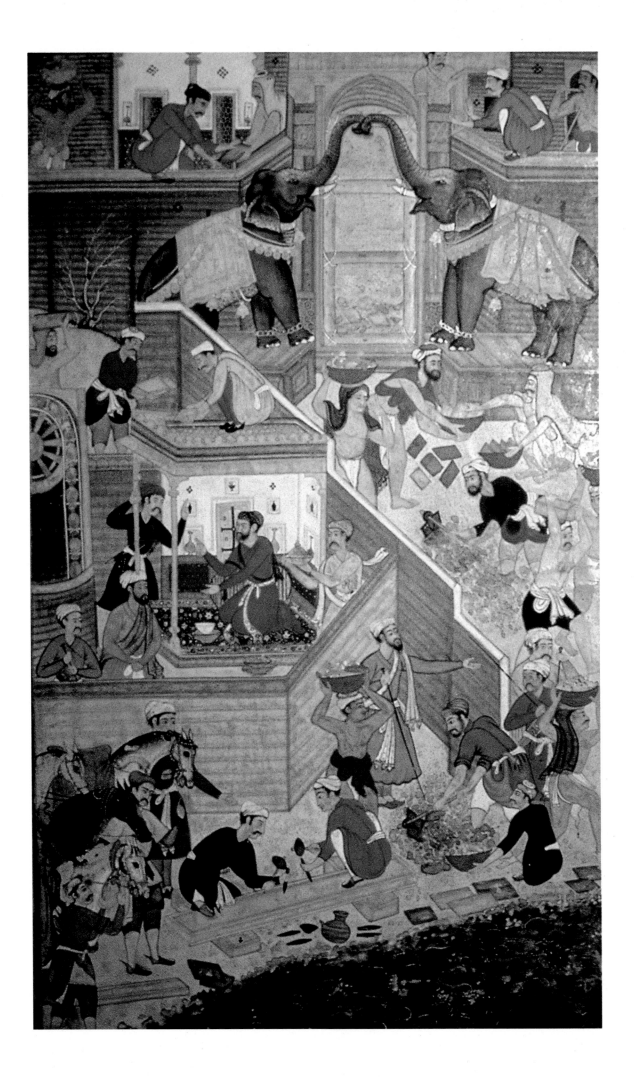

Opposite: Design by Tulsi the Elder, painting by Bhavani. *The Construction of Fatehpur-Sikri*. From an imperial copy of the *Akbarnama*. c. 1590. Opaque watercolor on paper, 14¾ × 9½″ (37.5 × 24.2 cm). Victoria and Albert Museum, London

Above: Gate of Fatehpur-Sikri in a contemporary photograph, from the exhibition "Fatehpur-Sikri Today"

Below: North porch (Hawa Mahal) of Jodh Bai's palace in Fatehpur-Sikri, from the exhibition "Fatehpur-Sikri Today"

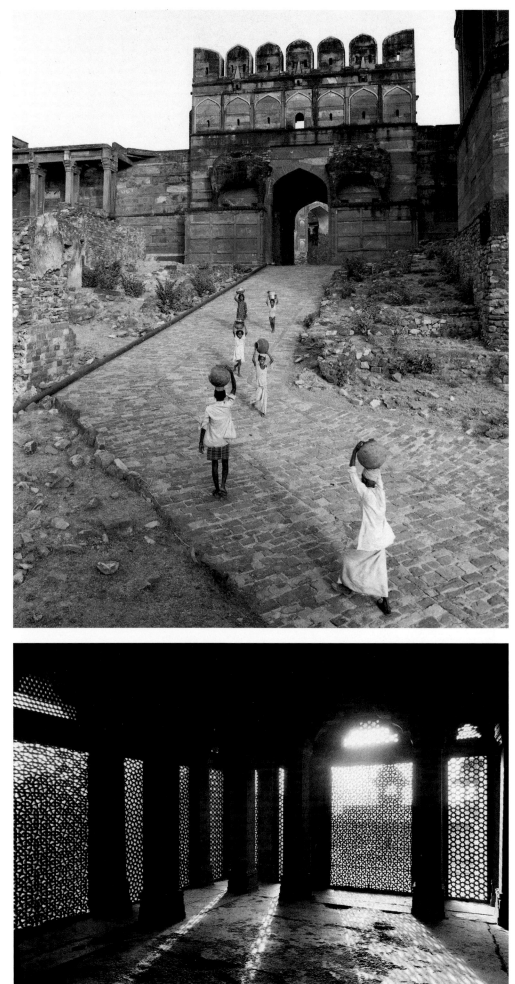

Painted Delight

The Philadelphia Museum of Art has given the name "Painted Delight" to an exhibition of 140 Indian paintings of outstanding quality from collections in Pennsylvania. Most of the paintings, which are representative of many of the Mughal and Rajput schools, are small in size; they were painted to be contemplated by princely patrons and represent an "essentially aristocratic folk art," an intimate art for connoisseurs who took their delight in them. They are meant to be seen in the way one listens to chamber music.

The many schools of these paintings are named after the kingdoms or fiefs where they were patronized, following the example of the imperial court of the Mughals, where the emperor Akbar (1542–1605)—himself a painter—called painters from all over northern India to work in the imperial studios. This was just over a millennium after the walls of rock-cut monasteries and shrines were covered with monumental wall paintings. The great wall paintings were the apogee of Indian "naturalism," its "classical" phase, teeming with figures replete with the breath of life. Modeled in color and line, their dynamically sinuous forms were to leave their impress for many centuries, even when, attenuated in means, painting was reduced to small-scale book illustrations on palm leaves.

The illustrated book was to preserve the tradition of classical Indian painting for centuries, during the time when the great stone temples were built—and lent their walls for paintings in regional styles—and also when temple building had ceased, under the rule of Islam. Books, however, continued to be illustrated, and the traditions of Islamic book illustration infiltrated those of Indian painting. When paper instead of palm leaves came to be used, the page size increased; new glowing colors were introduced—and a new vision filled the painted field. It was planar, yet it preserved the ample curves that outlined and modeled the figures. All other means of suggesting the figures' substantiality were suppressed. Juxtaposition of glowing color fields replaced the tonality of modeled form that suggested volume in classical Indian painting.

Akbar's searching mind and observant eye were open to the forms of art and nature in India. Akbar's influence ushered in a new naturalism to which the Indian artists responded in their own inborn manner. A true renaissance of the classical form of Indian painting set in. As in classical Indian wall painting—like that of Ajanta—the shapes of nature were rendered in their substantiality, as if palpable, and this naturalism was attuned to a feeling for the divine principle in all that lives and can be captured by rendering its form. The wondrous complexity of Mughal painting of the early Akbar school prefigured the forms Indian painting was to take in the next three hundred years.

STELLA KRAMRISCH
Curator of Indian Art, Philadelphia Museum of Art

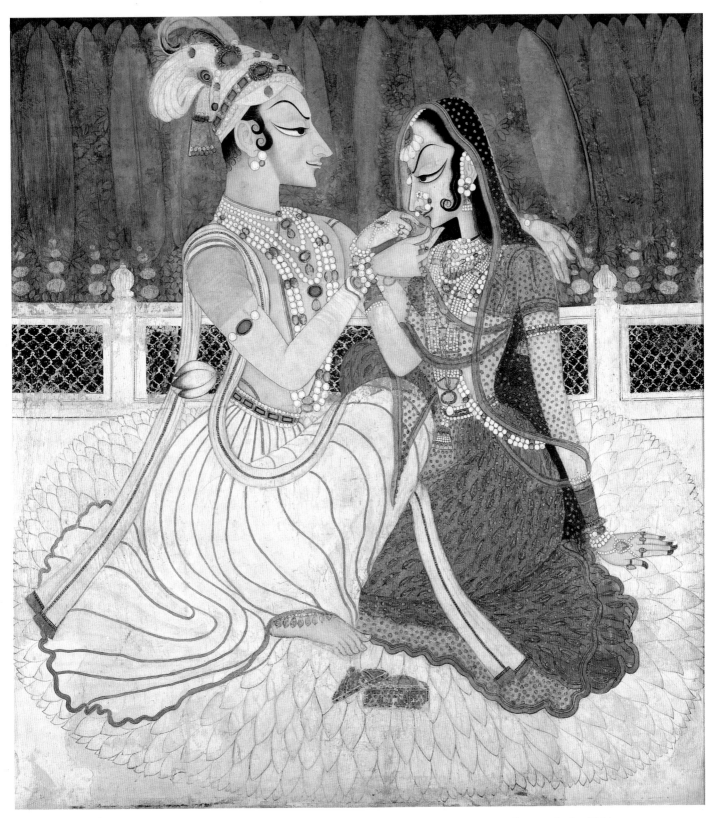

Radha-Krishna. Kishangarh, Rajasthan, mid-18th century. Opaque watercolor on cloth, 40¾ × 37 ". Philadelphia Museum of Art. Purchased: Edith H. Bell Fund

This painting of Radha and Krishna depicts mortal lovers made divine. They were Sawant Singh, the prince, poet, and ruler of Kishangarh, and his beloved Bani-Thani, a girl of strange beauty, herself also a poet. Their poems celebrate the god Krishna and his beloved Radha. In this unusually large and subtle painting, the two human lovers merge into the divine image, its form based on Bani-Thani's sharp-featured beauty. The high arch of their brows, the winged eyes, and the small mouths express affinity and longing. Their nearly disembodied hands flutter as they raise the betel leaf *(pan)*—a token of love—to Radha's mouth.

The divinized lovers are seated on a gigantic lotus flower on which also is placed the casket that the poet-prince has opened in order to raise the *pan* to Bani-Thani/Radha's lips. Her right hand rests on the lotus seat. A lotus blossom is placed in her lovers' belt. Banana leaves are softly brushed on the background of the fenced terrace and enhance the mood and symbolism of the painting.

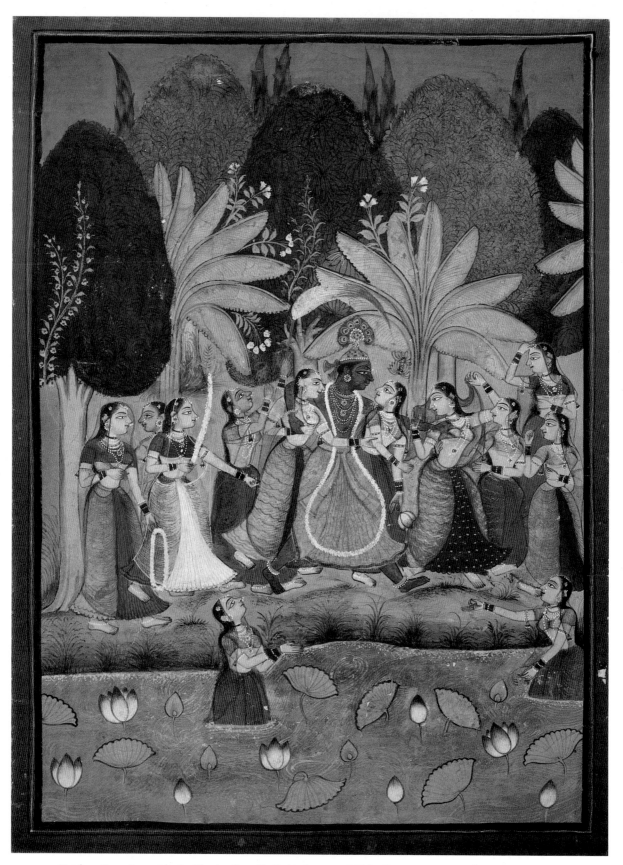

Krishna Sporting with the Gopis. Bundi, Rajasthan, c. 1680. Opaque watercolor on paper, 12 1/2 × 9 ". Philadelphia Museum of Art. Purchased: Katharine Levin Farrell and Margretta S. Hinchman Fund

The scene of Krishna sporting with the *gopis* is staged—in the Bundi school of Rajasthan—in a grove full of trees, which form a backdrop for a row of speeding *gopis* seeking the embrace of Krishna, who seems to have arrived just then for this purpose. The patter of the girls' feet, the lotus flowers in the pond below, the blossoms of the trees above further enliven the sway of bodies, skirts, and arms lined up on the bank of the pond. Krishna, the center of attention, does not occupy the middle of the painting, but the *gopi* to the left in the pond helps to stabilize the composition. The Bundi school excels in large, lush trees; saturated in color, they conjure here a humid atmosphere in which pert faces and expressive gestures convey the joy of Krishna's arrival.

The Blessed Goddess Kali Enthroned on a Giant's Corpse. Basohli, Western Himalaya, 1660–70. Opaque watercolor on paper, 8 3/16 × 8 7/8". Collection Dr. Alvin O. Bellak

The Basohli school, in the Himalayan foothills, enters the history of Indian art full-fledged in the mid-seventeenth century. Its visions are unequaled in the immediacy of their impact, achieved here in color fields of great intensity. Often, as in this image of the Dark Goddess with her two attendants, muted tones set off the glow of the more powerful colors. The palette is far more complex than in the *Bhagavata Purana* pages, which appear ebulliently narrative, as against the force of contained power in this painting. The incorporation of modeling and shading accentuates the solemnity and tension of the picture. These elements may look back to Mughal practice; here, their effect condenses the pent-up vigor of arrested motion in which the scene is presented. Rows of white pearls and dots of gleaming beetle wings guide the eye of the spectator toward the bulging and up-turned eyes of the figures. They appear spellbound in the intensity and stillness of their widely spaced contact.

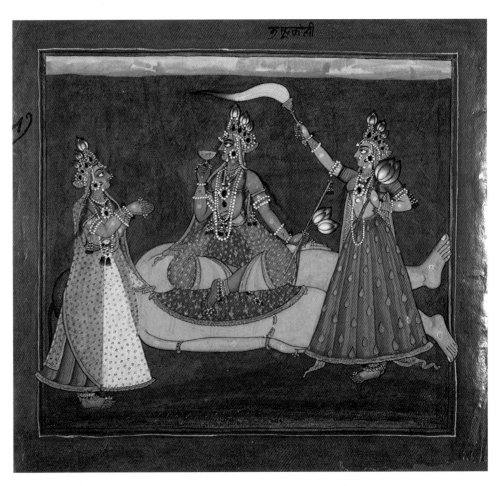

Durga Slaying the Buffalo Demon. Bundi-Kotah, Rajasthan, c. 1740. Opaque watercolor on paper, 10 × 11". Private collection

The triumphant goddess Durga, in full leap from her lion mount, has already decapitated the buffalo-bodied demon. The lotus pond in the foreground, a typical device in Bundi-Kotah paintings, is here part of a phantasmagoric setting in which steep cliffs frame a turquoise vastness below an arch of a deep orange sun-glow. Like sentient fingers, leaves of a banana plant protrude into the vastness from behind the cliff, while on the left dark verdure receives the slain buffalo's body and the demon's resurgence. The victory of the goddess is shown against fathomless space: her flying, griffin-like, leaf-sprouting white lion sinks his snout into the black buffalo's thigh, the lion's tail swishing at a right angle toward the leaping goddess of calm mien. A sandal drops from her foot. Gyrating arms and the flying leap of legs and garment are modeled with utmost sensitivity of line and shading in this unique depiction of the victory of the goddess over her archfiend, the buffalo demon, in a school where her victory over lesser demons was a favorite theme.

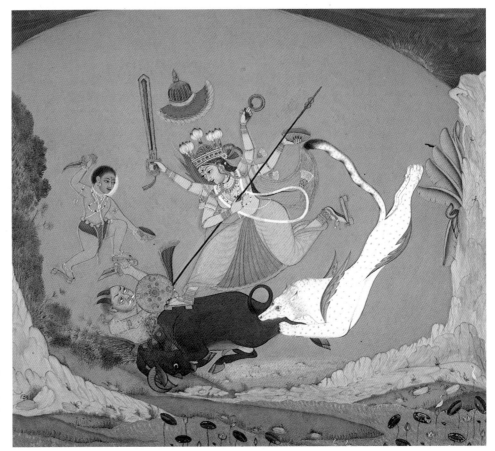

Life at Court
Art for India's Rulers, 16th–19th Centuries A.D.

Hunts, harems, and historic moments with courtiers, courtesans, queens, and kings form the basis of the special exhibition "Life at Court: Art for India's Rulers, 16th–19th Centuries A.D." at the Museum of Fine Arts, Boston. The exhibition consists of paintings of dazzling beauty, and objects in metal, glass, and ivory of fine quality. Such works were frequently owned and admired by the Hindu, Muslim, and British rulers of India from the sixteenth through the nineteenth centuries.

In traditional Indian art, characterized by the idealized images of divinities and their attendants, visualization of the world of "here and now" was a unique and relatively late phenomenon. Inspired by the Islamic renditions of courtly life, and by the pragmatic visions of the Mughal rulers in the sixteenth century, Indian artists began to paint scenes with specific secular themes and portraits of actual people. The impact of this new interest in empirical observation on the more tradition-bound schools of Indian painting is one of the most significant issues in later Indian art.

The exhibition brings together important secular paintings and royal objects created for Mughal, Deccani, Rajput, and British patrons, and illuminates the historical, political, and cultural interaction between this diverse group of rulers. Secular paintings selected for the exhibition are primarily nontextual pictures whose chief concern is to visualize aspects of courtly life, ranging from battle scenes, official audiences (*darbars*), and hunting expeditions to entertainment and intimate scenes in the lives of rulers.

The beginnings of the secular tradition are found in pre-Mughal, Deccani, and Mughal painting of the sixteenth and seventeenth centuries. A sixteenth-century pre-Mughal work, a page from the *Nimat Nama* (Book of Recipes) created for the Islamic ruler of Mandu, Nasir ad-Din Shah, illustrates the genesis of purely courtly or secular themes in India that were inspired by the Islamic tradition of painting at the Iranian courts. Written in an elegant Naskhi script, the text is illustrated with approximately fifty miniatures in which the king observes his large retinue of women attendants preparing all kinds of epicurean delights and aphrodisiacs. In contrast to the *Nimat Nama* example, a page from an illustrated manuscript of the *Chandayana*, now in the Chandigarh Museum, displays the indigenous Indian aesthetic that was prevalent all over north India by the sixteenth century. Although the pictures in this group are secular in the sense that they do not illustrate a religious text, they are still

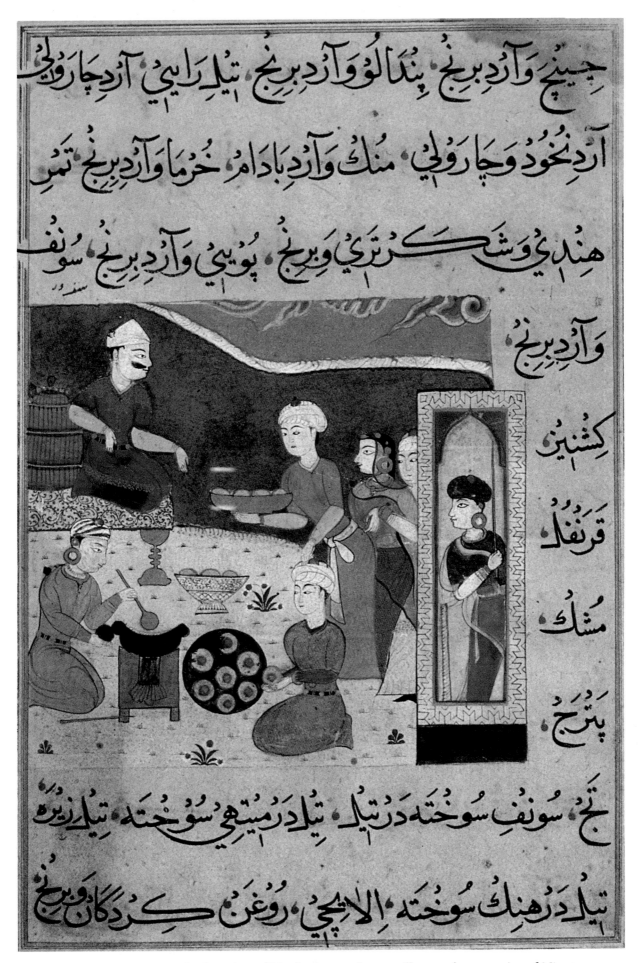

Preparation of Sweets for the Sultan of Mandu. A page from an illustrated manuscript of *Nimat Nama* (Book of Recipes). Mandu, central India, c. 1495–1505. Ink and watercolor on paper, 10 ⅝ × 7 ½″ (27 × 19 cm). India Office Library, London

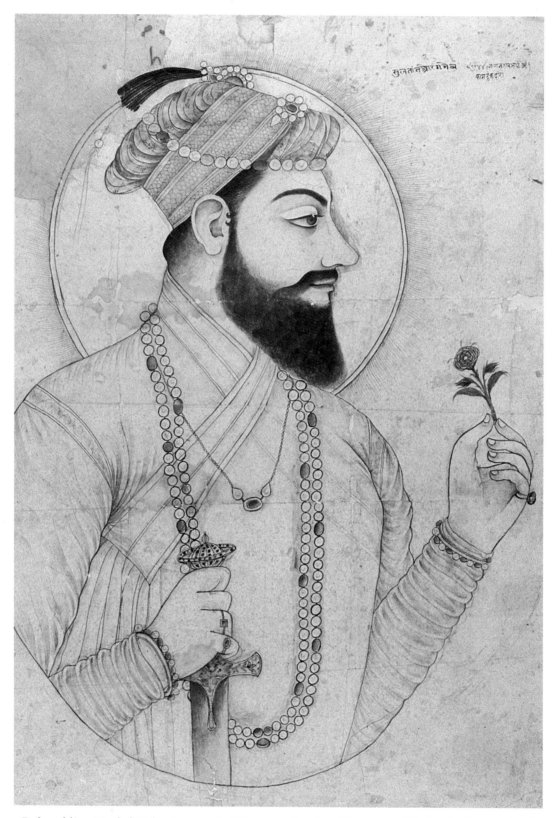

Ruknuddin. *Mughal Ruler Aurangzeb.* Bikaner, painted at Bhagnagar (Hyderabad), A.D. 1660 (v.s. 1717). Ink on paper, 27 ⅛ × 20 ⅛ ″ (69 × 51 cm). Gopikrishna Kanoria Collection, Patna

Opposite: Huqqa bowl. Bidriware, Bidar, Deccan, 17th century. Alloy inlaid with brass and silver, 7 ⅛ × 6 ¾ ″ (18 × 17 cm). Collection Dr. Mark Zebrowski and Mr. Robert Alderman, London

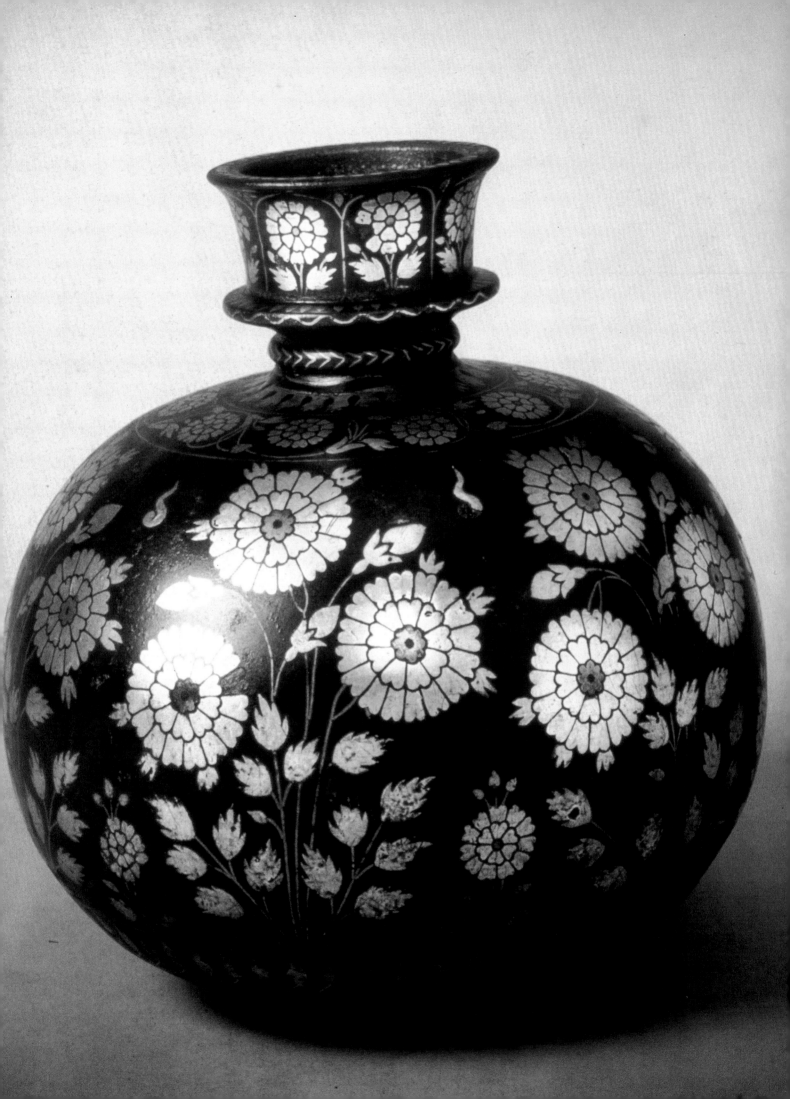

fundamentally different from the succeeding Mughal or Rajput pictures, because they are textual illustrations. Their main purpose is to visualize a story rather than a specific event in the life of a ruler or his numerous adventures.

Four pages from the world-renowned imperial manuscript of the *Akbarnama*, now in the Victoria and Albert Museum in London, provide a unique opportunity to study the vitality and vibrancy of Mughal painting during the reign of one of the most important Indian rulers, Akbar. Painted around 1590, the *Akbarnama* illustrations are also accompanied by the text, but now the text deals with specific events from the life of the emperor. The purpose of the images as well as the text is not simply to narrate a generalized story but to establish Akbar's absolute authority over the subcontinent through a careful selection of significant episodes from the early part of his reign (1556–70). Painting at the court of this great Mughal emperor is characterized by dense compositions, vigorous movement of the figures, rendition of believable sense of space, and portrayal of the figures with a psychological dimension. This concern with rendering the world of "here and now" was unique in Indian art, and can be directly attributed to the personality of the emperor and the availability of contemporary paintings and prints from northern Europe and Italy at the time.

In contrast to the Mughal painting of north India, which evolved under Akbar into a unique style of painting incorporating native Indian, Iranian, and Western elements, painting at the Islamic courts in the Deccan, especially in the early seventeenth century, remained much more faithful to its Iranian origins.

Painters under Akbar's successor, the fourth Mughal emperor Jahangir, developed sensibilities in keeping with a more personalized and intimate vision of their patron. Although the official audience scenes (*darbars*) continue to establish the sovereignty of the Mughal emperor, the energetic battle scenes of Akbar's reign are absent in Jahangiri painting of the seventeenth century. Actively encouraged by the emperor, who kept his own diary, artists strove to create sensitive and unusual studies of individuals, as well as of animals and other natural forms. The last years of Jahangir's reign, and almost the entire reign of his successor, Shah Jahan, were marked by constant struggle between the feuding princes for control of the empire. Paintings from Shah Jahan's reign reflect his preference for formal appearances.

The next section in the exhibition focuses on the development of the secular painting tradition at Rajput courts in the seventeenth century. Noted for their chivalry, courage, and fierce loyalty to the rulers, Rajput courtiers and kings had come to play an important role at the Mughal courts. By the mid-seventeenth century, rulers at Rajput courts such as Bikaner and Bundi, following the Mughal tradition, began to commission portraits of themselves as well as of their courtiers. However, the Rajputs did not wholeheartedly accept the Mughal modes or subject matter, but were selective in adopting the courtly customs set forth by the Islamic rulers. Thus, it is not surprising that there are neither battle scenes nor grand history pictures from the Rajput courts. The focus is primarily on the glory and ideal image of the Rajput king, who considered his powers to be divinely ordained. The interaction between Mughal and Rajput courts is evident in the life-size portrait of the Mughal ruler Aurangzeb (reigned 1658–1707) by Ruknuddin, a Muslim artist from the Rajput court of Bikaner. This sensitively drawn preparatory sketch was probably done in the Deccan when the Bikaneri ruler Anup Singh was serving in the Mughal army under the lead-

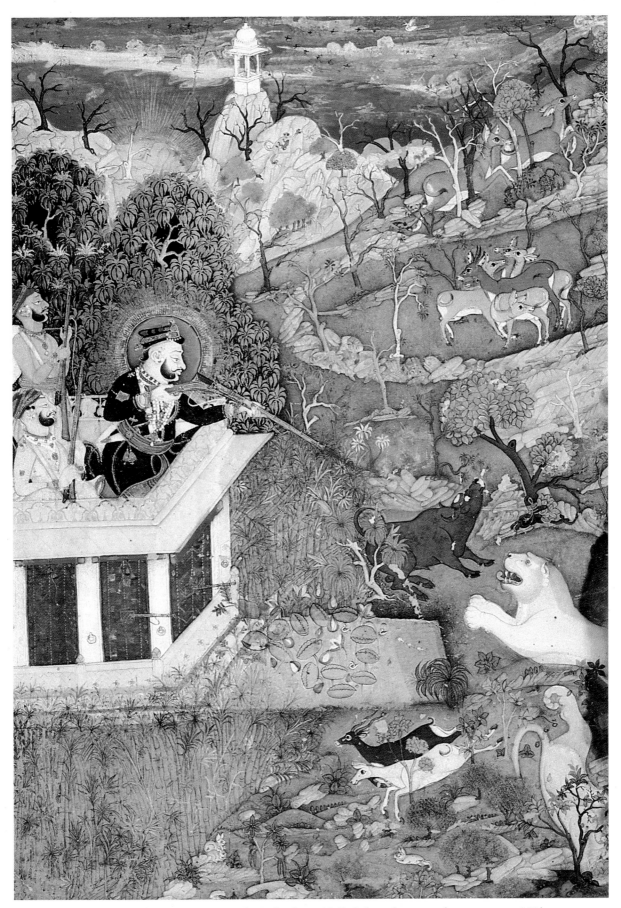

Ram Singh II Hunting Tiger. Kotah, Rajasthan, 1840. Ink and watercolor on paper, 16⅛ × 12⅝″ (41.2 × 32 cm). Gopikrishna Kanoria Collection, Patna

Overleaf: *Maharaja Ram Singh II of Kota with Maharaja Takhat Singh of Jaisalmer.* Kotah, Jaisalmer, 1843. Ink and watercolor on paper, 23⅝ × 17¾″ (60 × 45 cm). Gopikrishna Kanoria Collection, Patna

Ramsingh II is on the right, Takhatsingh on the left

Maharaja Jaswant Singh of Marwar (1873–1895). Jodhpur, Rajasthan, c. 1880. Ink and water-color on paper, 13⅛×10″ (33.5×25.5 cm). Collection Dr. Mark Zebrowski and Mr. Robert Alderman, London

ership of Aurangzeb. Other genre subjects reflect Mughal influence in the soft color, uncluttered space, and nonexaggerated figures.

It is in the eighteenth and nineteenth centuries that we begin to see a great flowering of secular pictures in all regions of north India. By this time, the imperial Mughal court had lost its preeminence, religious texts were illustrated less often, and each small kingdom in Rajasthan, Punjab Hills, and other parts of north and central India was producing its own brand of portraits, *darbars*, and hunting and harem scenes. Comprising the largest section of the exhibition, "The Great Flowering" emphasizes the regional diversity of north Indian painting. One of the important categories in this section deals with the role of women as patrons as well as artists. In addition to thematic groups such as portraits and entertainment scenes, there is also a section highlighting individual rulers who were great patrons of the visual arts, including Ram Singh II of Kotah (reigned 1828–66), well known for his colorful personality and a rather large physique, Sansar Chand of Kangra, and Balwant Singh of Jammu.

In addition to the Rajput and Mughal pictures, "Great Flowering" also includes an important group of pictures done for the British, inspired by their patronage, or influenced by their presence on the subcontinent. One of the obvious results of the British rule in India was the mutual fascination of the British officers and Indian rulers with each other's clothing and customs. Some of these works give us a lively view of that aspect of British interest in the Indian culture that tended toward romanticization of the country.

By contrast, *Maharaja Jaswant Singh of Marwar*, based on a photograph, reflects the influence of Victorian taste and British power on the Indian rulers. Just as the Mughal painting in the sixteenth century charted a new path for Indian painting, pictures made for or inspired by the British rulers dramatically changed the course of traditional painters, in effect thrusting them into modern ways of rendering reality.

In "Life at Court," paintings, together with three-dimensional objects and textiles, re-create the sumptuous settings of the Indian courts. An eighteenth-century Mughal canopy complete with floor covering and authentic pillows forms a center stage for the exhibition, and brings to life the outdoor pavilion settings seen in many of the paintings. Similarly, a group of glass and silver inlaid huqqa bowls provides a life-size scale to the miniature-scale world of the paintings. Silk robes, embroidered with gold, and opulent sashes make the painted textures of contrasting textiles more real. Selected specifically for their visual and contextual relationship with paintings, these precious objects in glass, metal, jade, and ivory re-create the complex world of courtly leisure and political intrigues in pre-modern India.

Vishakha N. Desai
Assistant Curator of Indian, Southeast Asian and Islamic Art,
Museum of Fine Arts, Boston

Pride of the Princes

Indian Art of the Mughal Era in the Cincinnati Art Museum

The Festival of India provides the Cincinnati Art Museum the perfect occasion to make its small but distinguished collection known to a wider audience. Its exhibition, drawn entirely from the museum's own holdings and from promised gifts, includes painting, calligraphy, objects, rugs, and textiles dating from the years of Mughal rule (1526–1858) in India. Many items have never been published and some objects, particularly a number of important recent acquisitions, have not been exhibited before. The following paintings and objects represent a sampling from the museum's collection.

Among the first Indian paintings acquired by the museum was a group from a dispersed copy of the *Gulistan* (Rose Garden) of Sa'di, the thirteenth-century Persian moralist writer and poet. These eight paintings, each by a different artist known to have worked on other manuscripts for the Mughal emperor Akbar, reflect the high standard of work commissioned by that ruler. They also suggest the still-powerful influence of Persian culture in the Mughal court in India, not only through the residual traces of the Persian style of painting but through the popularity of this and other Persian texts, not to mention the adoption of the Persian language itself.

One of the eight paintings, *The Catch of the Giant Fish*, shows two men hauling in a net containing a giant fish. This scene illustrates the beginning of the tale, in which the powerful fish escapes from the net of the fisherman who had never before failed to land his catch. A vignette follows in which an innocent youth drowns in the same body of water in a flood tide. The moral of the story revolves around the principle of fate: the fish simply had another day left, while the unlucky youth did not. The netting of the fish is observed by a group of men in a boat with a hull of lashed planks and a cheetah-headed prow. Other figures move through the landscape, which, as it recedes in space in its bluish haziness, increasingly resembles that of northern European paintings.

The influence of the Mughal court styles can also be seen in the paintings of Rajasthan. Painting flourished in the Bikaner court, particularly under Anup Singh (ruled 1675/8–98), a great patron and collector. *The Elephant Hunt of Maharaja Anup Singh* accords perfectly with a description of an elephant hunt given by Abul Fazl, historian to the emperor Akbar. An old elephant has been tied to a tree as a decoy for the unsuspecting beasts splashing in the water, and a magnificent animal has been caught in ropes while Anup Singh himself looks on from his howdah at the upper

Manochar. *The Catch of the Giant Fish*. Page from a dispersed manuscript of Sa'di's *Gulistan*. Mughal, c. 1595–1600. Image 10 ⅞ × 5 ¾″. Gift of John J. Emery, 1950

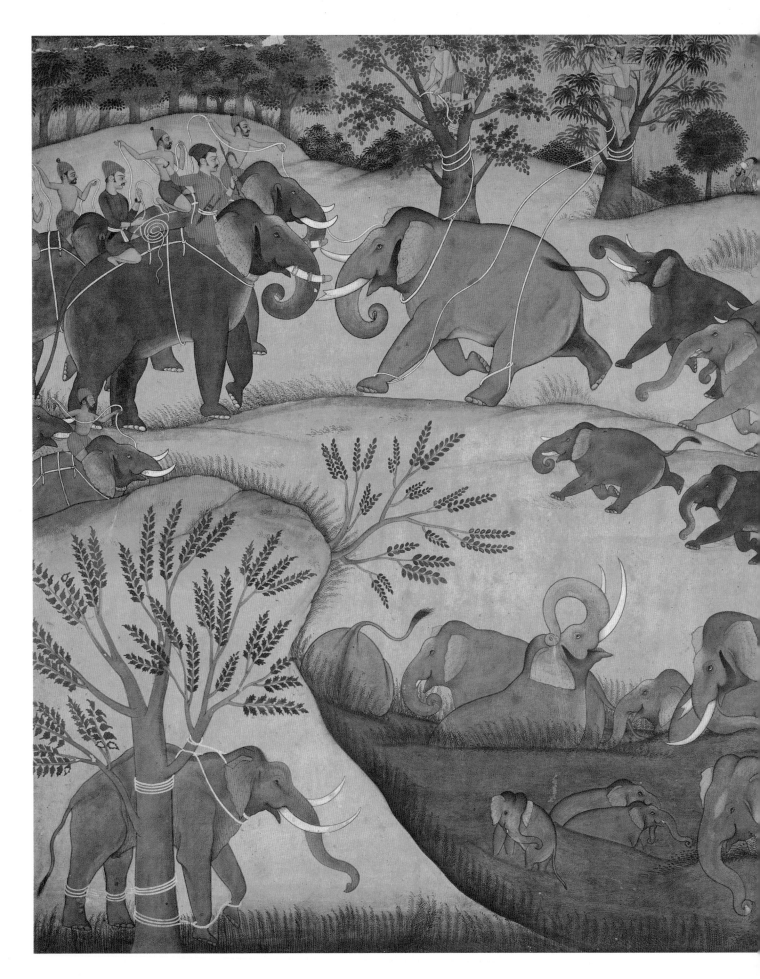

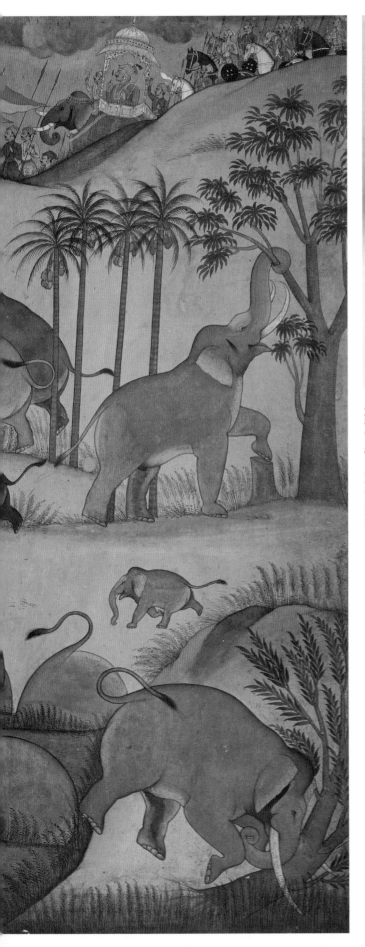

Above: Writing cabinet. Probably made for the Portuguese market, 17th century. Wood inlaid with ivory, stained and incised, and various other woods, 13½ × 18⅜ × 12½″ (closed). The William T. and Louise Taft Semple Collection, 1962

Left: *The Elephant Hunt of Maharaja Anup Singh of Bikaner*. Rajasthan, Bikaner, last quarter of the 17th century. Color and gold on paper, page 12¼ × 15½″. Gift of Mr. and Mrs. Charles Fleischmann in memory of Julius Fleischmann, 1979

right. Painting under Anup Singh represents a synthesis of several distinct traditions—Mughal, Rajput, and Deccani—which is understandable in light of Anup Singh's service as leader of the Mughal armies in the Deccan under the emperor Aurangzeb.

One of the few objects from the Mughal era in the collection is a writing cabinet, probably made for the Portuguese market in the seventeenth century. Fashioned from teakwood veneer inlaid with ivory and other woods over a wood core, this and similar cabinets follow the European, and particularly the Iberian, model in format and function, with a front lid and multiple drawers. The decoration is strictly Indian in this case, with hunting scenes predominating; other examples combine Indian with European themes or ornamentation.

It appears that late in the reign of the Mughal emperor Jahangir (1605–27) a decorative style emphasizing naturalistically drawn and colored flowers came into vogue. Such flowers, often organized in rows when employed on larger surfaces, became the conventional ornamental style under Jahangir's successor, Shah Jahan. Rows of flowers are found in profusion on the monuments, margin decorations of albums, objects, rugs, and textiles made for Shah Jahan. One such textile is a painted cotton coverlet. One of about twenty known examples, it has rarely been exposed to light and therefore features practically all of the original coloring. The coverlet was perhaps made for the Persian market or at least under strong Persian influence, for most of the figures wear Persian dress. Several other painted cottons, including an example 22′8″ by 12′2″ in Cincinnati, reflect Persian taste in their utilization of a central medallion similar to those seen in certain Persian carpets. A Persian population is known to have existed at this time in the Golconda region.

An unusual calligraphic panel bears two lines of script in Urdu. The script, brightly embellished with internal floral and geometric decoration in a style known as *gulzar*, is framed by a wide illuminated border, which incorporates at the bottom a cartouche inscribed in English, "Muzafurnagar June 1831." The principal inscription may be translated as "The Honorable Mr. George Fleming Franco." George Franco is known from India Office Library records to have been a career civil servant of the East India Company. He had risen professionally to be a judge and then Officiating Commissioner of the Meerut division by the time of his retirement in 1852, but in June 1831, when this panel was commissioned, he was serving as the Sub-Collector and Joint-Magistrate of Muzaffarnagar, a small district headquarters town about sixty miles northeast of Delhi. Franco must have commissioned this calligraphy as a souvenir of his residence in Muzaffarnagar.

These are but a few of the ninety pieces in "Pride of the Princes," but they offer a good indication of the range and quality of paintings and objects in that exhibition and in the Cincinnati Art Museum.

DANIEL S. WALKER
Curator of Ancient, Near Eastern and Far Eastern Art,
Cincinnati Art Museum

Above: Panel of illuminated calligraphy. Urdu text in Taliq script. North India, Muzaffarnagar, dated 1831. Ink, gold, and color on paper, 15 ½ × 23 ½ ″. Gift of Mrs. Daniel S. Campbell, 1984

Below: Coverlet. Golconda region (Petaboli?), 1640–50. Cotton, drawn and painted resist and mordants, dyed, 28 ¼ × 32 ¼ ″. The William T. and Louise Taft Semple Collection, 1962

Indian Miniatures from the Ehrenfeld Collection

The exhibition "Indian Miniatures from the Ehrenfeld Collection," organized by the American Federation of Arts, with 127 works dating from the sixteenth to the mid-nineteenth centuries, presents an overview of the history and development of Indian miniature painting. Some important features of Indian miniatures are overall patterning; the interplay of two- and three-dimensional forms; the tilting of the ground plane so that each subject or element in a painting can be viewed with equal clarity; the use of bright, pure colors derived from metallic, mineral, or vegetable pigments, bound by a glue or gum, and applied to fine paper; loving, detailed, and graceful treatment of plants and flowers; depictions of saints, historical personages, legendary figures, fanciful animals and birds, alone and in intricately entwined composite forms; an intimate sense of the landscape; minute depictions of architectural forms; and the interplay of space.

Two of the earliest works in the collection, which are included in the exhibition, are leaves from the illustrated books the *Hamza-nama* and the Cleveland *Tutinama* (so named because most of its leaves are in the Cleveland Museum of Art), both of which date from the very beginnings of Mughal painting under Akbar. The Mughals of India, a dynasty of Persianized Timurids, inherited their ancestors' love of the "arts of the book." Babur, founder of the Mughal dynasty, invaded India in 1526. However, his grandson Akbar "the Great," who reigned from 1556 to 1605, was responsible for consolidating the political and economic power of the Mughal empire. Persian miniature painters and calligraphers flocked to the Mughal court seeking patronage. The Persian miniature style merged with the indigenous Indian artistic traditions to form a vigorous new Mughal style.

Akbar established a workshop in which the arts of the illustrated book could be developed. The imperial painters specialized in illustrated literary manuscripts, epics, and histories representative of Hindu as well as Muslim elements of Akbar's empire.

Under the reigns of Akbar's son and successor, Jahangir (1605–27), and his grandson, Shah Jahan (1628–58), Mughal painting shifted its emphasis to court portraiture and natural history studies. The style became more refined, contemplative, and coloristically subtle. Individual illustrations with elaborate thematically related margins filled the sumptuous imperial albums of the seventeenth century.

The kingdoms and states of the Deccan, a great plateau that dominates the geography of south India, were also important painting centers. The rich coloring

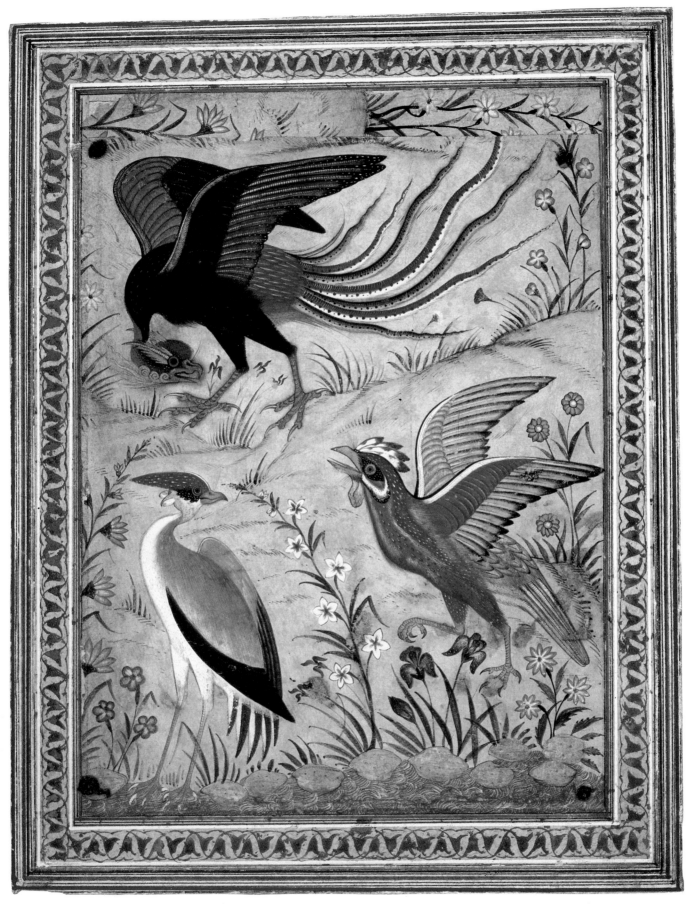

Fantastic Birds. Mughal, Akbar period, c. 1590. Within borders, trimmed and remounted, 6 ⅝ × 5″

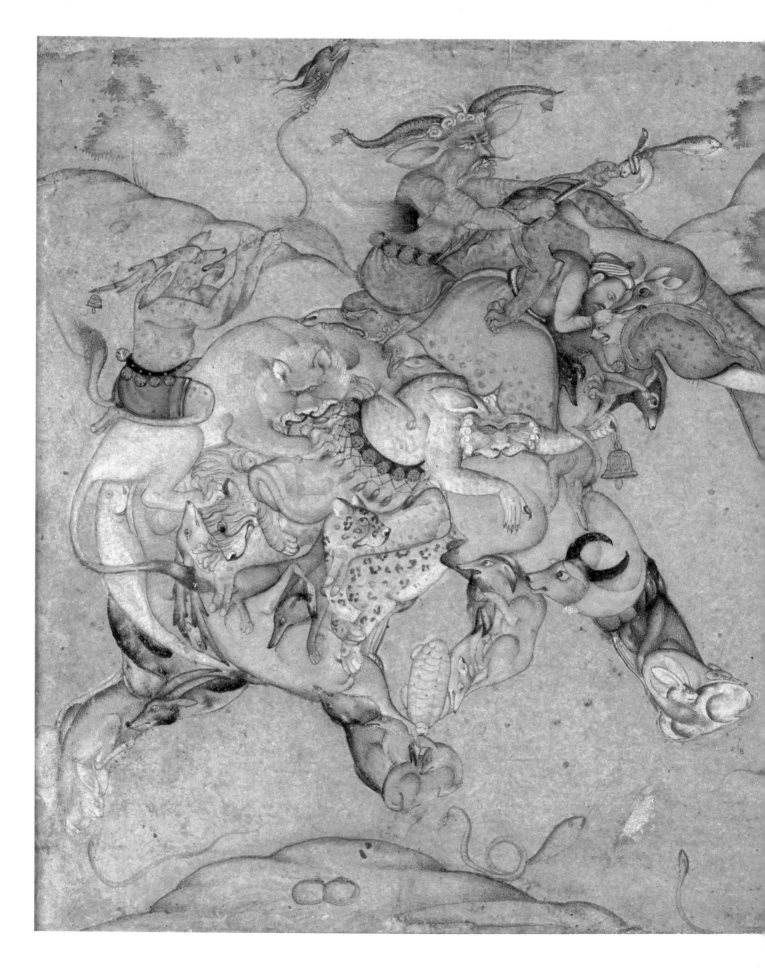

Above: Attributed to Govardhana. *A Young African Elephant*. Mughal, Jahangir period, c. 1616. Trimmed 5 ⅜ × 7 ⅞ ″

Left: *Composite Elephant*. Mughal, Akbar period, late 16th century. 4 ½ × 5 ¾ ″

Brahma, Shiva and Vishnu Worship the Goddess Indraksi. From a *Devi* series. Basohli, c. 1660–70. 8 ¼ × 9 ″

and circular line of traditional painting in this region formed the basis for highly finished and elegant courtly styles that reflect Mughal, Persian, and even Ottoman influences.

Contemporary with the Mughal school were the schools of Rajasthan and the Punjab Hill States. Some of the most important subjects of these styles included illustrations of Ragas and Raginis, respectively masculine and feminine personifications of the musical modes, and the stories of Krishna and Radha. Among the most charming works in the collection are miniatures depicting Krishna, the blue god (an incarnation of the Hindu god Vishnu). These miniatures dating from many periods of Indian painting depict Krishna as child, deity, warrior, and lover.

The schools of Rajasthan and the Himalayas also delighted in illustrating the epic tale of Rama, another of Vishnu's incarnations, and in producing stylized portraits of their patrons and rulers. Some of these wide-ranging styles preserve tradi-

The Goddess Standing on the Corpse of a Man. Basohli, late 17th century. Page 9 × 8½"; image 7¼ × 6½"

tional visual values while others are strongly Mughal in inspiration, but all reflect their milieu of cultural, social, and stylistic pluralism. As guest curator of the exhibition for the American Federation of Arts, Daniel J. Ehnbom, Ph.D., an active scholar in the field, has selected the works and written the material for the accompanying catalogue. In addition, Robert Skelton, Keeper of the Indian Section at the Victoria and Albert Museum, London, and Pramod Chandra, Bickford Professor of Indian and South Asian Art at the Fogg Art Museum, have contributed essays on the collecting and study of Indian miniatures to the catalogue.

DANIEL J. EHNBOM
Guest Curator

AMY V. MCEWEN
The American Federation of Arts

Standing Portrait of a Kripal Deva of Jammu. Mankot, c. 1700. 10 ¾ × 6⅛ ″

Cowherds Seek Krishna's Protection from the Rain. Kulu, c. 1700. 9 ⅝ × 5 ¾"

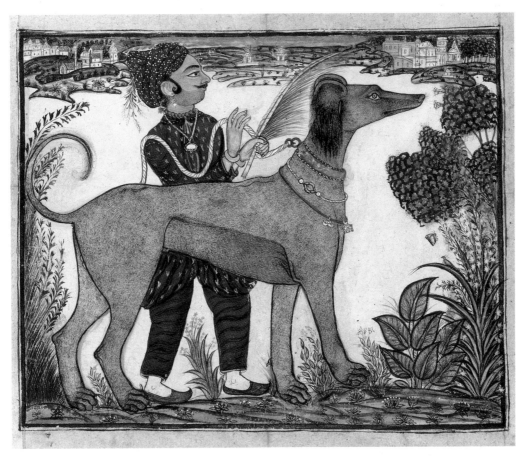

Ascribed to Svarupa Rama. *A Saluki Hound with Its Keeper*. Mewar sub-style, c. 1800. 7½ × 9½"

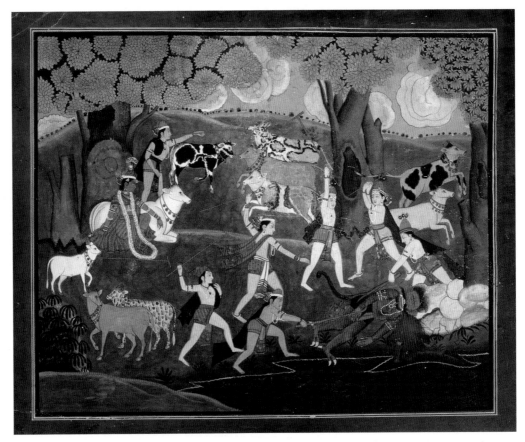

Cowherds Beat a Demon with Sticks as Krishna Watches. Leaf from a *Bhagavata Purana*. Bilaspur, c. 1770–80. 10¾ × 13½"

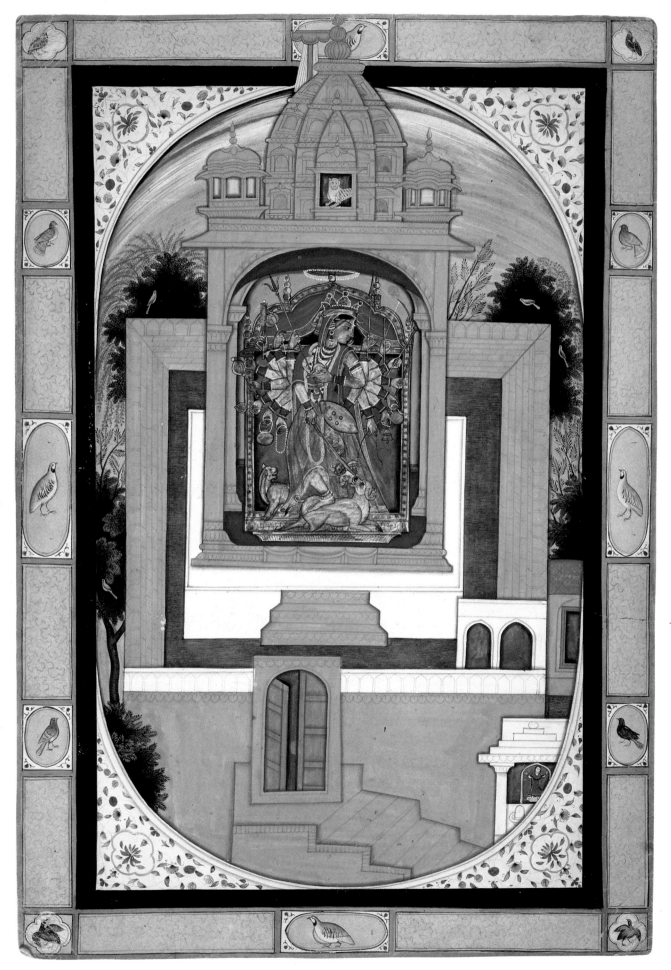

Attributed to Sajanu. *The Goddess Enshrined*. Kangra school at Mandi, c. 1800–1810.
13¼×9¼″

Court Costumes of India

In the nineteenth century, when the arts of peace crowned the endeavors of war, the royal courts of India achieved a brilliant splendor. Great schools of painting, music, poetry, and philosophy, reflecting every aspect of the kingdom's life in microcosm, revolved around the central figure of the ruler.

Considered the medium between his people and the gods, the Indian sovereign, in the person of the Hindu maharaja or the Muslim nawab, dressed to inspire awe in all who beheld him. The flourish of his aigretted turban, the patrician cut of his tunic, the elegance of his jeweled slippers served to present the monarch as the epitome of regal bearing. His apparel, whether the heavy silks and brocades of winter or the semitransparent cottons of summer, was a masterpiece of weave and design.

When the Indian ruler gave royal audience at the court, his magnificent appearance was completed by the jeweled standards and arms rising behind his throne. The pride the rulers took in their warrior blood was further displayed in the elaborate caparisoning and armoring of their horses and elephants.

The royal ladies of India did not take part in the ruler's public appearances but remained secluded in the *zenana* or harem. The *zenana* was enclosed by latticed screens and arranged with enameled artifacts, and the ladies of the harem occupied themselves in sybaritic pursuits, whiling away the hours in leisurely self-indulgence and beautification. The daily rituals of personal decoration commenced with a scented bath. Then maidservants delicately applied herbal cosmetics to the faces and bodies of the ladies. Flowers were plaited in their hair. Henna was used to paint designs on their hands and feet. The sartorial whims of the ladies were then tempted by an exuberance of veils, chemises, floor-length skirts, and pantaloons. Dressed in these exquisite garments, the royal women now decked themselves with a variety of jewelry, from delicate diamond anklets to glass bangles to the heavy ornaments that encircled their waists and throats.

The heirs to the kingdom, who remained within the harem during their infancy, were dressed in imitation of their parents. In their gem-encrusted caps and gold-threaded garments, the royal children looked like delightful miniatures of adults as they dashed about the sunlit courtyards of the *zenana*.

The rare occasions when the languid harem ladies were permitted to accompany the ruler on his journeys broke the monotony of harem routine, but the rigid

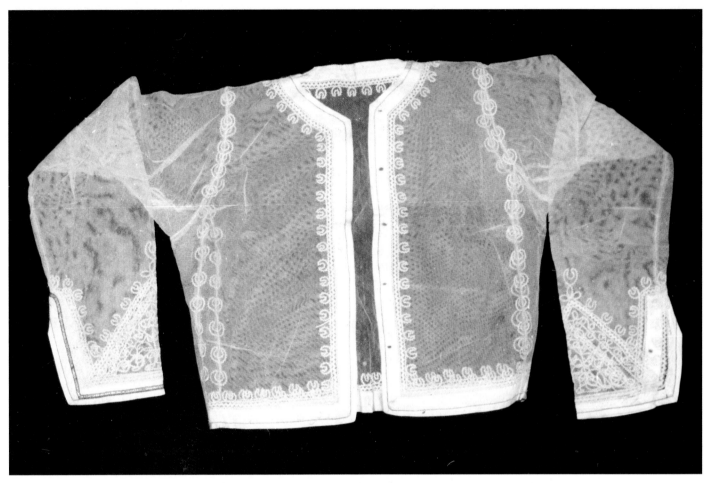

Above: *Saluka* (for women). Rampur, late 19th century. Cotton net, embroidered with cotton thread

Below: *Pashwaj* (for women). Chamba, mid-19th century. Silk, embroidered with gold thread, pearls, and emeralds

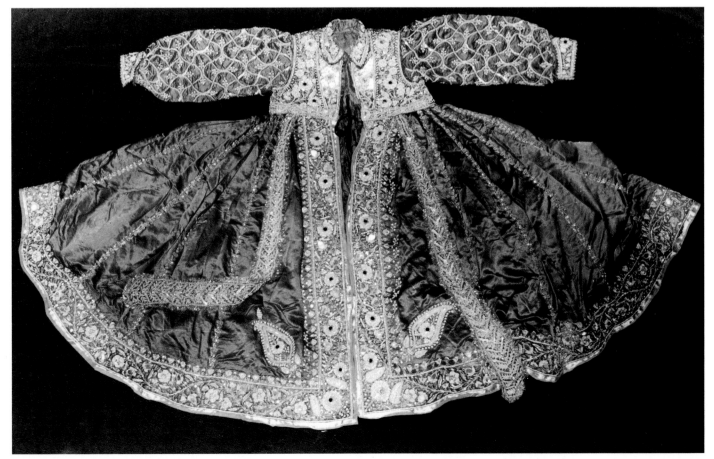

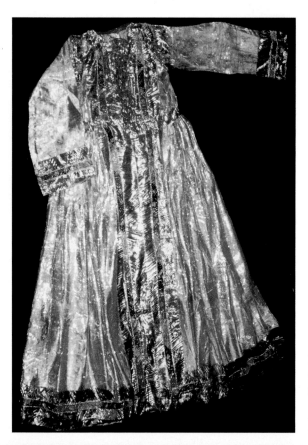

Left: *Pashwaj* (for women). Rampur, late 19th century. Tissue gold appliquéd with gold and satin fabric, embroidered with gold thread

Below: *Kurta* (for women). Chamba, mid–19th century. Silk, embroidered and appliquéd in gold

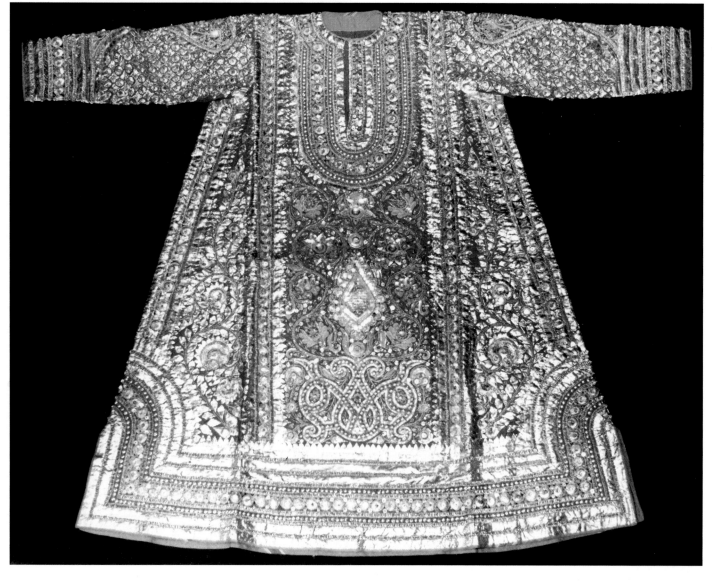

customs of seclusion held fast. Royal wives and concubines followed the ruler's procession in veiled palanquins and chariots. At intervals they alighted from their curtained conveyances and passed between silk screens held by armed eunuchs to rest in sumptuously patterned tents. Magnificent tents also housed the ruler when he traveled to administer remote parts of his kingdom, when he was at war, or when he was engaged in the pleasures of the hunt.

India's rulers maintained high standards of aesthetic excellence through the constant labors of gifted artisans and architects, whether it was in the tents in which they traveled, in the palaces in which they lived, or in the temples and mosques in which they worshiped. Such rigorous standards also governed the creation of princely garments. Armies of jewelers, weavers, embroiderers, and tailors plied their hereditary crafts for the discerning tastes of nineteenth-century kings and courtiers. Palace storerooms were continuously replenished with textiles and other fine things brought by caravans traveling between the Indian kingdoms.

By the end of the nineteenth century, this medieval and fragile world was assaulted by the Occident, and Indian princes began to emulate their new overlords—the British. Royal life styles were influenced by foreigners, and foreign fashions dramatically affected the manner in which India's princes and princesses now dressed. Factory-made fabrics from distant Europe displaced traditional textiles. Men's headwear, garments, and footgear became more uniform. Some Indian rulers even began wearing Western clothes. Within the *zenana* the royal women still dressed in traditional costumes, although many of these were now covered in alien designs, such as English flowers and Chinese dragons.

In the early decades of the twentieth century the more enterprising Indian princes, inspired by their travels abroad, indulged their fantasies to extraordinary extremes. One fashion-conscious potentate installed a wardrobe more than a mile long in his palace to house his newly acquired clothes. Another designed his own sunglasses to accommodate frames carved from a pair of enormous emeralds. New fads, from braided frock coats to elaborate epaulettes to satin pumps, are revealed in the photographs of the stylish of the time.

In 1947 over five hundred independent Indian kingdoms were merged into the two new nations of India and Pakistan, and the voluntary abdications of India's kings ended the power and pageantry of India's courts. However, the descendants of royal families continue to perform major rites with traditional ceremony. On such occasions the past comes alive for a few moments. Gems flash in the sunlight above brilliantly colored turbans as a marriage procession makes its stately progress to a fort. In former palaces, the Indian new year is still celebrated by dazzling displays of fireworks and lights. And on great religious festivals the scions of legendary kingdoms once again don magnificent costumes to preside over the ancient rituals of the past, when the Indian king mediated between his people and the gods.

NAVEEN PATNAIK

The Image of Women in Indian Art

Devi, the Supreme Goddess, infinite in her capacity to create, is the wellspring of life. She is the universal Mother Goddess, the nurturer of the world, the essence of fertility and regeneration. She uses her powers not only to create life but also to destroy the negative forces of the universe. Thus she is both adored and respected. Men throughout the ages have been seduced by her sensual qualities and have relied upon her to provide life-giving waters to nourish the earth. Women have sought her protection from infertility and prayed to her for male offspring.

Devi is the archetypal female. As such she exists within all the goddesses and women of India. Artists throughout the ages, awed by their responsibility to produce a visual feminine image, created an ideal type of woman that was inspired by the concept of Devi. She was perceived as being sensual and beautiful. Her full breasts and large hips filled with the life source were given monumental status. These female properties crossed the boundaries of religious sectarianism, regardless of whether the images were *yakshis,* fertility nature deities of popular worship, the Tantric goddesses of Buddhism, the *shaktis* and goddesses that adorned the great medieval Hindu temples, or the self-conscious and modest representations of Muslim princesses and courtesans of the Mughal courts.

Durga is one of the most powerful Hindu female deities. According to the legend in the *Markandeya Purana,* she was produced from the frustrated wrath of the three principal deities, Brahma, Shiva, and Vishnu, in order to destroy the evil Mahishasura, the buffalo demon, who was threatening to unbalance the order of the world. Durga is a wrathful goddess filled with the anger of retribution; her wrath represents the combined power of all the gods to overcome adversity. Bronzes of Durga are placed in temples and family shrines, and paintings are hung on walls of homes to protect and guide the occupants.

Durga was bestowed with eighteen arms, each of which holds the weapons and attributes of the deities that will aid her in her fight against the buffalo demon. Accompanied by her animal-vehicle, the lion, Durga proceeds to annihilate the constantly emerging transformations of the demon. Her task is not an easy or an automatic one. It is a struggle, for it represents the constant battle of good versus evil. Complacency can play no part in this universal scheme. Seven times she beheads the demon, only for him to reemerge in a new and ferocious form. Then she drinks a bowl of inebriating liquor that is charged with spiritual energy (she holds the bowl in her right front arm) and she is finally able to slay the demon, who has emerged in anthropomorphic form from the body of the buffalo.

Mills College, Oakland, California

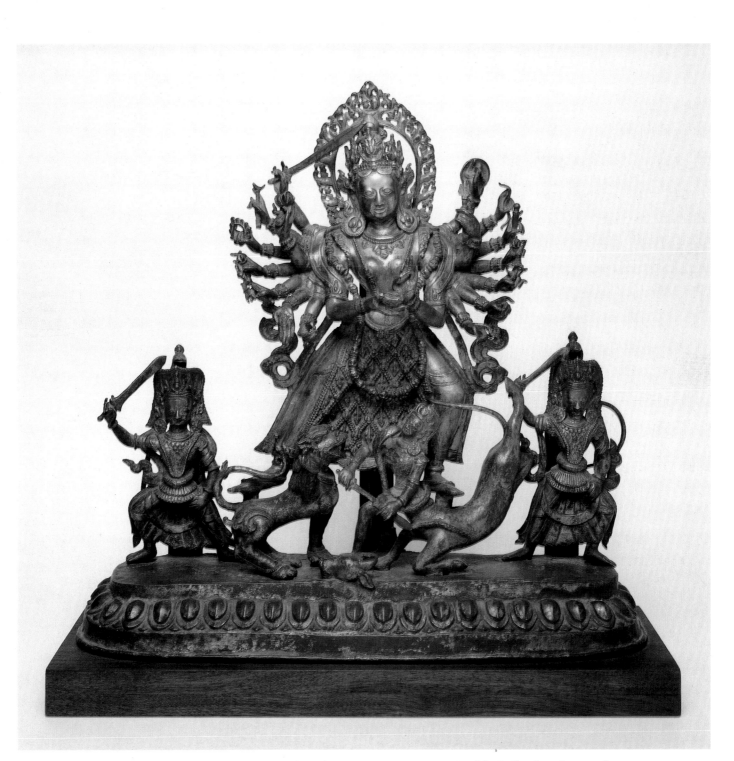

Durga Killing Mahishasura. Nepal, 18th century. Bronze, 22 × 20½". Collection Gary and Margarita Crawford

The portrayal of women in the paintings of the Mughal courts and Rajput kingdoms contrast vividly with the powerful images of the Hindu goddesses. No longer governed by the requirements of religious iconography, the depiction of women mirrored the courtly and secular life of the day. Women became the prized possessions of men, the jewels of the *zenana*. Manuscripts dating from the fifteenth century show that visual imagery at this time was in a state of flux. The monumental conception of the Hindu and Buddhist interpretations of the deities, sensually and often erotically portrayed, gave way to far more modest representations. A sense of

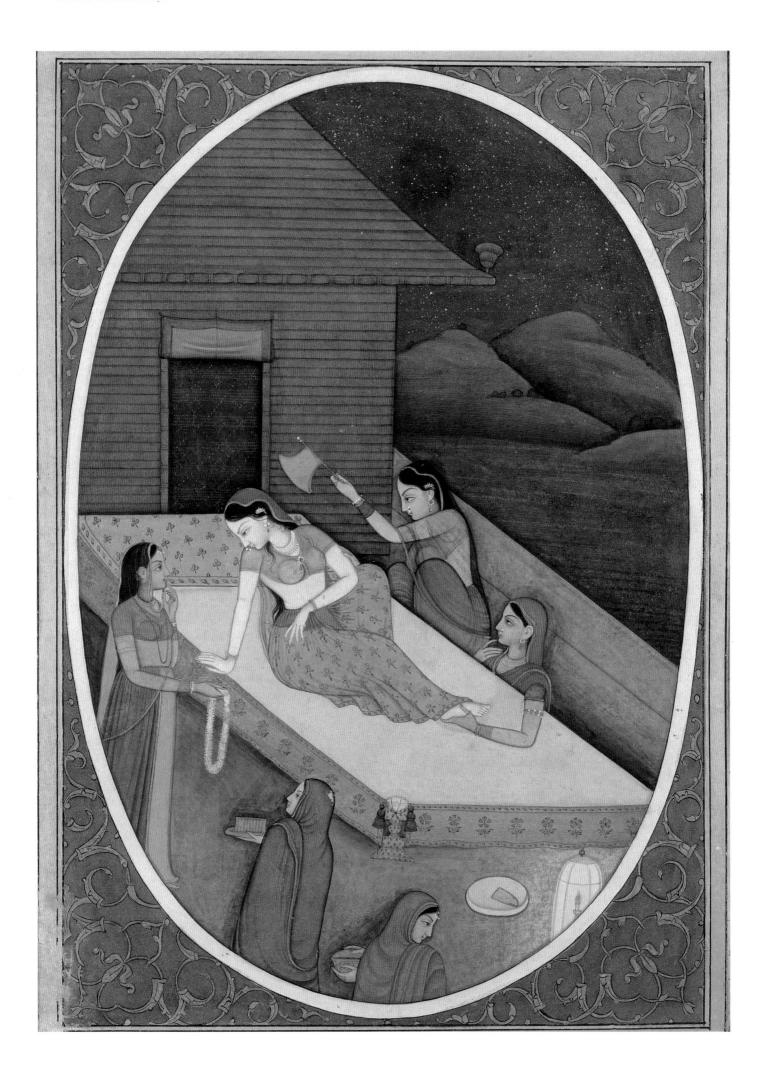

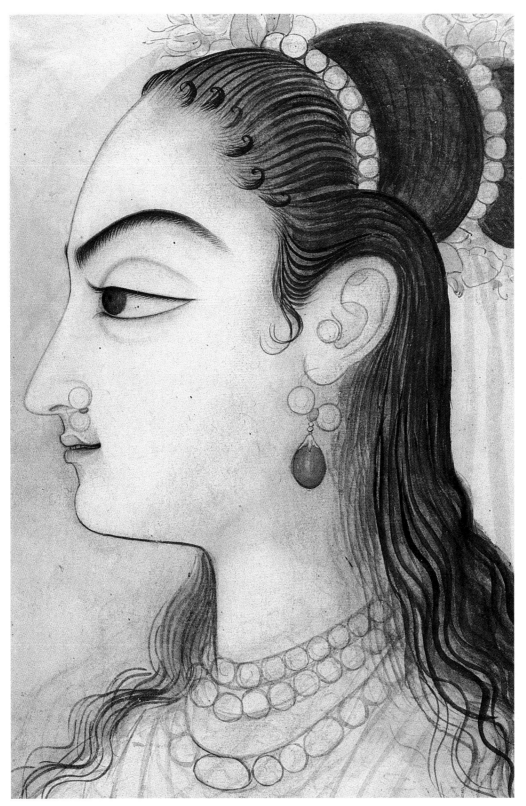

Head of a Woman. Kishangarh, c. mid-18th century. 12 ¼ × 8 ⅞ ″. Collection Dr. and Mrs. William Ehrenfeld

Opposite: *Mistress Awaiting Her Lover.* Kangra, late 18th century. 8 × 5 ¾ ″. Collection Gary and Margarita Crawford

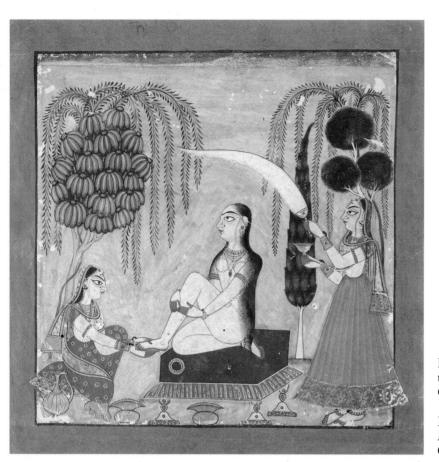

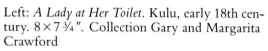

Left: *A Lady at Her Toilet.* Kulu, early 18th century. 8 × 7 ¾″. Collection Gary and Margarita Crawford

Below: *Krishna, the Gopis and Radha in the Forest.* Kangra, late 18th century. 7½ × 9½″ Collection Gary and Margarita Crawford

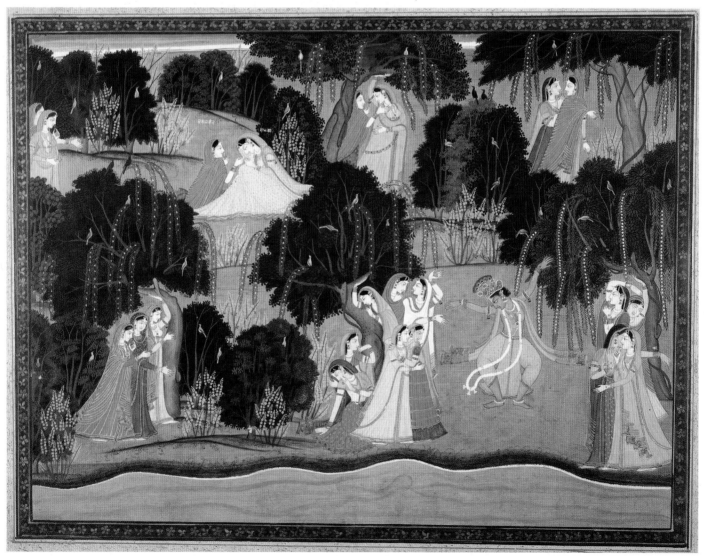

self-consciousness and awkwardness in the handling of the human body is witnessed, as in *A Lady at Her Toilet*. This trend developed in the ateliers of the Mughal courts, probably due to Islamic proscriptions against the portrayal of human figures. Despite such restrictions, however, the depiction of men and women provided the focus for most of the paintings of the Mughal period.

The representation of women continued to fascinate the male patrons of both the Mughal courts and the Rajput kingdoms. Images of women as beautiful mistresses and courtesans prevailed. The elusive nature of woman was emphasized, perhaps because of her seclusion and isolation from the world. The exotic and almost unattainable beauty that the ideal woman was conceived to possess is brought out in the fine portraits from Kishangarh (for example, *Head of a Woman*), which convey a sense of self-assurance unusual in works of this period.

A recurring theme is that of the beautiful woman awaiting the arrival of her lover. In a painting from Kangra, a beautiful woman is surrounded by female attendants, who bring her sweet-smelling garlands of flowers, fan her, and massage her feet as she anticipates her lover's arrival. The pale tonalities and somber hues express the poignancy of the woman's position and the uncertainty of her expectations.

The most romantic representations of women and feminine beauty were derived from the tales of Krishna that were painted in the Rajput courts of the Pahari Hills, the foothills of the Himalayas. In these small paintings we see Radha, Krishna's favorite *gopi* and mistress, and the other *gopis*, cow herdesses, exquisitely depicted. In a Kangra painting, *Krishna, the Gopis and Radha in the Forest*, the lovelorn *gopis* wander aimlessly through the forest, entwining their arms around the trees and each other as each of them dreams of making love with Krishna, the blue god dressed in saffron robes. Radha, seated at the top of the painting, envelops herself in the folds of her *sari*, concealing her beauty from the gaze of Krishna. She is jealous and heartsick because she is aware of Krishna's fickleness and unfaithfulness to her. Thus, these paintings go further than the superficial depiction of beautiful women; they also illustrate the predicaments of womanhood. Krishna, the Divine Lover, may come and go as he pleases, he may make love or not as he desires. For a woman it is different. Therefore, she is shown dreaming and forever waiting, yearning, pining, full of wistful longing. A sense of unrequited love permeates these paintings.

Whether the women depicted were powerful goddesses or beautiful courtesans, it is important to remember that the patrons of art were men. For the most part they were emperors and rajas who demanded that the portrayal of women meet specific requirements, the most important of which was that she be represented as an object of beauty. Therefore, early sculptural works convey the robustness and procreative proclivities of women. They depict a strong sense of power, self-confidence, and independence. This becomes tempered in the later works, in which a romantic conception of feminine identity emerges. Yet the visual imagery of these later secular figures seemingly transforms women into idealized goddesses. Set apart from the world of men, they are idealized and adored and placed upon pedestals.

MARY-ANN LUTZKER
Professor of Asian Art History, Mills College, Oakland, California

The Printed Book in India

The First Three Hundred Years

The New York Public Library will present the exhibition "The Printed Book in India: The First Three Hundred Years" as part of its activities for the Festival of India. The exhibition is being planned with the cooperation of festival organizers in India and will include items from Indian libraries in addition to those from the New York Public Library's own holdings, one of the largest collections of South Asian books outside of India.

"The Printed Book in India" will include both rare and historically important books printed in India, from the earliest surviving book (1561) through those of the nineteenth century. The exhibition will emphasize the role played by Indian scholars and craftsmen in the adaptation of a foreign technology to solve the problems posed by Indian social and linguistic conditions—the presence of not only a vast variety of vernacular languages but also Portuguese, Persian, Sanskrit, and later English as *linguae francae* of various types. Since the history of printing in India is generally viewed from a Western perspective, the crucial contributions of Indians, acknowledged in varying degrees by European printers in India, has often gone unappreciated.

The history of printing in India is closely tied to the multiplicity of languages that characterize Indian society. The early presses were those of missionaries who understood the necessity of learning the local languages, and later also the sacred one, of the natives. The missionaries speak often of the help they received from native pandits and munshis. These Indian teachers of language and culture often did much of the work of the translations that were published.

The early history of printing in India can be divided into three main periods: 1) the Portuguese from 1556 to 1630; 2) the Danish missionaries in Tamil Nadu from 1714; and 3) the Indo-British period from about the 1780s.

From the first period, the library possesses the earliest surviving book printed in India, the *Compendio Spiritual da Vida Christãa*, printed in Goa in 1561, in Portuguese. It is apparently the fifth or sixth book actually printed, but no copies of the earlier works exist, and they are known only from contemporary references. It is a typical product of the early missionary activity in India, that is, a religious handbook for the use of new converts. Although missionaries printed works in the vernacular languages later on, much of their printed matter is in Portuguese, the language in which Europeans and Indians conversed with one another. The Portuguese language retained this status throughout India until it was supplanted by the English language at the end of the eighteenth century.

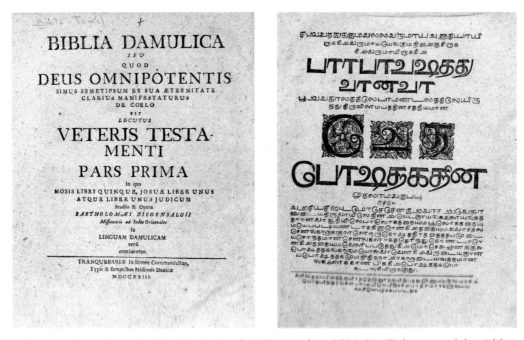

Biblia Damulica (Ziegenbalg Bible). Printed in Tranquebar, 1714–28. Title page of the Old Testament (vol. 1) in Latin (left) and in Tamil (right), 1723

From the second period, the library has a complete copy of the famous *Ziegenbalg Bible*, printed from 1714 to 1728 at Tranquebar, on the southeastern coast of India, as well as other works from this press. Bartholomaeus Ziegenbalg was a Danish missionary supported by funds from an English missionary society. In addition to his translation of the Bible and other religious works into Tamil and Portuguese, printed at the press that he started at Tranquebar, he made his own Tamil typefaces and also constructed his own paper mill. He employed Indian pandits to help with the translations, and when he visited Europe in 1716, he was accompanied by one of his Indian servants so that he could practice his Tamil.

From the third period of printing, the library has many early imprints from Calcutta, Bombay, and Serampore. Printing became a widespread phenomenon in India only during the early 1800s, after the art of punch cutting was mastered by Indian craftsmen, and typefaces for the large variety of scripts became widely available. In fact, this was brought about in large part through the work of a Bengali named Panchanan Karmakar at the Serampore Mission Press. He learned the art of punch cutting from Sir Charles Wilkins, the famous Orientalist, and passed it on to successive generations of Indian craftsmen. The Serampore Mission Press, using the typefaces made by Panchanan, published works in over forty different Indian languages, with the assistance of pandits gathered from all over India.

The New York Public Library has a very good collection of works from the presses of this period, including the first grammars, vocabularies, Bible translations, and literary prose works ever to be printed in many Indian languages. The exhibition will also include rare copies of Hebrew and Chinese works printed in India. Although the Chinese may claim the printing of the first book, the library will display a copy of the first Chinese book ever printed on movable metal type, the *Works of Confucius*, from the Serampore Mission Press.

RANDOLPH W. THORNTON
Curatorial Consultant, The New York Public Library

Jews of India

Jewish communities have flourished in India for over one thousand years, existing in harmony with their Indian neighbors and free from the restrictions and persecutions that Jews have been subject to elsewhere in the world. This environment of tolerance in India allowed Jews to retain their religious identity, while encouraging their integration into Indian political, economic, and military life.

Three separate groups of Jews have lived in India, each with its own history, linguistic and cultural affiliation, and level of integration into Indian society. The Jewish Museum's exhibition, "Jews of India," incorporates a photographic exhibition on one of these communities, "The Jews from the Konkan: The Bene Israel Communities in India," which was created by Beth Hatefutsoth, Tel Aviv, as well as ceremonial objects used by each of the three different groups of Indian Jews. It documents the history and life style of these communities, their religious practices, and the degree to which the rich artistic tradition of India influenced their ceremonial art and costume. The exhibition serves as an important record of Jewish life in India, a way of life that may eventually disappear as a result of mass emigration and assimilation.

The largest group of Indian Jews is the Bene Israel, who settled in western Indian in the Konkan region. The date and manner of their arrival in India is shrouded in mystery. The remarkable fact about the Bene Israel is that from the time of their arrival until their contact with other Indian Jews in the eighteenth century, they remained in complete isolation from the larger Jewish community. They practiced a simple form of Judaism, without any knowledge of the Bible, of the vast body of Jewish law contained in the Talmud, or of the Hebrew language. Yet they were Sabbath observers, circumcised their sons, observed many of the holidays, and kept kosher. In the eighteenth century, members of the Cochini Jewish community encountered the Bene Israel for the first time, and instructed them in rabbinical Judaism. The Bene Israel are virtually indistinguishable from their Indian neighbors in physical appearance and dress. Living originally in small villages in the Konkan region, they took up the occupation of oil pressing. But, beginning in the mid-eighteenth century, they began moving to Bombay, where they acquired skills in construction, office and governmental work, and teaching.

The second community of Jews, the Cochini, settled in southern India, in the tenth century or earlier. Between the thirteenth and eighteenth centuries, the original

Above: Bene Israel family in Bombay. c. 1890. From the exhibition "The Jews from the Konkan"

Below: Oil press in the village of Cheul in Konkan. Oil pressing was the main occupation of the Konkan Jews until the nineteenth century; today, only this family remains in the village. Photograph by Carmel Berkson from the exhibition "The Jews from the Konkan"

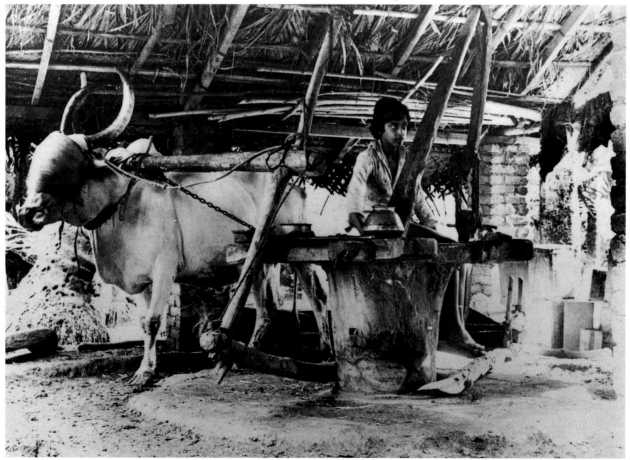

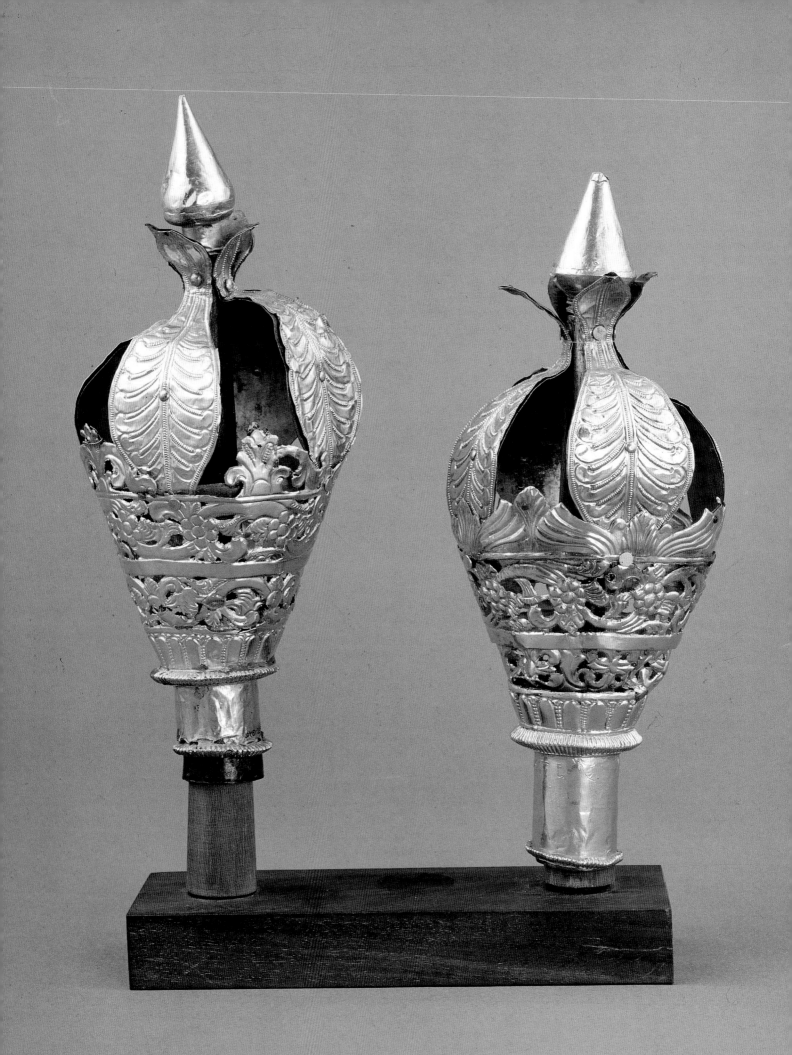

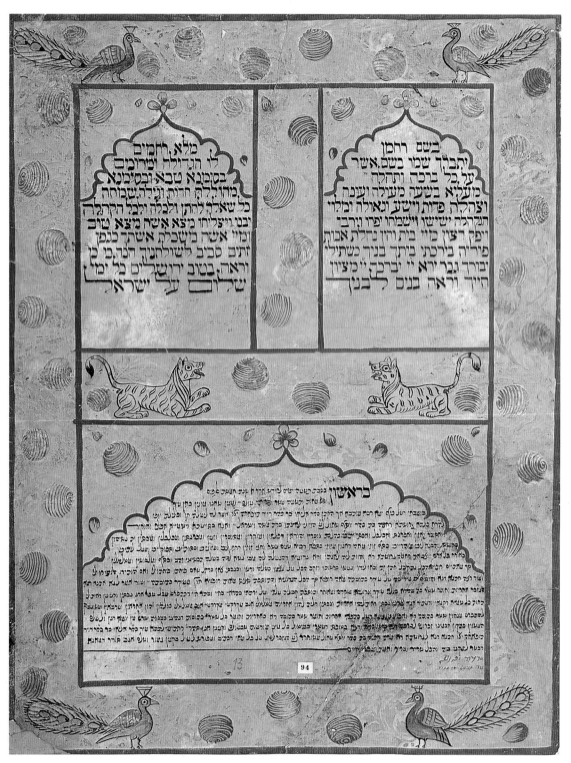

Marriage contract between Eliahu Tupahas and Nehama Shaul. Bombay, 1859. Ink and gouache on paper, 19⅝ × 15⅛″ (50.1 × 38.3 cm). The Zucker Family Collection

Opposite: Pair of Rimmonim (Torah finials). Cochin, 18th century. Gold leaf, repoussé and cut out; tin sheet backing added later, height 8½″. The Jewish Museum, New York. The Eva and Morris Feld Judaica Acquisitions Fund, 1982

population was augmented by Jews from all parts of the Middle East and even from Spain and Germany, Jews who always retained close ties through trade and communication with their co-religionists elsewhere in the world. A few Cochini became wealthy merchants, negotiators, and financiers, while the majority were small traders and artisans. The Cochini had originally adopted the local Malayali language and mode of dress; however, after the institution of British rule, wealthier members came to prefer Western dress and the English language.

The third group of Jews in India, the Baghdadi, arrived at a much later date and with a very different cultural affiliation. Jewish traders from Muslim lands had maintained temporary residence in India for many years, but the first true settler from this group was Shalom ben Aaron Obadiah Ha-Kohen of Aleppo, Syria. He arrived in Bombay in 1790 and settled in Calcutta in 1797; his son-in-law, Moses Cohen, is regarded as the founder of the Calcutta Baghdadi community. A second major community of Baghdadi Jews was established somewhat later in Bombay, largely by Baghdadis who had originally settled in the western Indian city of Surat. Baghdadi culture was originally Arab in language, folklore, and costume, and never really became Indianized like the Bene Israel and Cochini. However, the wealthier Baghdadi soon adopted English dress and language, while the poorer maintained their Arab identity until much more recently.

The photographic component of the exhibition, "The Jews from the Konkan," documents the life of the Bene Israel communities both in the villages of the Konkan and in the city of Bombay. The photographs, taken primarily by Carmel Berkson, an American living in Bombay, depict the homes and synagogues of the Bene Israel and their religious observances, as well as important members of the community. "The Jews from the Konkan: The Bene Israel Communities in India," was created by Beth Hatefutsoth, the Nahum Goldmann Museum of the Jewish Diaspora, Tel Aviv, Israel.

While the ceremonial objects included in the exhibition possess the same function as those used by Jews everywhere, they often bear the unmistakable stamp of Indian culture in their form and decoration. Two examples are a pair of eighteenth-century Torah headpieces executed in gold leaf that once ornamented the staves of a Torah scroll in a Cochin synagogue and a marriage contract that records the wedding of a Bombay couple in 1859 decorated with such characteristic Indian motifs as tigers, peacocks, and Oriental archways.

The experience of the Jews of India duplicates that of many of the Jewish communities that sprang up throughout the world as result of the exile from the land of Israel. Numerous elements of their culture, such as language, mode of dress, and decorative art style, were adapted from their host country. Yet the Jews of India still maintain a strong sense of Jewish identity, observing the laws and performing the rituals that link them in an unbroken chain to the Jews of ancient Israel and to their contemporaries dispersed throughout the world.

SUSAN L. BRAUNSTEIN
Assistant Curator, The Jewish Museum, New York

The Clive Collection of Indian Art at Powis Castle

Treasures from the Clive of India collection will be on show at Sotheby's, New York, in September 1985 in order to raise money for the establishment of an Indian museum at Powis Castle. Powis is one of over two hundred country houses in the care of the National Trust. Founded in 1895, the Trust is Britain's greatest conservation society and the country's largest private landowner.

The Clive Collection of Indian art was begun by the great Lord Clive, Clive of India (1725–74), whose victories at Arcot (1751) and Plassey (1757) made him a national hero and laid the foundations of Britain's Indian empire. Robert Clive arrived in India in 1744 at the age of eighteen. The eldest son of an impoverished country squire, he embarked upon a career as an East India Company merchant in the hope of restoring the family fortunes. However, Clive quickly transferred into the military branch of the service. The heroic defense of Arcot established his reputation, but it was his defeat of the Nawab of Bengal at Plassey in 1757 that created the Clive legend. Clive's subsequent annexation of Bengal marked the first stage in Britain's eventual domination of the Indian subcontinent. As well as territory for the company, Clive amassed riches for himself. By 1771, he owned five houses, magnificent art collections, and twenty thousand acres of land. Rebutting Parliamentary criticism of his activities in India, Clive made the celebrated remark: "When I recall entering the Nawab's treasury at Murshidabad with heaps of gold and silver to the right and left, and these crowned with jewels, by God at this moment do I stand astounded at my own moderation!"

Clive's son Edward, the second Lord Clive (1754–1839), was appointed governor of Madras in 1798. The following year war was declared against Tipu Sahib, Sultan of Mysore, an implacable enemy of the British. After a swift campaign, Tipu was killed on May 4, 1799, and his capital, Seringapatam, the richest city in south India, lay at the mercy of the victorious British army. There followed an orgy of looting, which left many of the soldiers "richer than their officers." Choice pickings from the captured city found their way into Lord Clive's collection, including the dead sultan's embroidered shoes, a gold tiger's head from his throne, and, most extraordinary of all, his state tent of painted chintz.

There have been Indian curiosities at Powis Castle since at least 1816, when a visitor was surprised to find a life-size "model of a war elephant, entirely covered with a coat of mail and bearing a spear fastened to the forehead and swords to its

The Royal Oak Foundation
(an American group affiliated with the National Trust, Great Britain)

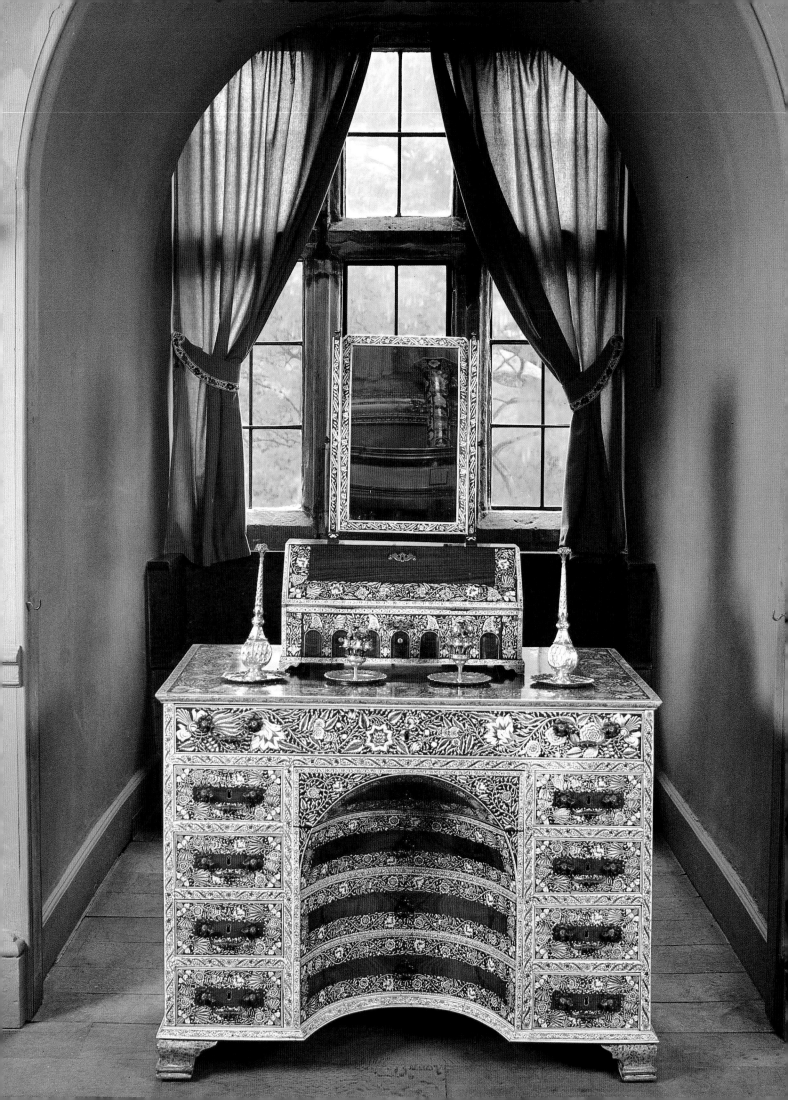

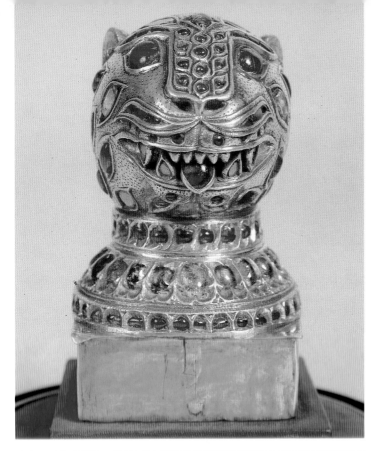

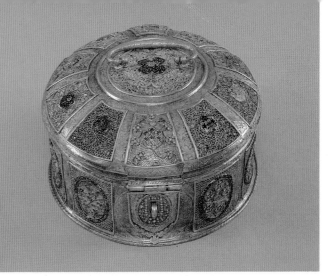

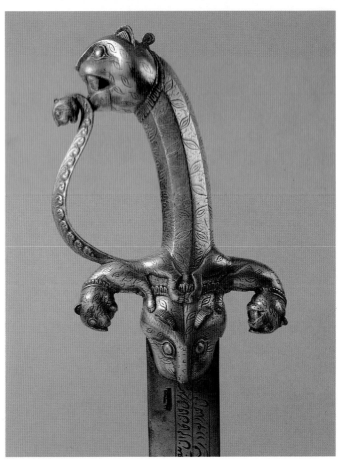

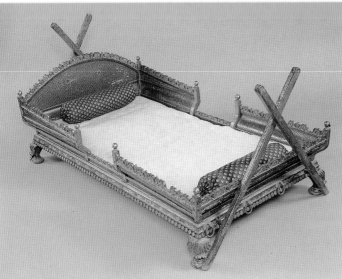

Above, left: Tiger head finial from the rail of Tipu Sultan's throne. Mysore, late 18th century. Gold on a wooden core, set with rubies, diamonds, and emeralds, 3¼ × 1⅞″ (8.3 × 4.7 cm)

One of the tiger heads that adorned the balustrade of Tipu's golden throne. It was given to the second Lady Clive by the governor-general, Lord Wellesley, who deplored the philistinism of the soldiers who had wrecked Tipu's throne for the sake of its value as bullion.

Opposite: Dressing table and mirror. Vizagapatam, mid-18th century. Rosewood inlaid with ivory and mounted with silver, table: 30⅞ × 41⅜ × 26⅜″ (78.5 × 105 × 67 cm); mirror: 29⅞ × 21⅜″ (76 × 54.5 cm)

Acquired by Clive of India together with several boxes similarly decorated. Ivory furniture was also bought by Clive's son and daughter-in-law. Lady Clive and her daughters saw the ivory craftsmen at work when their ship put in at Vizagapatam on their return voyage to England in 1801.

Above, right: Casket. Lucknow or Murshidabad, 18th century. Silver-gilt, decorated with colored enamels, turquoises, and semiprecious stones, 6⅜ × 11″ (16.5 × 28 cm)

Below, right: Tipu Sultan's saber. Length 37½″ (95.5 cm)

The saber (shamsher) has an Arabic inscription on the blade; the hilt is of cast and chased bronze overlaid with gold and decorated with tiger heads. Associated with Tipu by family tradition, this would seem to be confirmed by the quality of the craftsmanship and the presence of the tiger heads.

Below, left: Palanquin. Probably Murshidabad, Bengal, mid-18th century. Carved wood, lacquered green and gilt, cane bottom, 65 × 37⅜″ (165 × 95 cm)

Listed in the 1774 inventory of Clive's Indian curiosities, this palanquin is said to have been abandoned on the battlefield of Plassey in 1757 by the Nawab of Bengal. The palanquin was the Indian equivalent of a sedan chair.

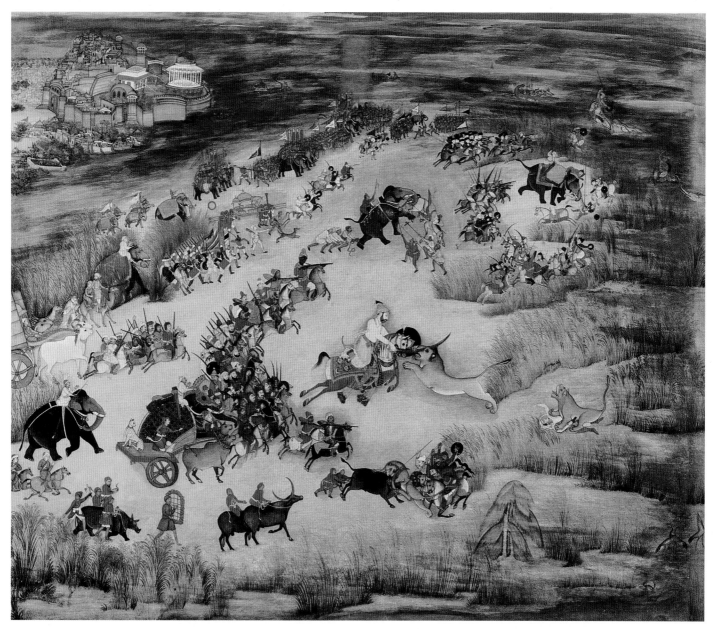

Attributed to Mir Kalan Khan. *A Lion Hunt.* c. 1760. Watercolor and gouache heightened with gold and silver, 28⅜ × 33¼″ (72 × 84.5 cm)

This was described as an "Indian Picture Hunting Piece" in a list of Clive's paintings dated 1771. The central figure appears to be Shuja-ud-daula, Nawab of Oudh, who was defeated by the British at the Battle of Buxar in 1764. Shuja was famous for his physical strength; he is said to have lifted two British soldiers—one in each hand.

Opposite: Section of Tipu Sultan's tent. Khandesh (Burhanpur), mid-18th century. Cotton, printed, painted, and dyed, approximately 77 sq. in. (630 sq. cm) when pitched

Constructed like a modern marquee, this splendid tent consists of a roof supported by a central pole and wall panels decorated with a row of niches, each enclosing a vase of flowers. The colorful inner lining was protected by an outer tent, which was "painted a beautiful sea green colour with rich ornamented borders." This is probably the tent "lined with fine chintz" in which Tipu's sons, the hostage princes, received General Lord Cornwallis following their father's defeat in the third Mysore War of 1792.

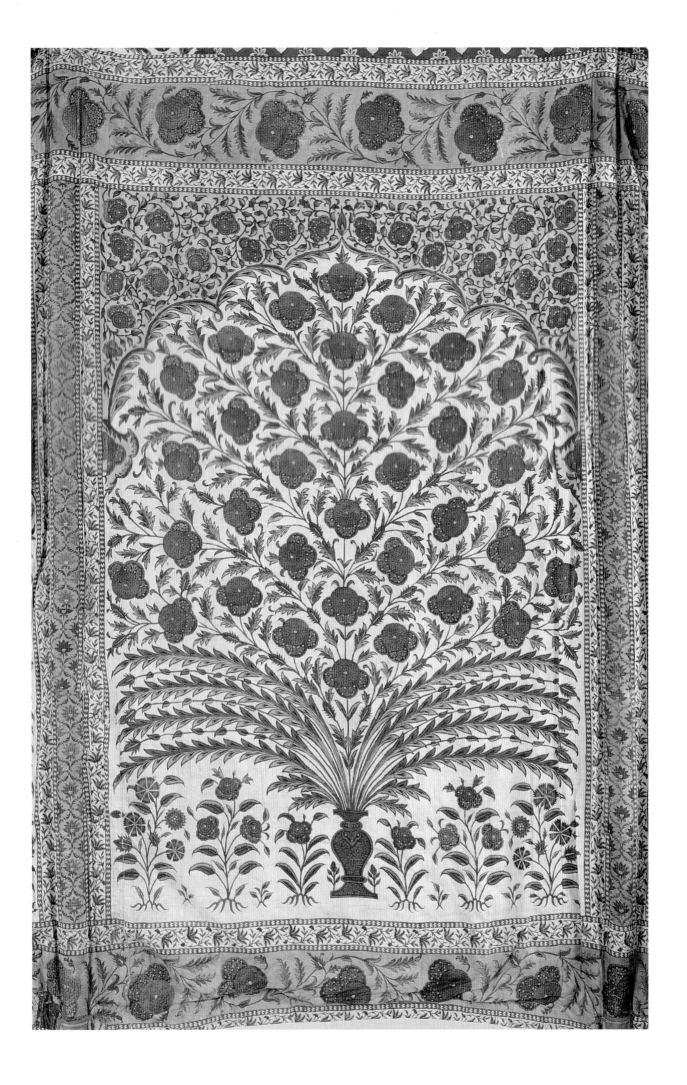

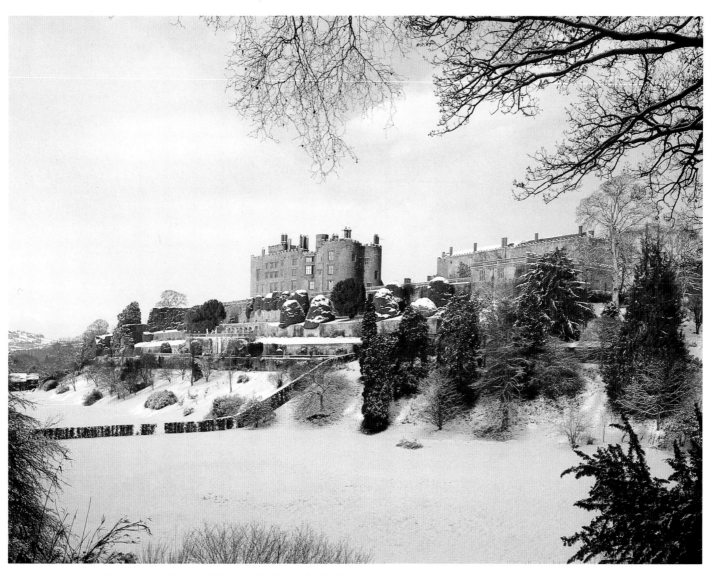

The garden front of Powis Castle, North Wales

Powis is one of the most romantic and important of all British country houses, but because of its remote position on the Welsh border, 200 miles north of London, it is still relatively unknown. Built c. 1300, it has been the seat of Clive of India's descendants, the Earls of Powis, since 1801. Powis Castle was given to the National Trust in 1952 by the fourth Earl of Powis.

tusks, which was brought home by the celebrated Lord Clive, governor of India." Part of this elephant armor is still at Powis, together with a glittering array of Indian loot including seventeenth- and eighteenth-century paintings, bronzes, furniture, armor, weapons, textiles, and exotic metalwork wrought in gold and silver and encrusted with jewels and enamels. All this magnificence came to Powis following the marriage of Clive of India's son to the Powis heiress, Lady Henrietta Herbert.

The Indian collection at Powis Castle is unrivaled in Britain outside the Victoria and Albert, the British Museum, and Windsor Castle. It has the added attraction of being very well documented. Inventories, letters, and diaries make it possible to identify the collecting interests of the different members of the Clive family between 1744 and 1805. The Clive papers paint a lively and often irreverent picture of English life in India during one of the most exciting periods in the country's history. As a record of the Clive family's long and distinguished association with India during the birth of the British empire, the Powis Castle collection is of national importance.

From Merchants to Emperors
British Artists in India, 1757–1930

The exhibition "From Merchants to Emperors" focuses on two centuries of British presence in India as reflected in artistic representations produced by artists from Great Britain. British interest in India originated with merchants in the sixteenth century; however, from 1757, with Lord Clive's victory in the Battle of Plassey, the roles of the merchants changed considerably. The trading company began to acquire territory and by 1772, when Warren Hastings was governor-general, the East India Company was administering an area and a population larger than that of its home country. The expansion of British authority in India provoked an interest in the country, and artists traveled out to India in the hope of securing commissions. In India, portrait painters found themselves in great demand; historical painters were confronted with a wide variety of subjects; while landscape artists were presented with all the elements of the picturesque, romantic, and sublime. The Indian Mutiny of 1857 prompted the Crown to take over direct administration from the company and to proclaim Queen Victoria as Empress of India. The show chooses as its terminal date the year 1930, which saw the completion of the capital of New Delhi, an ostensible symbol of empire.

The exhibition is divided thematically into five broad sections, which are basically chronological. "The British in India" looks at representations of rulers, historical occasions, and early British architecture. The artists of the period have also left behind a vast quantity of pictures that reproduce the life of the British in India with great fidelity and in voluminous detail. We see the domestic and official lives of the British, their household arrangements and numerous servants, their social institutions and their sports. In addition, a large amount of material in the form of caricatures reflects the ability of the British to poke fun at their own behavior and attitudes.

"The British View of India" reveals how British artists perceived the physical landscape, the countless ruins and monuments of the subcontinent, as well as the people and their customs. Earliest of the professional artists to come to India was William Hodges, whose pictures were published as volumes of aquatints entitled *Select Views of India*. Following him was Thomas Daniell, accompanied by his young nephew William, who toured the country extensively, making sketches and watercolors, which they took back to England. From these they produced their famous six-volume series of aquatints, *Oriental Scenery*. Their work aroused considerable interest in England, and several landscape artists followed them, including William

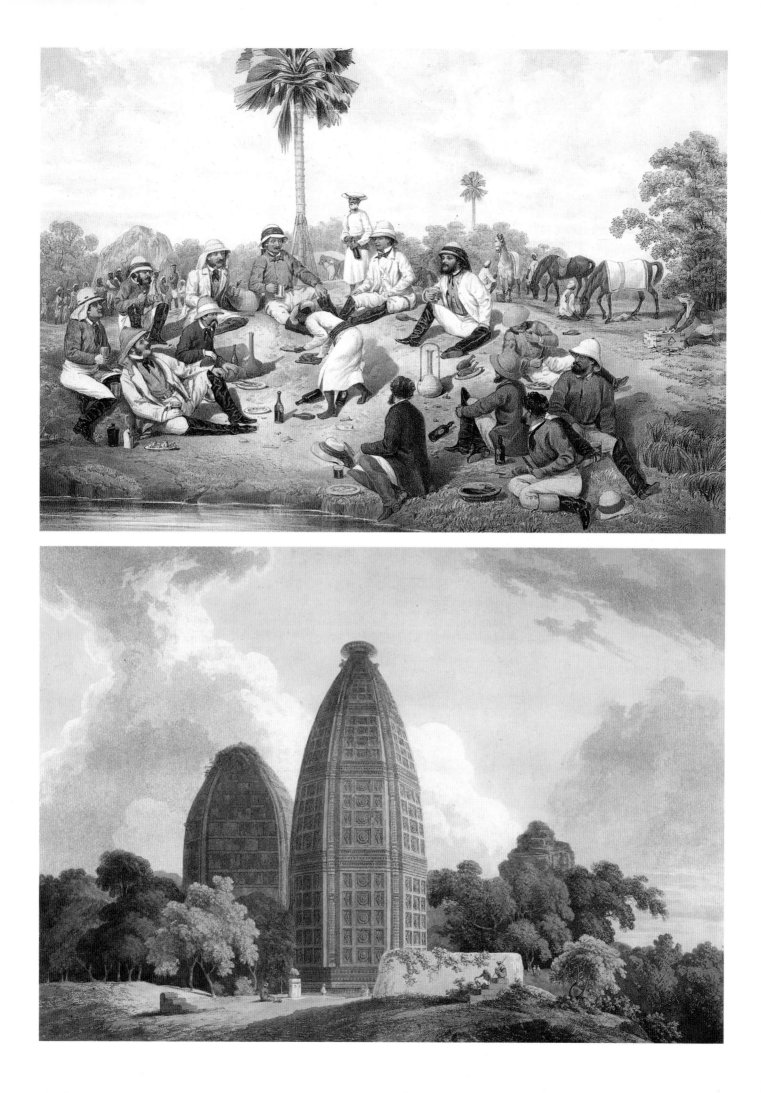

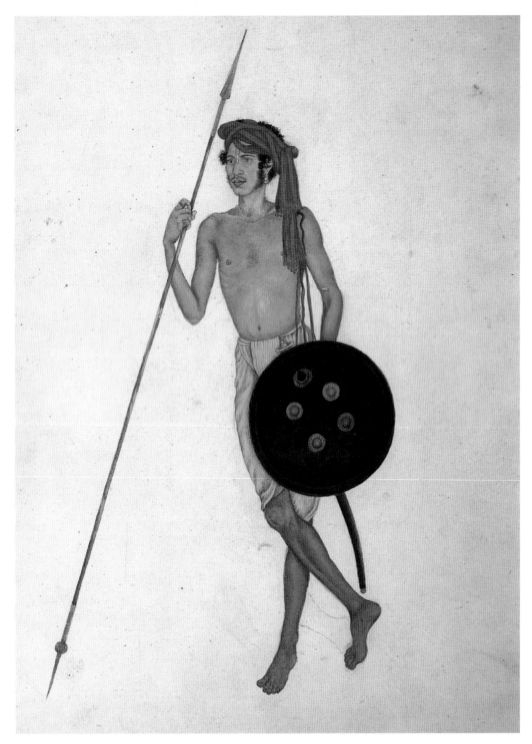

Trooper of "Skinner's Horse." c. 1820–30. Watercolor

This page from the famous Fraser album depicts a trooper from a unit known as Skinner's Horse. These troopers, "a set of fearless men in wild-looking dresses," were commanded by Colonel James Skinner, son of a Scots officer and a Rajput woman, and an extremely popular figure in India, known locally by the name of Sikander or Alexander (the Great). This watercolor is by an unknown Indian artist.

Opposite, above: Percy Carpenter. *Tent Club at Tiffin.* 1861. Lithograph

Hunting was one of the favorite pastimes of the British officers in India, and we hear from more than one writer of the culinary delights that were prepared for these outings. "The most elaborate *pic-nic* provided for a *fête-champêtre* in England . . . is nothing to the luxurious displays of cookery performed in the open air in India."

Opposite, below: Thomas Daniell. *Hindoo Temples at Bindrabund on the River Jumna.* From *Oriental Scenery.* 1795. Aquatint

Daniell, in his journal, speaks of these "beautiful and singular Pagodas . . . most elegantly sculptured." The temples so impressed him, and the composition of the picture was so successful, that in 1797 he painted it again in oils, as his diploma work for the Royal Academy.

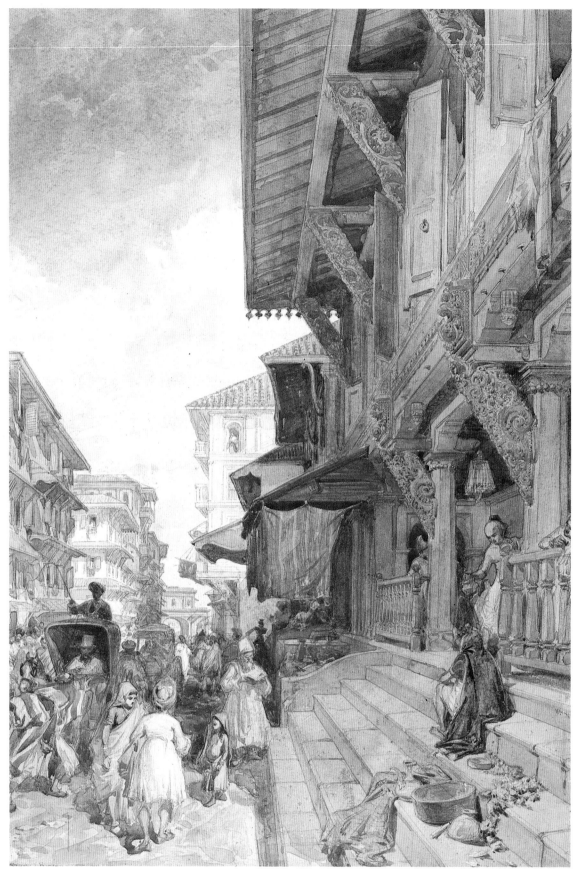

William Simpson. *Street Scene in Bombay.* 1862. Watercolor

A professional artist renowned for his recording of historical events, Simpson was commissioned by the London publishers Day & Son to travel to India and make drawings of the country. This Bombay street scene, with its bustling crowds and the attention paid to the city's architecture, is a striking example of Simpson's watercolors.

Samuel Bourne. *Snowy Heights from the Wangtoo Valley.* 1864. Photograph

Bourne made three difficult trips into the Himalayan regions. He had infinite patience when it came
to choosing the right time and the exact spot for his carefully planned landscape photographs. His jour-
nal speaks of his admiration for this valley: "It has seldom, if ever, been my lot to look upon and photo-
graph scenery so magnificent and beautiful." Admiring the tall, slender trees, he writes, "With the
splendid mountain ranges on each side of the valley for backgrounds, these trees combined to form
delightful pictures and I lingered amongst them for a week hard at work every day with my camera."

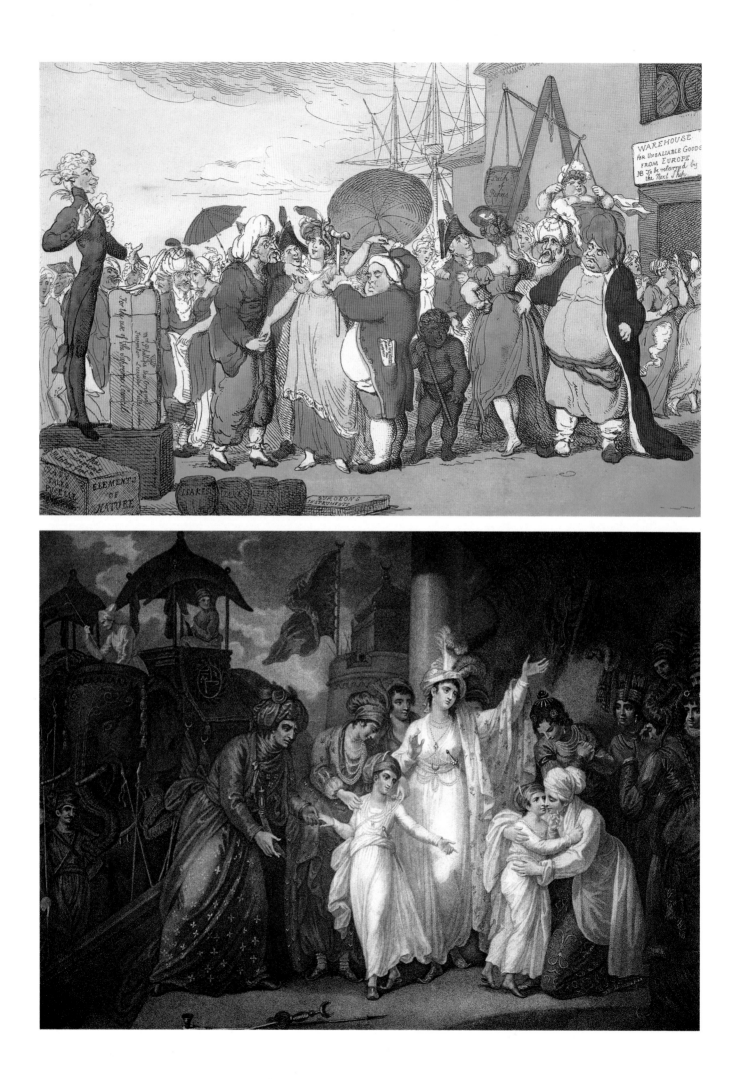

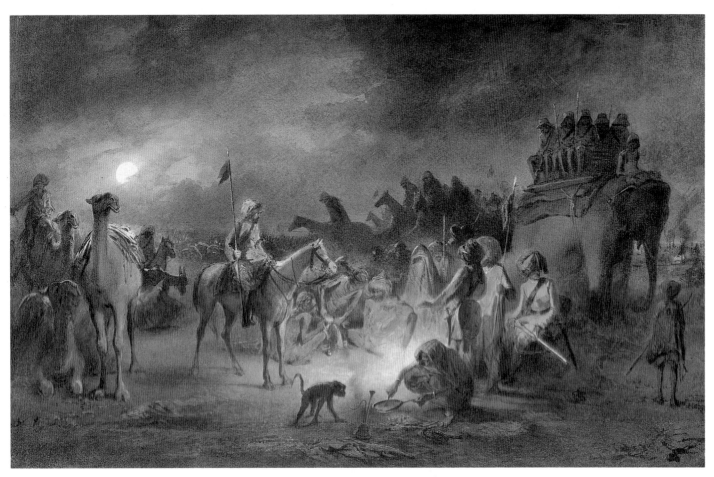

Egron Lundgren. *Dawn at the Mutiny Camp*. 1858. Watercolor

The somber hues of this Mutiny Camp scene—following the sacking of Lucknow—with its focus on the glowing camp fire, give this picture a haunting, even disturbing quality.

Opposite, above: T. Rowlandson. *Sale of English Beauties*. c. 1800. Colored lithograph

A subject matter for both caricaturist and writer. Viscountess Falkland: "The arrival of a cargo (if I dare term it so) of young damsels from England is one of the exciting events that mark the advent of the cold season."

Opposite, below: Mather Brown. *Departure of the Sons of Tippoo from the Zenana*. 1796. Lithograph

The incidents surrounding the surrender and death of Tippoo (Tipu) Sultan fascinated historical painters, who produced several versions of the key events. This painting was produced by an artist who had never visited India but, we are told, "received every assistance by drawings made in India."

Simpson and Edward Lear, who produced numerous scenic views of India. Other artists, like A. W. Devis and Emily Eden, turned to the peoples of India, portraying their colorful costumes and exotic customs, their trades and crafts, their religious festivals and social ceremonies.

"The Imperial Image after 1857" deals with the Sepoy Mutiny and its aftermath. It examines the imperial buildings that the British now began to erect, combining Indian elements with the Victorian Gothic style in grandiose civic structures. The climax of imperial British architecture was the creation of New Delhi and its viceroy's palace, the official residence of the viceroy along with his five thousand employees and servants, built by Sir Edwin Lutyens. The British also projected their imperial image by organizing lavish ceremonial occasions, known as durbars, to celebrate the official visits of ruling British monarchs. Illustrated photographic albums were prepared for such occasions.

"India Through the Lens" presents India as the early photographers saw it. In the period after 1857, with a few exceptions such as Lumsden, the photographer largely replaced the artist and painter. A daguerreotype view of Calcutta made around 1840 introduces this section, which exhibits the work of several professional Victorian photographers, including Samuel Bourne, Felice Beato, Robertson, Frith, and others. Landscape and monuments fascinated the photographer as they had the painter, but the medium also introduced a new documentary realism.

"Company School" concerns the works of Indians for British patrons. Apart from patronizing British artists who visited India, a select group among the British were also interested in the art produced by local artists. Indian painters were occasionally engaged by the British to produce works to their specification. This section will illustrate how far the Indian artists were successful in modifying their technique to suit their patrons' tastes and consider if they were influenced by British art and artists. Certainly, in the magnificent paintings of Indians by unknown artists that constitute the much-admired Fraser album, the local artists reveal a heightened sense of realism and powers of keen observation, which seem to be the result of their familiarity with British art.

Dr. Vidya Dehejia
Co-curator of the Exhibition
Department of Art History and Archaeology, Columbia University, New York

Yankee Traders and Indian Merchants, 1785–1865

The 1985 Festival of India marks the two-hundredth anniversary of the opening of direct trade between the United States and India. Traders of the newly independent nation were no longer constrained by the British East India Company's monopoly on trade with Asia. The ship *United States* departed from Philadelphia for Pondicherry in March 1784 and returned in September 1785, successful enough to encourage other American merchants to enter the trade.

The Peabody Museum of Salem's exhibition, "Yankee Traders and Indian Merchants, 1785–1865," commemorates the early decades of America's relations with India. The exhibition draws on the museum's permanent collections, which were initiated in 1799 by the East India Marine Society. Through the portraits of Yankee traders and Indian merchants, paintings of vessels engaged in the trade, logs and journals of voyages, and objects donated to the museum, especially those given in the early nineteenth century, this exhibition presents the initiation of relations between the United States and India.

Elias Hasket Derby of Salem began tentative explorations in the India trade when he sent his son Elias H. Derby, Jr., as supercargo on the third Asian voyage of the *Grand Turk*. Elias, Jr., sold the *Grand Turk* at the Isle de France (Mauritius) and purchased two smaller ships. These he took on a trading expedition to India, with stops at Bombay, Colombo, Nagapatam, Tranquebar, and Madras. Elias Hasket Derby became the leading American merchant in the first decade of direct trade with Asia. His ventures centered on the India trade, and their success made him the first American millionaire.

Members of the Crowninshield family of Salem entered the India trade in the employ of E. H. Derby. George Crowninshield married Derby's daughter Mary, and they had six sons. The father and sons formed the firm George Crowninshield and Sons, and by the end of the eighteenth century their business had surpassed that of the Derby family. A cousin, Benjamin Crowninshield, was master of a Derby vessel, the *Henry*, on a voyage to Calcutta in 1789. Benjamin was an acute and unusually impartial observer. In his journal he described at length a *suttee* (the ritual suicide of a widow) he had witnessed in Calcutta, commenting: ". . . and whether it is right or wrong I leave it for other people to determine. . . . it appeared very solemn to me. I did not think it was in the power of a human person to meet death in such a way."

Peabody Museum, Salem, Massachusetts

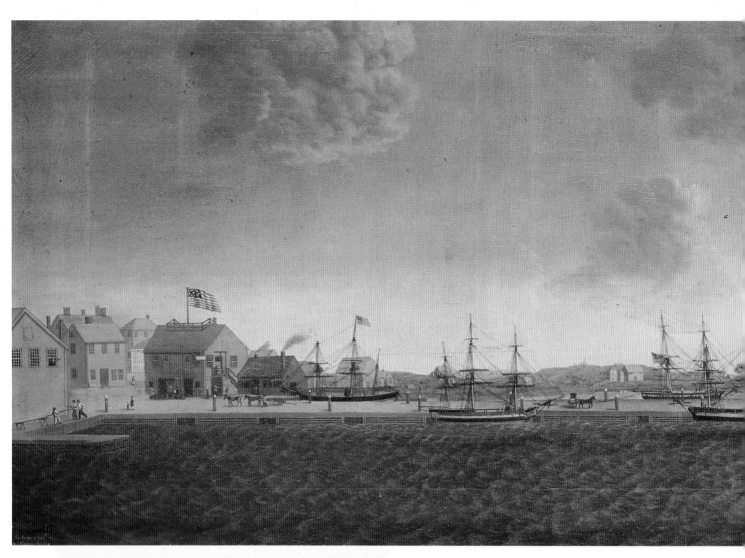

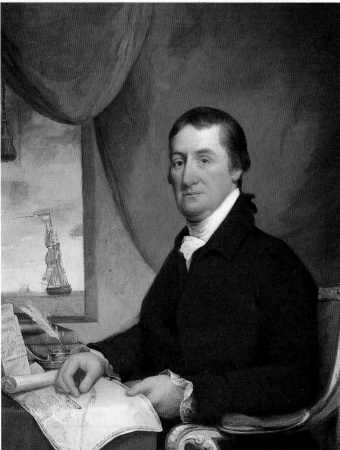

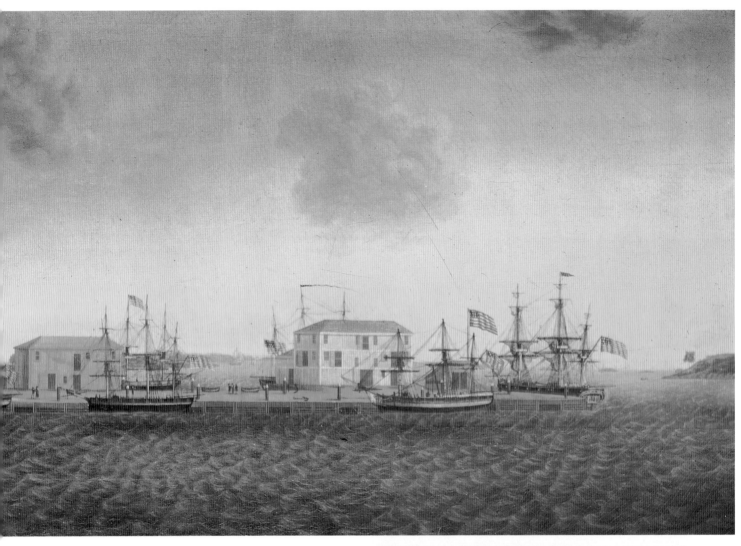

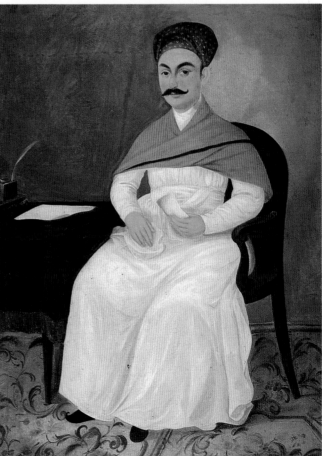

Above: G. Ropes. *Crowninshield Wharf.* 1806.
Oil on canvas, 32½×95″. Peabody Museum of
Salem. Deposit from the Essex Institute

Around the wharf are the ships *America, Fame, Prudent,
Belasarius*

Opposite: James Frothingham. *Portrait of Elias
Hasket Derby, 1739–1799.* Oil on panel,
41½×32¼″. Peabody Museum of Salem. Gift of
the Derby family, 1824

Right: Unidentified Indian artist. *Portrait of Nusser-
wanjee Maneckjee Wadia, 1753–1814.* c. 1802. Oil
on canvas, 39×29″. Peabody Museum of Salem.
Gift of Captain John R. Dalling, 1803

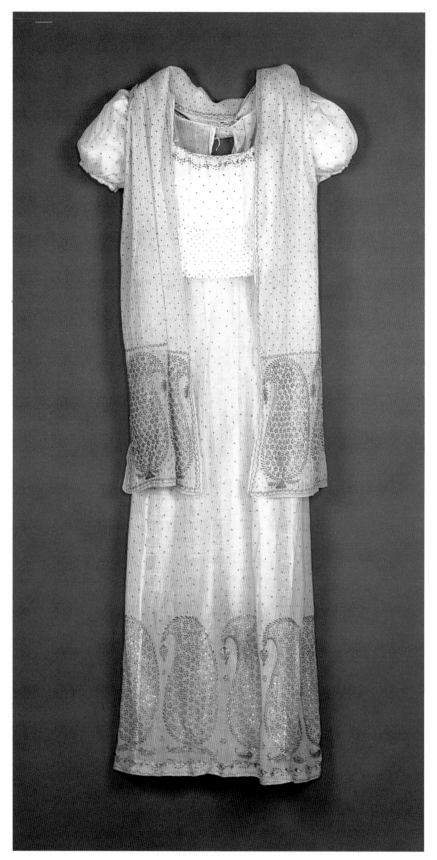

Dress and scarf. c. 1827. Indian cotton muslin with silver decoration, dress: length 55″; scarf: length 86″. Peabody Museum of Salem. Gift of Miss Jeannie Dupee, 1979

Made for the trousseau of Mary Derby Rogers

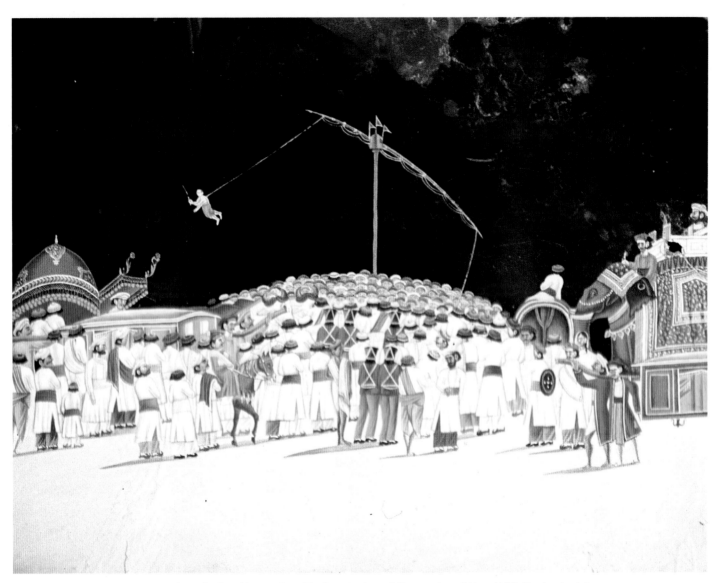

Above: Unidentified Indian artist. *Hook-swinging.* Oil on mica, 8½×6½″. Peabody Museum of Salem. Collected by Charles How Greenleaf, 1876–79. Gift of his daughter, Mrs. Katie D. Holt, 1948

Below: *The Goddess Lakshmi and Attendants.* Alabaster and pigments, height of central figure 10¼″. Peabody Museum of Salem. Gift of Rajender Dutt, 1850

The Derby and Crowninshield firms provided training, as captains, masters, or supercargoes, for many other New Englanders who later became independent traders and merchants. In the ports of British India, especially Bombay and Calcutta, American trade became important enough to attract Indian merchants as specialists, serving as commercial agents for Americans.

In Bombay, Nusserwanjee Maneckjee Wadia, a Parsi and the son and grandson of shipbuilders for the British, was an agent for both the Americans and the French. For his service to the French he was awarded the Legion of Honor by Napoleon Bonaparte, and his portrait was hung in a French government office in Paris. The portrait in the Peabody Museum was donated in 1803 by Captain John R. Dalling of Salem, who had done business with Nusserwanjee in Bombay. In the same year, Nusserwanjee gave a Parsi merchant's costume to the museum (then the East India Marine Society). A portrait mannequin of Nusserwanjee was made by a Salem woodcarver to display the costume. Captain George Nichols of Salem, who also dealt with Nusserwanjee, wrote in his *Salem Shipmaster and Merchant* that he thought him "a very fine man." Nichols purchased from Nusserwanjee "a beautiful striped muslin, very delicate" for his fiancée's wedding gown. Fine Indian muslin was treasured by American ladies of fashion in the early nineteenth century. Mary Derby Rogers had two dresses of muslin decorated with silver made for her trousseau in 1827.

In Calcutta, the firm of Rajender and Kalidas Dutt, Hindu *banians* (merchants), was a favorite of New England traders. In 1849 T. A. Neal, a merchant of Boston, gave the museum a life-size clay portrait statue of Rajender Dutt. Dutt himself, in 1850, gave the museum alabaster figures of the goddess Lakshmi and attendants. Charles Eliot Norton, later known for his influence on nineteenth-century arts and letters, began his career in the India trade as a supercargo for his brother-in-law's firm, Bullard and Lee of Boston. Norton found Dutt "one of the most agreeable and intelligent Hindus that I have met here" (*Letters of Charles Eliot Norton*). Norton, who was privileged to visit the Dutt home on several occasions, wrote in his *Letters* that the Dutts were a family of two hundred members, who "lived together with all their property in common and with no division for seven generations." Norton, in contrast to Crowninshield, found Hindu practices easy to judge: "Is it not a strange thing that such ceremonies [the sacrifice of goats to the goddess Durga, observed at the Dutt home] should be continued in a family some of whose members are intelligent men, acquainted with the literature and science, and, more than all, the religion of the West?"

The impact of the India trade on Salem, Massachusetts, went beyond the experiences related by the traders to friends and relatives due to the activities of an organization, the East India Marine Society, founded in 1799. Membership was restricted to captains, masters, and supercargoes of Salem vessels that had navigated "the Seas near or beyond the Cape of Good Hope, or round Cape Horn." Before the society's annual meeting the membership paraded through the streets of Salem. The procession included a "palanquin in which a boy apparelled in the most gorgeous habitments, borne by blackfellows, sweating under the unaccustomed burthen, in the East Indian dress attended with fan and hookah bearers and every other accompaniment of an East Indian equipage . . ." (*Salem Register*, June 30, 1823). The palan-

quin was sent to the museum by five members of the East India Marine Society, all in Calcutta in 1802. One of them, Moses Townshend, wrote to the society, "it may gratify the curious, will show the method of travelling in this country, and may answer a very good purpose on our festival day in case any accident should happen a member."

Most important, the East India Marine Society established "a Museum of natural and artificial curiosities, particularly such as are to be found beyond the Cape of Good Hope and Cape Horn." On display were many "curiosities" from India. New England traders found India fascinating, exotic, and incomprehensible. In 1833 Captain Joseph Webb donated a pair of hooks, which he described in the society's catalogue, "for the purpose of transfixing and suspending the natives before the public to recover their Caste when lost by some misdemeanor or for penance. In 1832 these identical hooks were inserted in the flesh below the ribs, and the individual hoisted . . . as witnessed by the donor." This was their way of showing devotion and regaining their place in society. By 1830, painted and clothed models of Indians of various castes, sects, and occupations, made in or near Calcutta, began to appear in the collection: a set of six life-size models were donated by James B. Briggs before 1831, and a set of twenty-one smaller models were given by Captain Samuel Barton in 1833. A Salem woman, Carolyn King Howard, who frequented the museum during her childhood in the 1830s, recalled in her book *When I Lived in Salem:* "From the moment I set my foot in that beautiful old hall, and was greeted by the solemn group of Orientals . . . that circle of sitting and standing figures, who were placed in the centre of the hall in those days, became real friends of mine. Three of them were life-sized likenesses of East Indian merchants, in their own dresses . . . I learned to know their dark faces well, and Mr. Blue Gown, and Mr. Camel's Hair Scarf and Mr. Queer Cap, each had his own pleasant individuality and must be greeted whenever I went to the Museum. . . . There was an Eastern flavor in Salem then."

SUSAN S. BEAN
Curator of Ethnology, Peabody Museum, Salem, Massachusetts

India: A Festival of Science

Science and technology are nothing new to India; they have been an integral part of the Indian tradition since time immemorial, dating back several millenniums. In fact, until the dawn of the Industrial Revolution, India was always in the forefront as far as contemporary scientific knowledge and its understanding were concerned; not only that, India had made substantial and significant contributions to this knowledge in several areas: astronomy, cosmology, chemistry, mathematics, metallurgy, health and medical services, surgical operations, town planning and architecture, shipbuilding, and more. Among other things, India gave the world the zero, the so-called Arabic numerals, the decimal place value system of counting, and plastic surgery.

The Industrial Revolution of the eighteenth century completely transformed the society, economy, and ways of life of other nations, particularly in the West, while India, fettered by its colonization, fell behind.

India's scientific and industrial reconstruction, as it were, began in earnest only after it gained independence. As a matter of policy, the country is committed to harnessing science and technology for its all-around development. In its efforts, the achievement of self-reliance has been all along a major objective. While much remains to be done, in the four decades since independence India has come a long way, making giant strides in a wide variety of areas. In food and agriculture: India has achieved self-sufficiency in food despite a continually rising population, now at 700 million; in health and family planning: life expectancy has risen from around thirty to fifty-four years; in providing energy from conventional and nonconventional sources; in transport and communications; in education; in scientific and industrial research: India has a highly developed infrastructure for scientific education and research, is a top supplier of trained science and technology manpower worldwide (scientists, technologists, and doctors), is among the top pioneer nations in sea-bed mining, and was among the first few to set up a station in Antarctica; in small-scale, light, and heavy industries: India is a pioneer in small-scale industries and their appropriate technologies, as well as in rural development. In fact, India is among the top ten industrial powers, and a member of both the "nuclear club" (without weapons) and the "space club" (without ICBMs or IRBMs).

The exhibition "India: A Festival of Science," inaugurated at the Museum of Science and Industry in Chicago, conceptually weaves together three interlinked sec-

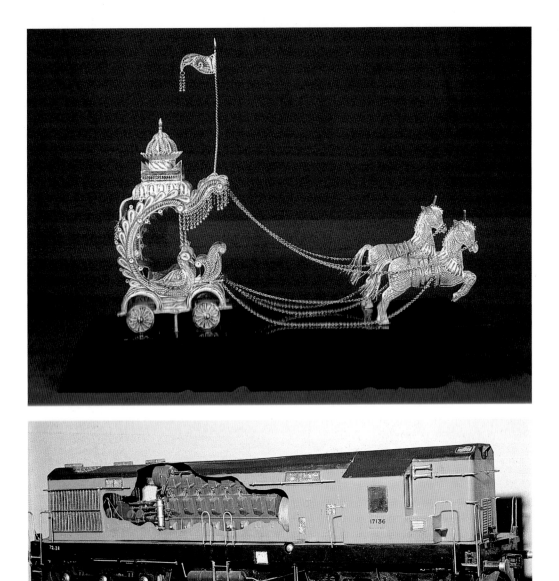

Above: A chariot made of silver filigree. This will be shown along with the tools and techniques of silver filigree work in a live demonstration

Below: A metal working model of the engine of a diesel electric locomotive developed in India for the Indian Railways, which has the fourth-largest network in the world

tions, on: 1) the evolution of scientific concepts and theories; 2) the evolution of tools, techniques, and technologies in a wide variety of areas, from arts and crafts to metals and metallurgy; 3) the face of modern India, which depicts some of the post-independence efforts and achievements in solving the major problems facing India.

The exhibition, along with its associated programs and activities, attempts to make Americans aware of aspects of India that they may not ordinarily encounter. Beyond that, it hopes to communicate some of the vibrancy, the ferment, the struggles, the triumphs, the tribulations, and the joys that are so characteristic of life and living in India.

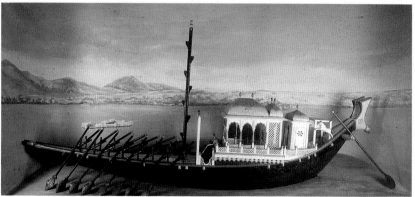

Above: Surgical instruments re-created from descriptions of Susruta (c. 1st century A.D.)

Below: Model of an Indian raja's state barge, a royal luxury boat used to ply the River Hooghly in eastern India and also the rivers of Rajasthan in western India from the 16th to the 19th centuries

Right: An artist's conception of the INSAT spacecraft in the geostationary orbit

Aditi—A Celebration of Life

In this lavish look at life in India through the world of the child, all of the richness and complexity of that culture is revealed. Rites of passage, fairs and festivals, performances and crafts, all drawing on ancient myth, legend, and belief, mark the path of growth. "Aditi—A Celebration of Life," an exhibition held at the Thomas M. Evans Gallery of the National Museum of Natural History, Smithsonian Institution, with two thousand objects, both contemporary and ancient, and forty folk artists from India, illuminates this path and brings the visitor into a direct and palpable understanding of Dr. Kramrisch's observation:

> Art in India, as elsewhere, is the form imposed by the artist on life. In India, more than anywhere, form results from performance. The making of the work of art is a ritual. Its magic is active in the form. By performing the rites of art, the craftsman transforms himself and his substance. Form, performance and transformation are simultaneous, inseparable aspects of Indian art. They inhere its creation and produce their effect in concrete shape. (Dr. Stella Kramrisch, from her essay in the book accompanying the exhibition "Aditi—A Celebration of Life")

The *Rig Veda*, one of the ancient Hindu texts of India, refers to Aditi, the mother of the gods, who is the source, the process, and the stuff of life; who unifies beginnings and endings, man and woman, nature and the gods. Her name denotes the creative power—abundant, joyful, and unbroken—that sustains the universe. The exhibition takes its name from Aditi since it is just such creative power that imbues the world of the child at every stage of the life cycle through India's myriad traditions in rural and ritual arts and performance.

In India, all traditional artists, at one time or another, use their skills not only to make things for children but also to celebrate the many customs and rituals connected with the child. Because of their resilience and beauty, traditional forms of expression are deeply implanted in contemporary Indian life and greatly influence the ideals, values, and experiences of Indian children. Dr. Kramrisch notes in her essay that "all members of a household are visually and magically affected by the ongoing practice of ritual art: it molds their minds, assuages their souls, and gives strength to their hearts."

The concept of the goddess Aditi challenges Western linear thought with the principle of cyclical regeneration. Every ending is a beginning: the death of an indi-

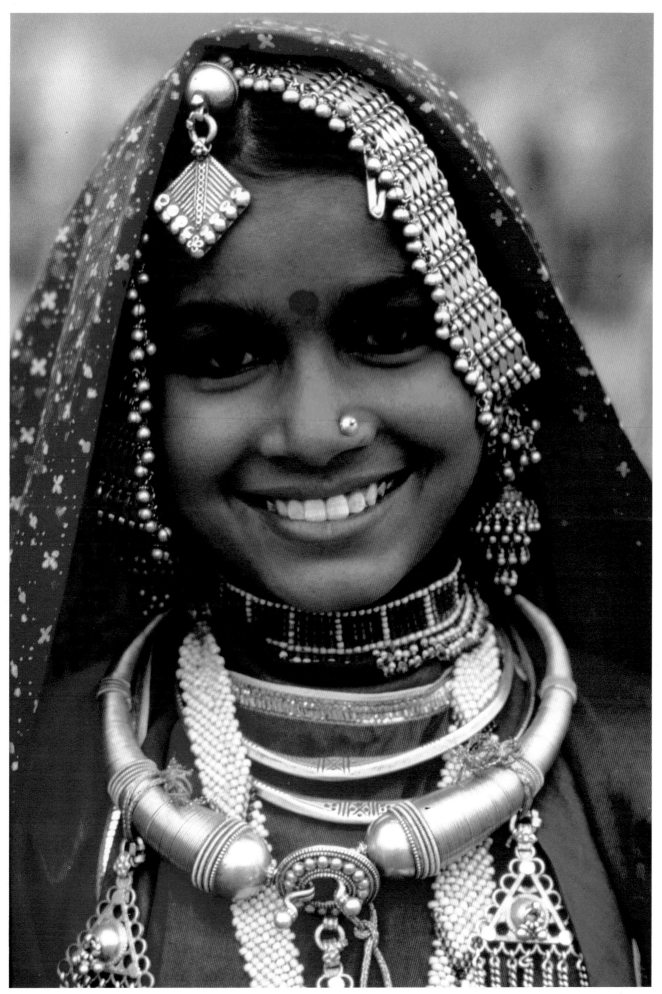

A girl in the traditional dress of Rajasthan

vidual signals his rebirth. This cycle of regeneration is emphasized by the stages of the exhibition. The visitor proceeds through eighteen sections, each concerned with a different aspect of the life cycle: from coming-of-age, courtship, marriage, birth, and a child's learning to participate in the life of the community, to, again, the child's coming-of-age. As Dr. Sudhir Kakar points out in his essay in the *Aditi* book: "The notion of the human life cycle unfolding in a series of stages, with each stage having its unique 'tasks' and moral responsibilities, is an established part of traditional Indian thought. . . . "

Each stage of the exhibition is literally brought to life by the craftsmen and performing artists themselves. The visitor learns, as Dr. Kakar puts it, that the child "is considered nearest to a perfect, divine state, and it is the adult who needs to learn of the child's mode of experiencing the world. . . . that the norms and values of adulthood are not conveyed to the child; . . . they are imparted through a clear set of expectations and in a manner that is highly ritualized."

For instance, in the section concerned with marriage, craftsmen create a corridor of wall paintings depicting a bridegroom's procession. As visitors pass through this area, they are joined by actual dancers and musicians who re-create the ritual of a marriage procession. The section that explores "the promised world" of the child incorporates puppeteers who perform ancient stories with their handcrafted marionettes and craftsmen who fashion an array of toys in grass, cloth, wood, and clay. In another section dealing with the child's initiation into learning, a family of folk balladeers from Rajasthan sing out the story painted on a twenty-foot-long scroll. The performance of a ballad in connection with a story-scroll is a traditional way to familiarize a child with the vast fund of oral tradition that forms the basis for the child's initiation into the adult world.

Throughout the sections of the exhibition, objects and occasions are juxtaposed with the individuals who give them meaning—the dancers, singers, musicians, and puppeteers; the toy-makers, painters, and embroiderers; and the jugglers, magicians, and acrobats of India. Through the centuries, such folk artists have maintained and nurtured innumerable traditions in Indian crafts and performing arts. Here, they conjure up the world of the child, its potential beauty and richness in a society of ancient traditions.

Certain questions are suggested by the exhibition: To what extent will India's traditional craftsmen and performing artists be able to adapt their skills to the demands of a society in transition? To what degree is a child's development linked to his society's traditional culture? According to Rajeev Sethi, the exhibition's curator and designer, "Aditi" seeks to define the folk traditions of India—their beauty and worth to the culture—so that these traditions will receive the attention and respect that can aid in their continued survival.

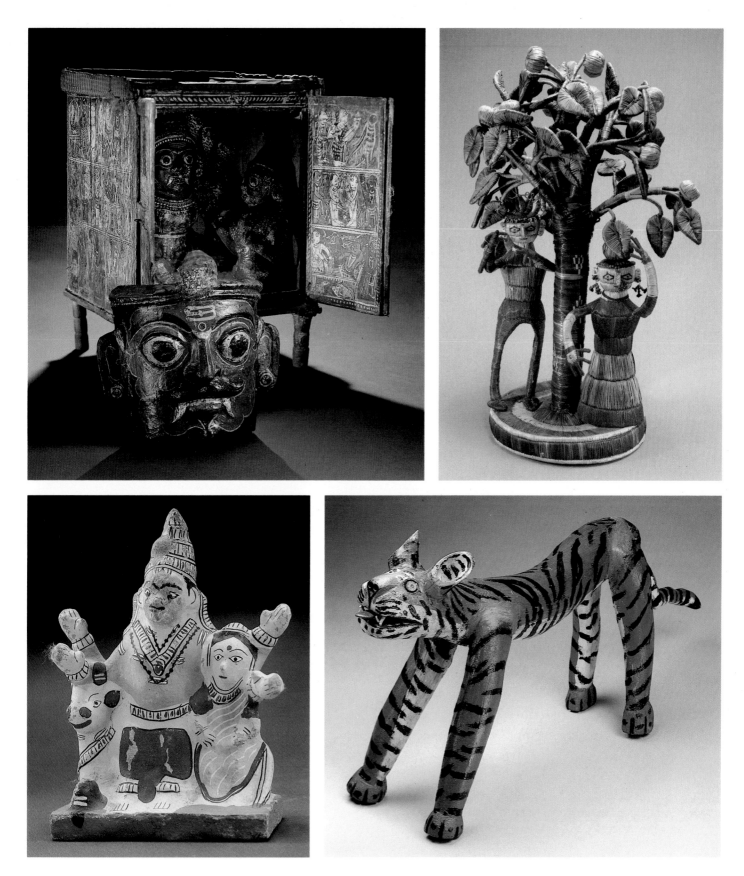

Above, left: A portable Mother Goddess shrine and a mask worn by her priest. Andhra Pradesh, 20th century. Painted wood, 20½ × 16¼″. All India Handicrafts Board, Crafts Museum, New Delhi

Above, right: *The Dalliance of Radha and Krishna Under the Kodam Tree.* Contemporary. Handicrafts and Handlooms Exports Corporation of India, Ltd., New Delhi

Below, left: *Shiva and Parvati with Nandi.* Contemporary. Painted papier-mâché, 7 × 5 × 3″. Handicrafts and Handlooms Exports Corporation of India, Ltd., New Delhi

Below, right: Toy tiger. Nagaland, contemporary. Painted wood, 20½ × 11 × 6″. All India Handicrafts Board, Crafts Museum, New Delhi

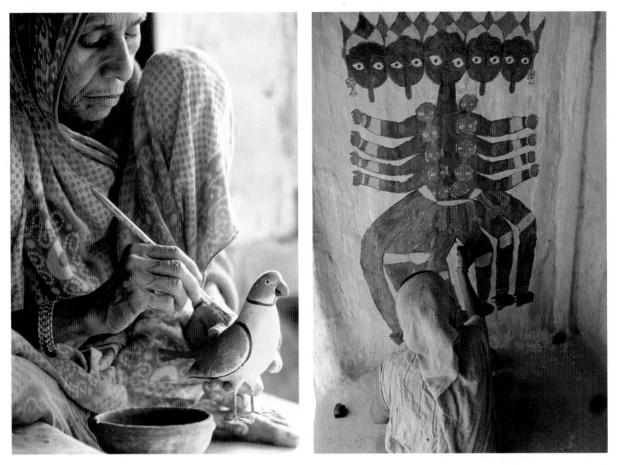

Above, left: Clay toy-maker, Varanasi. The parakeet is a symbol of love and fertility

Above, right: A wall painter from the village of Madhubani in Mithila, whose women are famous for their tradition of wall painting

Below: Masked dancers, Karnataka

Opposite: At Shadipur Depot outside Delhi, Bhopa balladeers Ram Karam, his wife, Gotli Devi, and sons Shish Ram, Kailash, and Harjilal perform before a scroll depicting the story of the Rajput warrior Pabuji

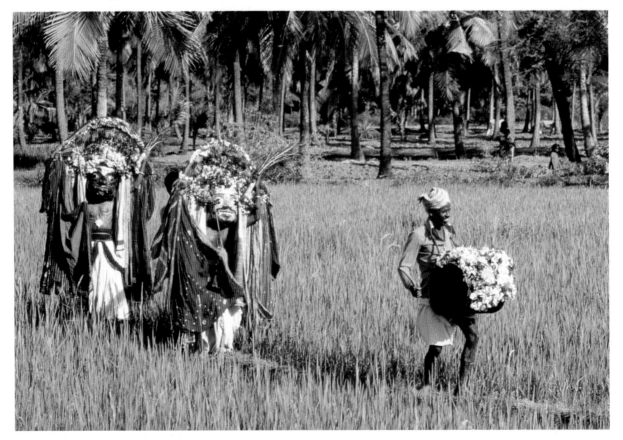

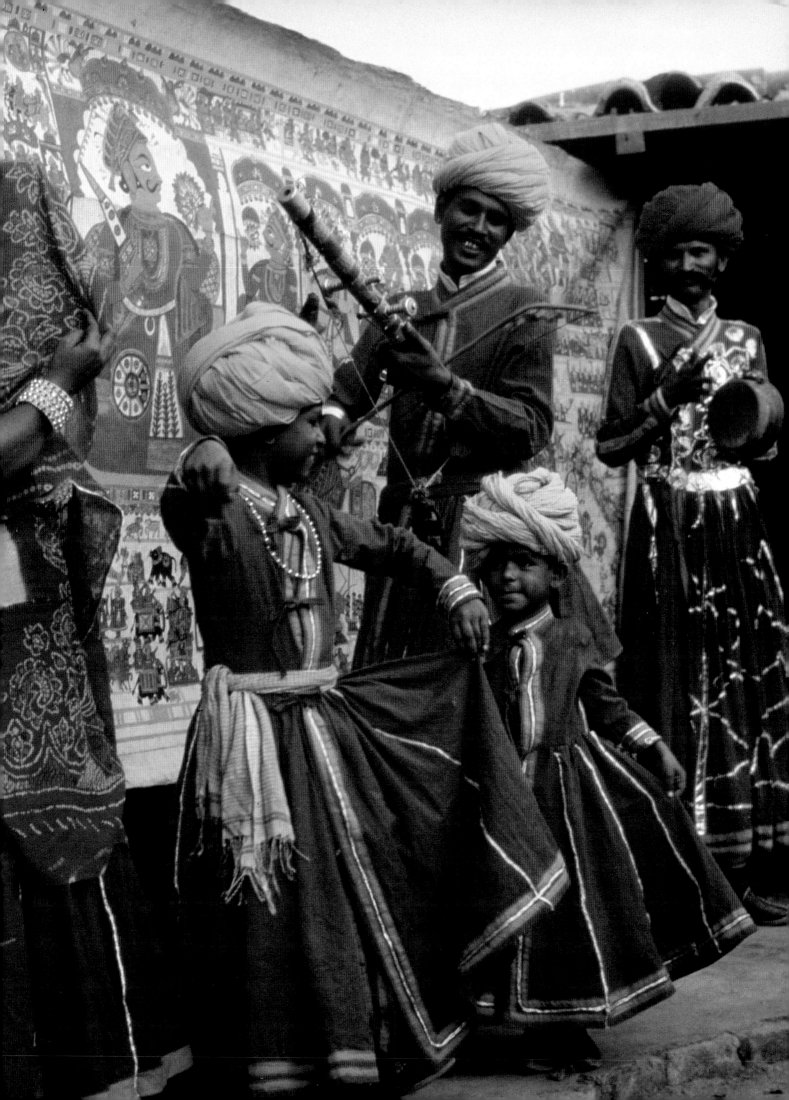

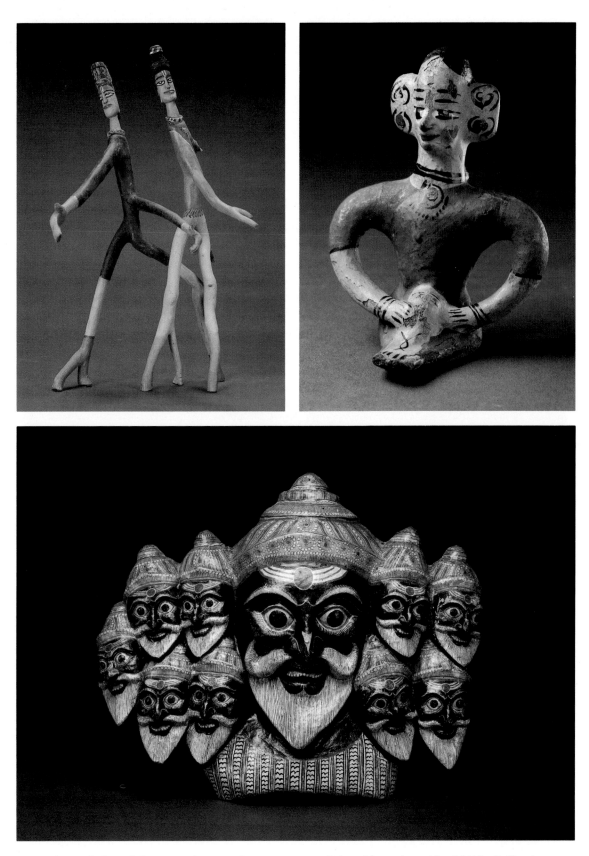

Above, left: *Lakshmana and Rama.* Contemporary. Painted branches, 18 × 10¼". Collection C. L. Bharany, New Delhi. These figures are used as teaching aids to tell the story of the *Ramayana*

Above, right: *Mother Massaging Her Child.* Andhra Pradesh, contemporary. Painted wood, 4⅜ × 3½". All India Handicrafts Board, Crafts Museum, New Delhi

Below: A contemporary ten-headed Ravana mask used in the *Ram-Lila.* All India Handicrafts Board, Crafts Museum, New Delhi

Opposite: The sacred thread ceremony *(upanayana),* a Hindu coming of age ritual, Varanasi

Mela
A Festival Fair of India

The *Mela* on the National Mall in Washington, D.C., presents a composite festival fair, welding together the folk traditions of diverse regions and peoples of India. Combining the skills and talents of sixty folk artists, craftspeople, and performers from India and the Indian-American community in the United States with handicraft displays, vendors, delectable food, and a learning center, the *Mela* presents visitors with a rich and multiform sensory experience of a long-lived vibrant culture.

As part of the Festival of American Folklife, the *Mela* is an event, not a staged performance nor a static exhibit. It lives and grows on the interaction of folk artists and the more than one million visitors to the mall. And, as such, it relies on traditional, experiential means to convey knowledge about the folkways of another culture.

The *Mela* is based upon the Indian concept of *utsav-mela*, the notion that the traditional fair is experienced as a sensory manifestation of a religious, cosmological, or social festival. Fairs in India celebrate the divine feats of gods such as Krishna and goddesses such as Durga, or the enlightenment and accomplishments of Hindu sages, Muslim saints, or Sikh gurus, or the exploits of historical or mythological heroes such as Rama or heroines such as Sita, or express thanksgiving for a successfully harvested crop. Ritual activities form the core of such celebrations. Religious icons may be constructed by Hindus and worshiped. Figurines may be taken on dramatic processions followed by millions of devotees. And crafted images and models, such as *taziya*, the tomb-replicas of martyred Muslim heroes, may be buried, deposited in a river, or, as is the case with the demonic Ravana statues constructed for *Ram-Lila*, set afire and exploded.

Compressing the Indian calendar, albeit selectively, the *Mela* seeks to re-create and demonstrate some of these ritual activities, in an effort to expose visitors to the moral, spiritual, and social values that underlie Indian culture.

As suggested by the Indian concept, along with the ritual activities associated with a particular festival come the sensory delights of the fair. Fairs in India occur relatively frequently, and bring together the young and the old from different villages and regions. The times and sites of fairs are often marked by astrological auspiciousness and geographical convergences. Most local fairs are quite small, but some, such as the Kumbha *melas*, may attract as many as ten million people, making them the largest gathering on Earth.

Smithsonian Institution, Washington, D.C.

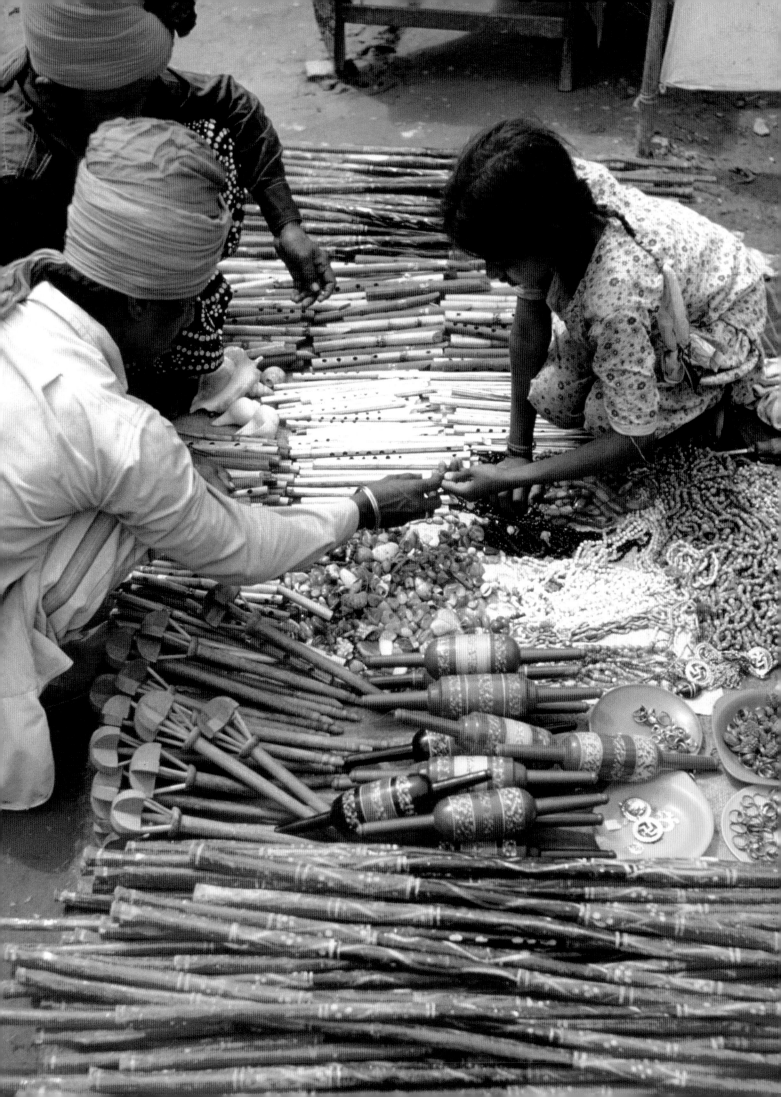

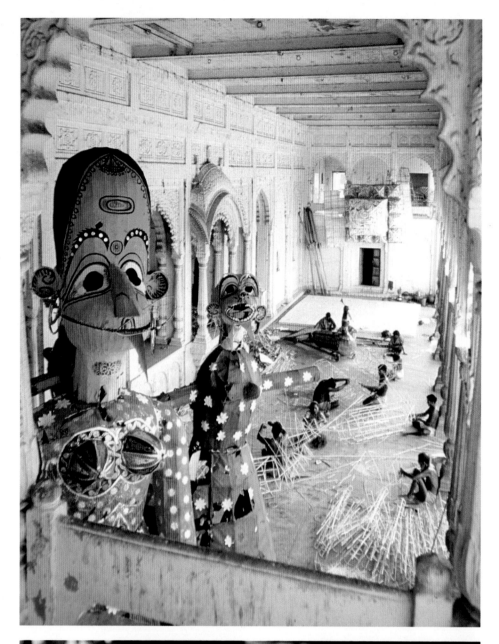

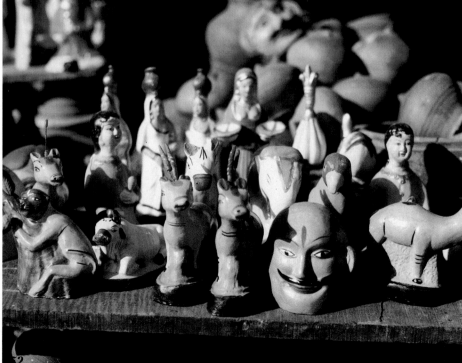

Above: Preparing cane and paper effigies for a sacred dance drama, *Ram-Lila*, to be performed at an annual festival, New Delhi

Below: Terracotta toys for sale at a *mela*, or fair, in Lucknow

Preceding page: Flute and gourd flute seller at a country fair, Kaila, Rajasthan

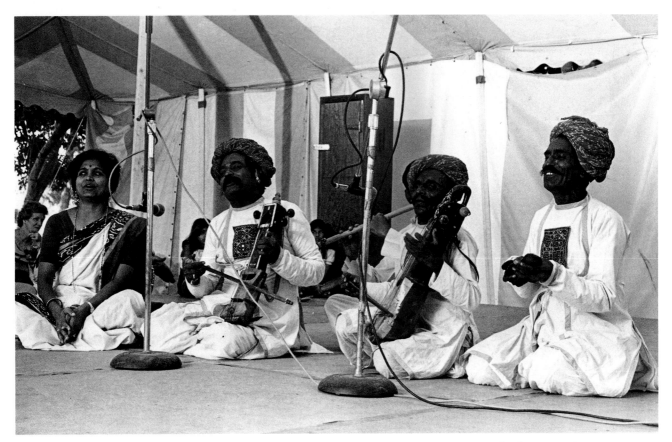

Indian performers at the 1976 Festival of American Folklife. The 1985 Festival of American Folklife will fill the National Mall in Washington, D.C., with the sights, sounds, tastes, and smells of an Indian *mela*

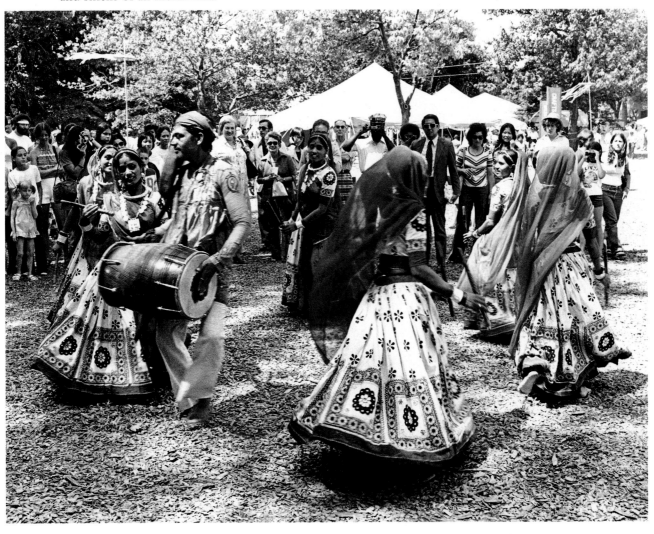

Mil, the root term for *mela*, refers to meeting and mixing. And, indeed, the Indian *mela* allows for people of different backgrounds to come together and join in a common sensory experience. All Indian fairs incorporate the sounds, fragrances, tastes, sights, and forms of that culture.

The *Mela* on the National Mall is no exception. Drawing visitors from all over the United States, as well as those from other countries, the *Mela* brings together diverse people to meet and share in the sensations of traditional India. Festival visitors are greeted by the rousing drums of India, the sensual joy of harvest-celebrating folk dances, and the songs celebrating exemplary human and godly exploits. Flowers, incense, and spices impart to visitors the fragrances and scents of India. A variety of foods, snacks, sweets, and beverages from different regions of India provide authentic tastes and convey a feeling of its foodways.

Indian fairs also provide children with an adventure in learning—something that is also captured in the *Mela* on the mall. Americans watching Indian acrobats and jugglers are entertained, and also educated. For it is in the movement of the street- and *mela*-performing acrobats that the knowledge of the ancient poses of yoga are retained and transmitted. And it is in the movement of the juggler that the dance of the monkey-god Hanuman is reenacted. The *Mela* also includes magicians and impersonators to challenge the eye of visitors and test their understanding of the natural and social world.

Various activities in the *Mela* encourage visitors to learn by participating in Indian culture. American children and their parents are encouraged to join in folk dancing, try their hand at the ephemeral village art of floor painting, or have their palms dyed with the celebratory designs of henna. On the mall, as in India, the *Mela* serves as a vehicle for learning about the wider world, meeting different people, and being exposed to new and, at the same time, traditional skills.

No Indian fair is complete without its jostling crowds, makeshift stalls, sinuous lanes, and roaming vendors. The culture of commerce, and the intensity it generates, pervades the Indian fair. On the National Mall, a host of handcrafted items are displayed, discussed, and sold as part of the *Mela*. Appropriately, many of these items are toys. Wooden toys, clay toys, pith toys, grass toys, and others are made by craftsmen demonstrating their uncanny ability to take common materials and mold them to the enjoyment of their child constituents. Kites, miniatures, trinkets, and bangles, among other items, also provide for the bazaar-like environment of the *Mela*.

The *Mela* brings to life in an organic way a personal experience of Indian folklife on a scale never before seen in the United States. The creation of an empathetic understanding of Indian folk traditions is approached, in the *Mela*, through both the mind and its senses. The aromas of Indian snacks, the sounds of minstrels, the forms of icons and images—indeed, the ambience of *Mela* as a whole provides Americans with an experience that is at once informative and enjoyable, and at the same time conveys the richness, vitality, and worth of Indian folk artists and their traditions.

The Women Painters of Mithila

North of the Ganges River in the state of Bihar lies a land of ancient and quiet loveliness, shaded by old mango groves and watered by the restless meltwater rivers of Nepal and the Himalayas. In this land, known since ancient times as Mithila, a unique and conservative culture flourishes, dominated by the Maithil Brahmans and Kshatriyas. The men of these two communities are famous as priests and scholars. Their women, though largely illiterate, find cultural expression through exquisite paintings created for ritual occasions, when they cover their courtyard walls in brilliant images and create abstract designs in rice powder on the floor, resembling in form and function the sand paintings of the Navahos. Some of the abstract line drawings on paper are adaptations of these floor paintings. The twenty pieces in the Visual Arts Resources exhibition were collected by art historian Betty LaDuke, in 1980 and by myself during the course of anthropological field studies in 1980 and 1984.

It is a mild irony in Mithila that the fame of the women has surpassed that of the men, for Mithila art is now known throughout the world. In the 1960s, a few local officials realized that if the women would only put some of their paintings on paper as well as on their walls, there might be a worldwide market for their creations. They proved to be correct. On my last trip to Mithila, as I sat in steamy compounds during the monsoons, women proudly showed me tattered copybooks with the scrawled names and addresses of collectors from Germany, England, Japan, France, and the United States. These brief visits have been very welcome, the purchases partly alleviating the severe poverty for some families in this economically depressed part of the country.

The art of Mithila is closely linked to religious observances, particularly marriage. Harmony between man and nature is maintained by the ritual services of the Brahman priests performing their ancient Vedic rites. Interspersed with the Brahman-controlled rites is a related tradition controlled by the women of Mithila and largely devoted to female deities such as Gauri, Durga, and Kali. A Maithil Brahman wedding is a synthesis of rituals: a priest chants the Sanskritic portion of the ceremony; but these priestly actions are punctuated by ceremonial interludes when the women pull the bride and groom away for their own ceremonies before their goddess Gauri in which men other than the groom are forbidden. Gauri is the goddess to whom the bride has prayed since girlhood to bring her a good husband. The groom himself is evidence of the goddess's power to fulfill these prayers.

Visual Arts Resources, University of Oregon

The function of the paintings being ritualistic, the art is all highly symbolic. The primordial energy of the universe (*shakti*) is embodied in the various female forms of God, as well as in living human women, and both goddesses and women are favorite themes in Mithila art. The *Snake Goddess* is one of the forms of snakes worshiped during the festival of Nag Panchami every year during the monsoons, when snakes are prevalent. In the photograph, a Kayastha widow stands before her painting of the Goddess Durga astride her tiger, painted for the marriage of her fifteen-year-old daughter. In the paintings, we also find human women, mothers of future generations, depicted in various phases of their marriage ceremonies (*Bride and Groom's Ride*).

The teeming life beneath the still surfaces of Mithila's ubiquitous ponds symbolizes the creative power of Mithila's sequestered women. Because a single seed dropped in the pond produces many lotuses, it is a worthy symbol for the bride and groom to ponder at their wedding (*Duragoman Puren*). Another major symbol at marriage is the bamboo, which represents the lineage of the groom (*Bansa*). The symbol is based on the similarity of the two words *bansa* (bamboo) and *baansa* (lineage), both a cluster of tall trunks produced from a single knot of root. The pots, insects, snakes, sun, moon, leaves, elephants, and other more abstract designs all have a meaning, some of it Tantric in origin.

Perhaps the most powerful of the symbolic drawings is the *Kohbar*. Every Mithila family compound is composed of four huts set in a rectangle around a central courtyard. One of these houses, the *kohbara ghar*, exists solely for the marriage of daughters of the household; here, for the four nights of her marriage ceremonies, she and her new husband (whom she has not yet seen) perform certain rites under the supervision of the women. The *Kohbar* is the design that must go on the walls of that hut.

My first visit to the *kohbara ghar*, early in my work in Mithila, was on a trip to several villages a few miles west of Madhubani in order to meet some of the women who were producing Mithila art commercially. The poverty of the village hardly prepared me for the splendor that greeted me as I ducked into the thatched mud hut of my first *kohbara ghar*. I stepped into a world of pale geometrical fantasy, every wall covered with exquisite white patterning on the beige mud surfaces of the hut. The only light coming through a single unframed window of vertical bamboo bars added an incongruous sense of imprisonment or protected isolation, which intensified the fantastical quality of the small room. I have seen many *kohbara ghars* since then, but never such a spectacular example of *kohbara ghar* art. Nevertheless, at the marriage of a daughter, every *kohbara ghar* will invariably be painted with this and other symbolic designs (*Bansa*), their aesthetic quality dependent upon the talents of the older women of the household. As this collection shows, some of these women have a masterful sense of design, the pieces expressing the "grace" achieved in unifying inner harmony and external form.

CAROLYN HENNING BROWN
Assistant Professor of Anthropology, Whitman College, Walla Walla, Washington

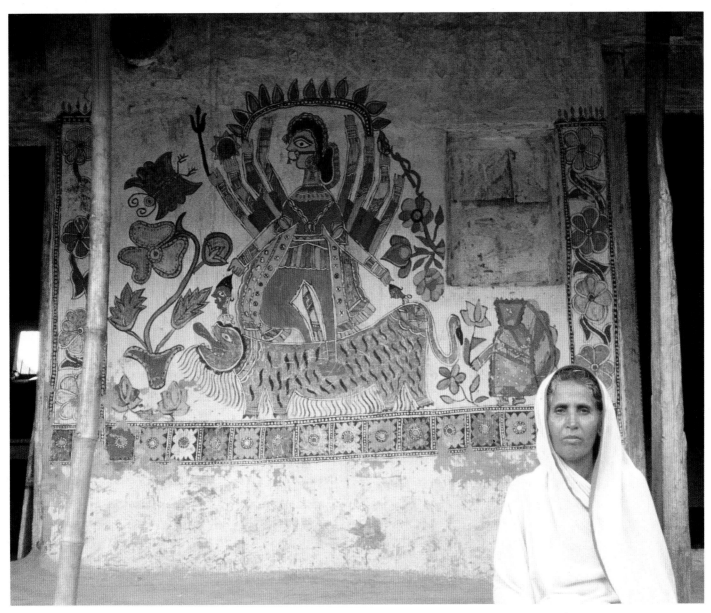

A woman painter of Mithila stands in front of one of her paintings

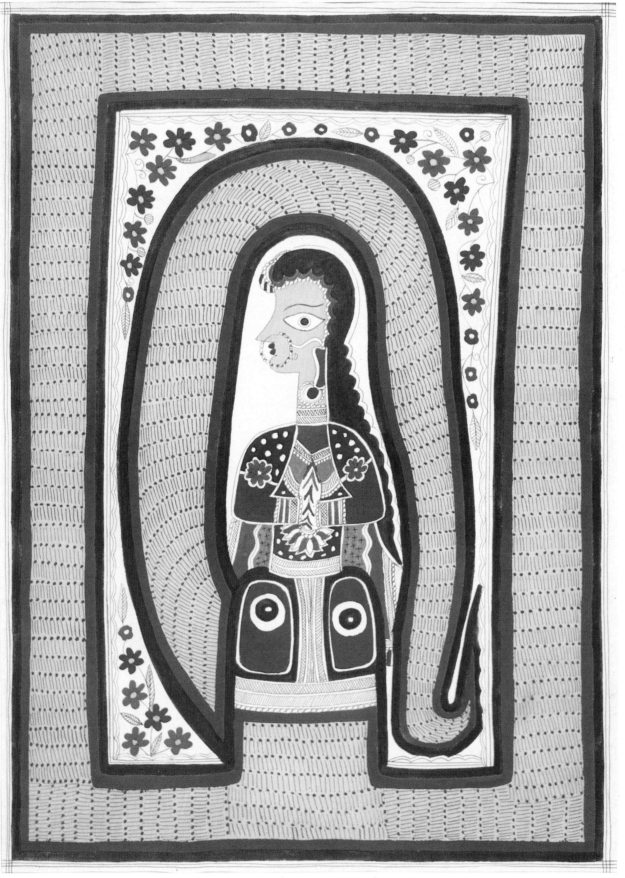

Brea Devi. *Snake Goddess.* 37 × 29″. Collection Betty La Duke

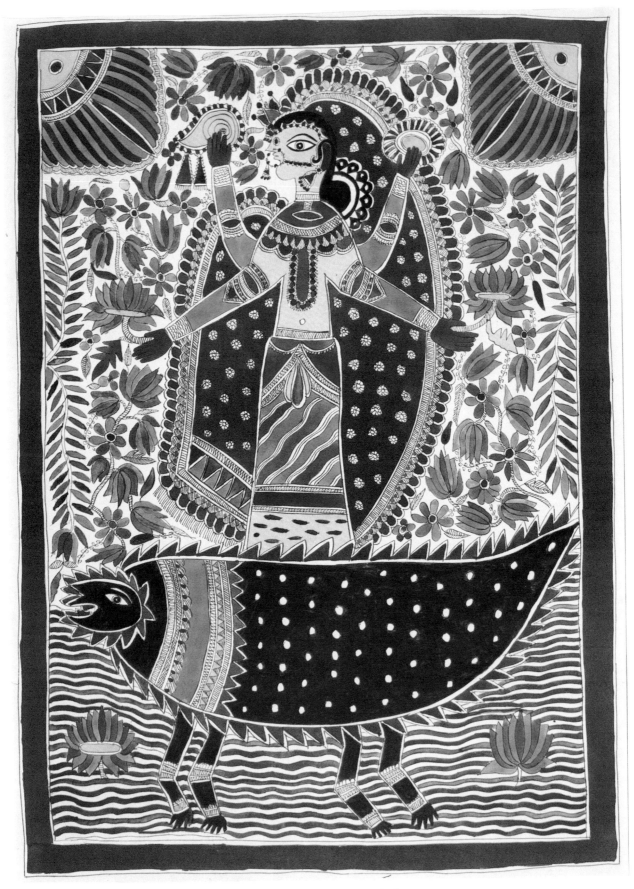

Santi Devi. *Water Goddess*. 37 × 29″. Collection Betty La Duke

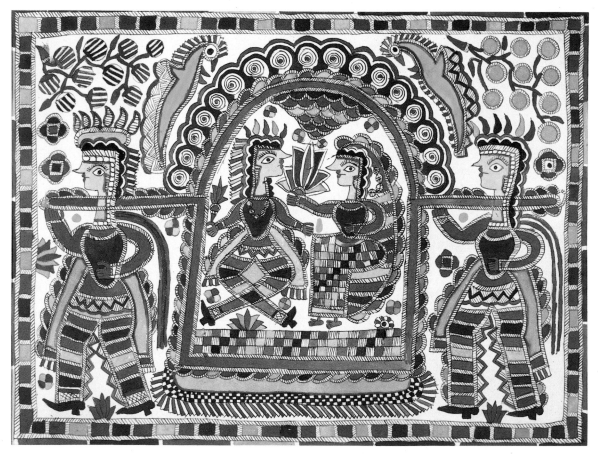

Above: *Bride and Groom's Ride*. Ink and tempera, 29 × 37″. Collection Carolyn Henning Brown

Below: *Bansa (Bamboo)*. Ink, 29 × 37″. Collection Carolyn Henning Brown

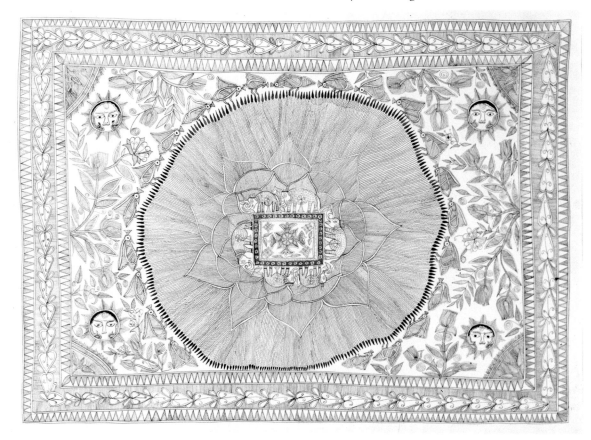

160

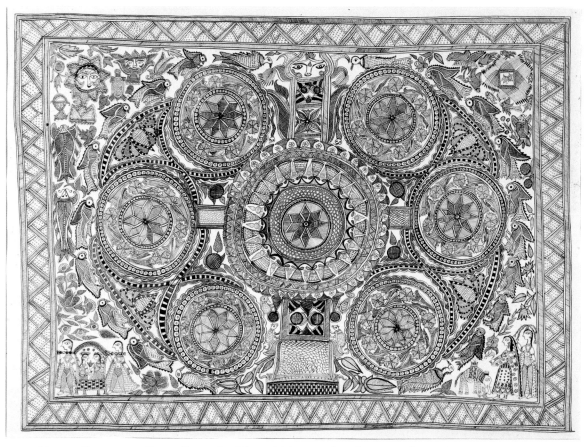

Above: *Duragoman Puren (Lotus for "Second Marriage")*. Ink, 29 × 37″. Collection Carolyn Henning Brown

Below: Bua Devi. *Tiger Gods and Rats.* 29 × 37″. Collection Betty La Duke

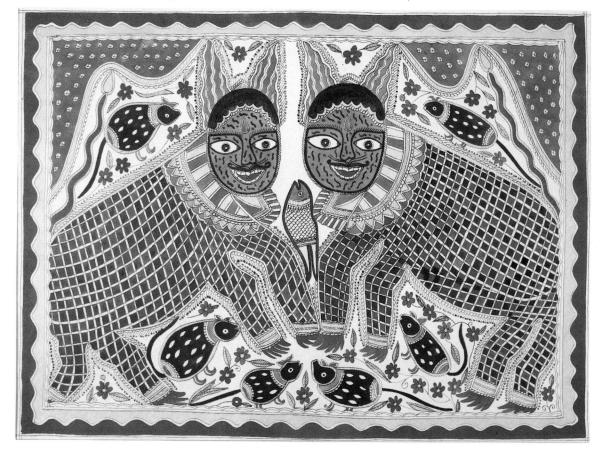

New Tantra
Contemporary Indian Art Inspired by Tradition

The exhibition "New Tantra: Contemporary Indian Art Inspired by Tradition," at the Wight Art Gallery, University of California, Los Angeles, is the first major North American showing of a significant and unusual strain in contemporary art. The inspiration of traditional Tantric art and philosophy has provided some of India's most talented artists with a natural point of entry into the world of graphic and conceptual abstraction. "New Tantra" will show the work of eight outstanding painters whose works have in common a sophisticated treatment of Tantric themes.

The painters selected for "New Tantra" exhibit diverse approaches to composition, technique, degree and types of abstraction, and iconography. As distinct from traditional Tantric art—which still flourishes in many parts of India and elsewhere—this diversity strongly reflects the personal style and philosophy, in addition to the regional or doctrinal origins, of the artist. Unlike the practitioners of traditional Tantric art, the artists of "New Tantra" are also responsive to a broad range of stimuli from outside India, including international movements in contemporary art.

Some of the highly gifted modern Indian artists, whose recent artistic creations define the scope of New Tantric art, are also concerned with those very principles that inspired the pioneers of abstract art. For example, these Indian artists also believe in the same set of axioms: positive and negative, crucial for cosmic and artistic creations, are complementary rather than contradictory; the symbolism of positive and negative or male or female principle represented by a triangle facing up or down; the theory of chaos versus cosmos, awakening of the manifested energy in the form of the flux of light; the hierarchical symbolism of square and circle; *bindu* as a cosmic point of reference; oval, the egg shape, as a symbol of Brahmanda; and the role of primordial sound—which creates light and which in turn produces color—in the creation of cosmos. However, since these artists are impelled by Tantric sensual, philosophical, and spiritual embodiments rather than those of Upanishadic ideas, they have given different interpretations to these very elements to achieve visual and aesthetic results quite distinct from those achieved by the pioneers of abstract art. It is also significant that just as traditional Tantric art was created by using images and their residues as well as totally abstract elements such as the square, circle, triangle, and oval shapes, so also contemporary Indian artists are using both image and abstraction in their work. Some incorporate visual images and their fragments or in-

vent new combinations by transforming the basic figurative forms of the human body and/or natural elements according to their conceptual vision; others favor purely abstract forms.

Although the distinctions are difficult to make, those artists in this exhibition who align themselves more with figurative images and their residues, and transformed them or created new combinations, are K. C. S. Panikar, P. T. Reddy, and G. R. Santosh. Also included in the exhibition are works by Biren De, K. V. Haridasan, Mahirwan Mamtani, Prafulla Mohanti, and Om Prakash, all of whom are more concerned with a purely abstract or geometric imagery.

It is evident that the Indian artists of New Tantra are impelled and motivated by their inner convictions to derive inspiration from Indian sources, creating such works of art that could at least denote some affinities with the salient aspects of Indian traditions, culture, and Tantra and its theoretical and aesthetic variations, along with their subtleties and nuances. Doubtless, they are now realizing that until they successfully transform various stimuli received from foreign and indigenous sources into their own vocabulary, giving it a distinct indigenous flavor, they cannot evolve their personal creative vision, often responsible for the emergence of an original style. The use of sensual lush colors—not only implying some sort of esoteric symbolism but also emphasizing the relationship of sounds and colors—in collaboration with hieratic images or their residues, geometric and organic forms, and the flux of light contribute to a heightened sense of design and sharpen their aesthetic aspirations. This in turn is firmly supported by technique, which under any circumstances should not be allowed to subdue spontaneity, initial vibrations, or creative vision.

Dr. L. P. Sihare
Director, National Museum, India

Dr. Edith A. Tonnelli
Director, Wight Art Gallery, UCLA

G. R. Santosh (b. 1929). *Painting*. 1982. Oil on canvas, 79¾ × 60″. National Gallery of Modern Art, New Delhi

Biren De (b. 1926). *June '70*. 1970. Oil on canvas, 72 × 48″. National Gallery of Modern Art, New Delhi

K. C. S. Paniker (1911–1977). *Picture in Gold*. 1969. Oil on board, 48¼ × 83″. National Gallery of Modern Art, New Delhi

K. C. S. Paniker (1911–1977). *Words and Symbols*. 1965. Oil on canvas, 47 ¾ × 59 ½ ". National Gallery of Modern Art, New Delhi

Opposite: Prafulla Mohanti (b. 1936). *Surya*. 1980. Watercolor, ink, and gouache, 30 × 22″. National Gallery of Modern Art, New Delhi

K. V. Haridasan (b. 1938). *Brahmasutra*. 1974. Acrylic on canvas, 39 × 39″. Lalit Kala Akademi, New Delhi

Om Prakash (b. 1932). *Intensified Direction*. 1972. Oil on canvas, 72 1/4 × 44 ″. National Gallery of Modern Art, New Delhi

Contemporary Indian Painting

from the Mr. and Mrs. Chester Herwitz Family Collection

The exhibition will include approximately seventy-five works by eight artists representing the most important art centers in India today. By focusing on a small group of artists, the exhibition will attempt to provide a number of in-depth portrayals of the artistic production seen in the studios of Bombay, New Delhi, Calcutta, and Ahmedabad.

Artists will include M. F. Husain, Bikash, Battacharjee, Raza, Vinod Dave, Tyeb Mehta, Rambir Kaleka, and Gieve Patel. The styles of these artists range from the most lyrically delicate evocations of Indian mythic traditional imagery to pungent mixed-media treatments of socially charged material.

Thomas W. Sokolowski
Director, Grey Art Gallery and Study Center, New York University

Opposite, above: Anapum Sud. *Untitled*. 1980. Etching, 20 × 26″

Opposite, below: Anapum Sud. *Biography of a Crime*. Etching, 20 × 26″

Grey Art Gallery and Study Center, New York University

Raza. *Rajasthan II*. Acrylic on canvas, 68 × 68″

Opposite: Vinod Dave. *Untitled*. 1984. Mixed mediums, 14 × 11″

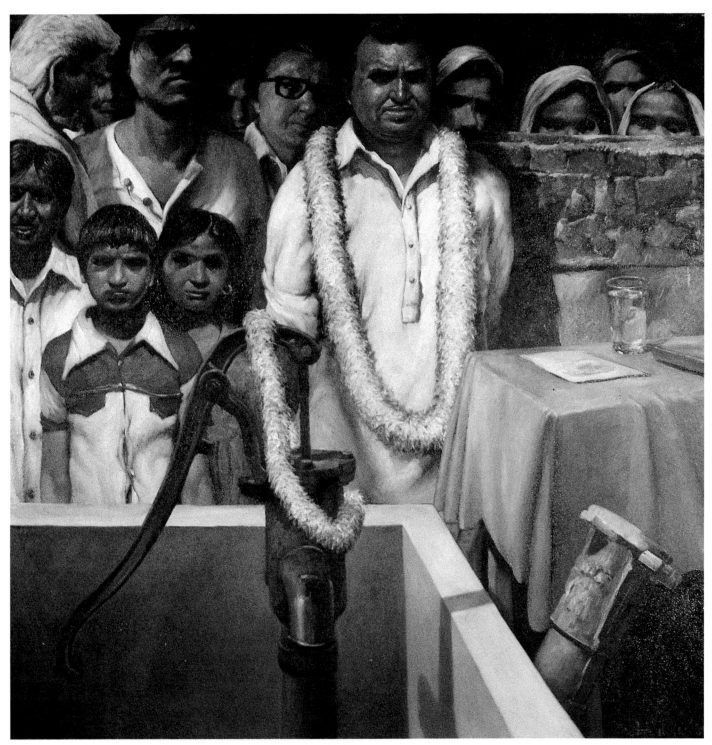

Bikash. *Inauguration of a Tubewell*. 1983. Oil on canvas, 48 × 48″

Opposite: M. F. Husain. *Untitled*. 1983. Acrylic on canvas, 69 × 36″

The Master Weavers

The exhibition "The Master Weavers" is a result of the concerted effort by the Indian government to revive the traditional skills of handloom weavers and to improve the quality of Indian textiles, which had deteriorated over the years since the advent of the power loom led to mass production. The textile industry in India provides an enormous politico-economic base, second only to agriculture. The sheer volume—over ten million handloom weavers and three hundred and ten million meters of cloth a year—is astonishing. The aim of the industry is to provide the clothing needs of a very large nation. The Development Commission for Handlooms in New Delhi set out to determine what the quality handmade textile can do that the industry cannot and to determine who the master weavers really are.

This exhibition of approximately one hundred textiles shows us who the master weavers are through the glorious examples presented. The exhibition is arranged in areas of technique, beginning with block-printed and painted fabrics. This includes those fabrics that incorporate any form of drawing, painting, or filling in of areas with a mordant, resist, or dye, with or without block printing, as well as block printing and *roghan* (tinsel) work. In this section are silk and cotton spreads and scarves, prayer mats and temple hangings.

Embroideries of northwestern India are exemplified by the *phulkari* (flower-form) embroidery traditionally done on skirts and blouses, and the *rumal*, a square kerchief fashioned by ladies of the court as covers to wrap royal wedding gifts. The resist-dye techniques traditionally known in India are: *ikat*, the yarn-resist technique by which the warp or weft or both can be tie-dyed in such a way that when woven the "programmed" pattern appears in the finished fabric; and *bandhej*, a technique that includes tie-resist and wrap-resist dyeing. In this section are the bold and varied single-*ikats* of Orissa, the double-*ikat* geometric and floral silk fabric of Patan in Gujarat, and the dramatic, geometric double-*ikats* of Andhra.

Included in the exhibition are brocaded textiles of two broad classes: one encompasses cotton, silk, and mixed brocades; the second, *zari* brocades, have gold and silver threads used as weft or warp to create glittering raised ornamentation.

The most familiar Indian textile to Westerners is the *sari*, unstitched lengths of fabric draped around the body to form the main garment in traditional India. Although these garments are not stitched, they are "structured," being draped in various conventional and ceremonial ways. Examples in the exhibition show the variety of designs, textures, techniques, materials, and weaves that are employed in the *sari*.

EILEEN ROSE
Associate Director for Program, SITES, Washington, D.C.

SITES/Smithsonian Institution Traveling Exhibition Service, Washington, D.C.

Silk hanging. Developed by Weavers' Service Centre, Bombay, Maharashtra. Block-printed and dye-painted *Tree of Life*, of Golkonda, 11′ 1⅞″ × 8′ 3¼″ (340 × 252 cm)

A stylized tree rises from a rockery of colorful flowering plants. Its numerous flowers, of many stylistic origins, are printed and painted in shades of red, pink, and blue. The ground is the natural off-white of the silk. Over 400 blocks have been used.

Silk spread. Developed by Weavers' Service Centre, Delhi and Bombay, Maharashtra. Block-printed, 10′ 3¼″ × 8′ 5⅛″ (313 × 257 cm)

A fine pattern of the fragmented wave with lotus and fish give a texture to the silk ground of the spread. One hundred and fifteen different flowers, drawn from the Mughal and Rajasthani traditions of miniature paintings and textiles, have been speckled with gold. The clarity of line and, technically, the wide range of dyes within a small area are particularly noteworthy.

Opposite: Cotton prayer mat. Printed by Sundar Raj, Vegetable Kalamkari Centre, Polavaram, Andhra Pradesh; J. K. Reddaiah, Weavers' Service Centre, Hyderabad, Andhra Pradesh. Dye-painted, block- and screen-printed, of Machilipatnam, 12′ 11⅞″ × 19′ 4⅝″ (213 × 590 cm)

This rectangular textile is divided into 105 small compartments by finely printed decorative scrolls, each with a cusped arch. Each arch holds within it the name of God, *Allah*, screen-printed in gold, the bold characters showing two alternative calligraphic styles.

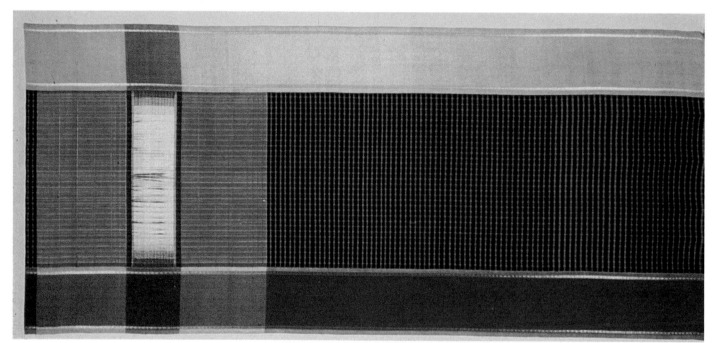

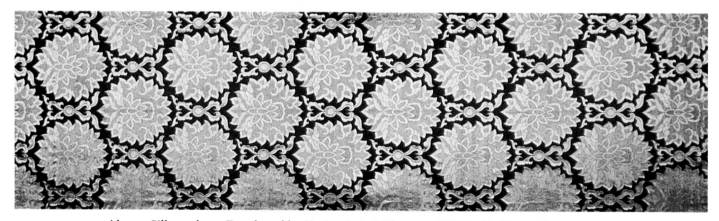

Above: Silk yardage. Developed by Kasim Arts, Udhopura, Pili Kothi, Varanasi, Uttar Pradesh. Brocade, *gyasar*, of Varanasi, 98⅜ × 28⅜″ (250 × 72 cm)

Gyasar, a Tibetan term, is used in Varanasi for a heavy satin silk and gold brocade with Buddhist motifs. It was originally exported to Tibet and China to be used in Buddhist monasteries and ceremonials. It was also part of the pilgrim trade to Sarnath. The pattern of this brocade is reminiscent of the Chinese flaming cloud. However, it is commonly referred to as the marigold pattern.

Center: Cotton *sari* with silk borders and *pallav*. Developed by Weavers' Service Centre, Kanchipuram, Tamil Nadu. Brocade, of Kanchipuram, 17′ 10⅛ × 3′ 10⅞″ (544 × 119 cm)

Below: Silk yardage. Developed by Kasim Arts, Udhopura, Pili Kothi, Varanasi, Uttar Pradesh. Brocade, *gyasar*, of Varanasi, 98⅜ × 28⅜″ (250 × 72 cm)

A stylized gold flower medallion in regular repeats is known as the *rusnata* or the Russian motif.

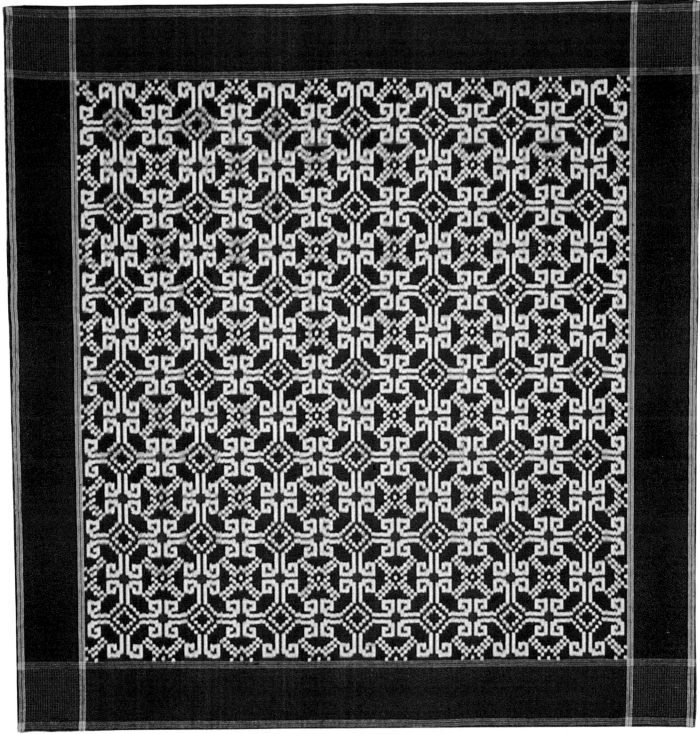

Cotton spread. Woven by G. Govardhan, Weavers' Service Centre, Hyderabad, Andhra Pradesh. *Ikat, telia rumal,* of Puttapaka, 81½ × 73¼″ (207 × 186 cm)

A 7-inch madder border frames a central field of an uninterrupted geometric pattern in deep madder, white, and black squares, diamonds, crosses, and diagonal checks. This spread is dyed in vegetable colors.

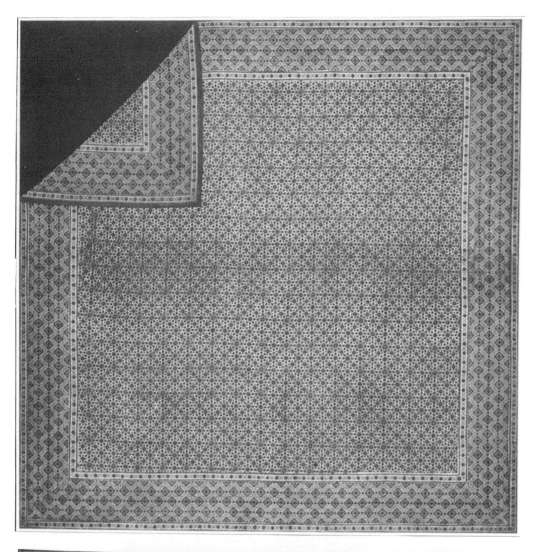

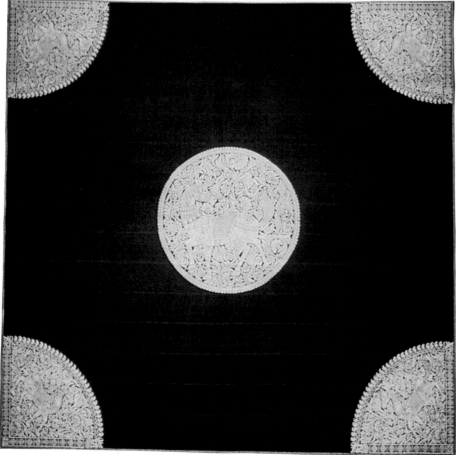

Above: Cotton spread. Printed by
Khatri Mamad Siddik, Dhamadka,
Kutch, Gujarat. Resist-printed,
ajrakh, of Dhamadka, 70⅞ × 70⅞″
(180 × 180 cm)

The border and field of this spread are
printed in traditional designs of floral and
geometric patterns. Most of these are de-
rived from *ajrakh*, a class of Islamic tex-
tiles from Kutch and Sind, which were
used by men as *lungis* and shoulder cloths.

Below: Silk spread. Developed by
Weavers' Service Centre, Kanchi-
puram, Tamil Nadu. Brocade, of
Kanchipuram, 59⅞ × 59⅞″
(152 × 152 cm)

This spread has gold brocade *konias* in
four corners and circular medallions in the
center. The *konias* and the medallions
have the motif of a horse amid flowers
and foliage.

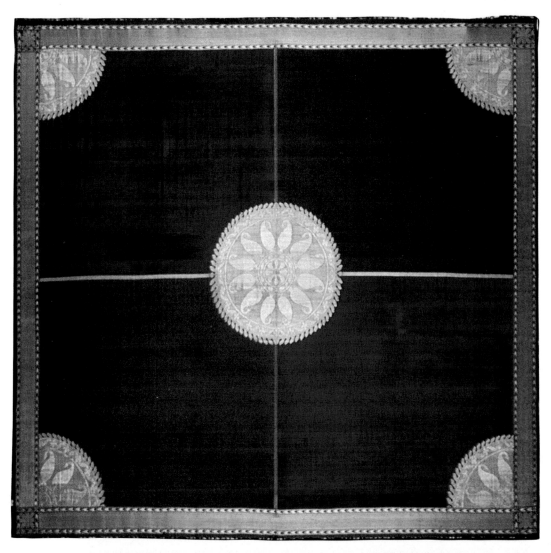

Above: Silk spread. Developed by Weavers' Service Centre, Indore, Madhya Pradesh. Brocade, of Chanderi, 76¾ × 76¾″ (195 × 195 cm)

In the center of this spread is a brocaded circular medallion containing gold and silver decorative motifs, the most prominent being a pendant with twelve silver mangoes on a gold ground. A quarter of this is used in each corner, at the intersection of the framing borders.

Below: Cotton spread. Block-printed

The art of printing and painting cotton fabric with an identical design on both its surfaces was practiced in Andhra Pradesh by the *kalamkaras* and in Kutch and Sind by Moslem *khatris*. After resist block-printing and mordanting, the printer sprinkles finely powdered goat dung over finished surfaces to avoid shrinkage and smudging of the wet print. He then prints the reverse surface.

Forms from Mother Earth
Contemporary Indian Terracotta

More terracottas are made in India today than in any other country in the world, yet few have ever been exhibited. Their diversity in form, decoration, and purpose rival those of Meso-America. The first exhibition of contemporary Indian terracottas in America is at the Mingei International—Museum of World Folk Art. Based on the exhibition conceived and designed by Haku Shah for the National Craft Museum in New Delhi, the show revolves around several rural potters who have been brought from their remote Indian villages to demonstrate their art in the museum's gallery. Each craftsman has been drawn from a different cultural corner of India's complex geography. As they work throwing pots on their own wheels and building sculptures out of clay, the potters express individually the traditional techniques and methods of their forebears. In this way, their products distinguish one potter's style from another. Vessels and sculptures displayed in different stages of completion emphasize their means of production.

Terracottas from diverse areas of India have been chosen carefully to complement and contrast the work of these potters, while photographs, slides, and other visuals portray their natural environment.

Terracottas are made by shaping the most basic and accessible of elements, clay, into items of grace, beauty, function, and meaning. In India, terracotta vessels are thrown on wheels or built up by hand, while sculptures gain their forms through kneading, pinching, and molding clay. Pots are used for carrying, cooking, storage, and in various rituals. Potters and householders sculpt toys, religious images, and ornamentation for houses and shrines. Every four or five villages and each town in India has its own family or community of potters working to supply vessels and sculptures to meet the local demand. The techniques and styles of each group of these contemporary craftsmen are a distinct blend of ancient traditions and modern innovations. The size, shape, color, and decoration of pots and the identity, form, and character of sculptures varies from community to community. As India contains tens of thousands of towns and hundreds of thousands of villages, the full scope of Indian terracottas is almost incomprehensible. Their diversity expresses exciting similarities and strong differences to those of other countries.

The importance of Indian terracottas has long been ignored. Museums, collectors, travelers, writers, and photographers have been so dazzled by India's kingdoms and empires, its temples and palaces, and its fine art and religious eccentricities that

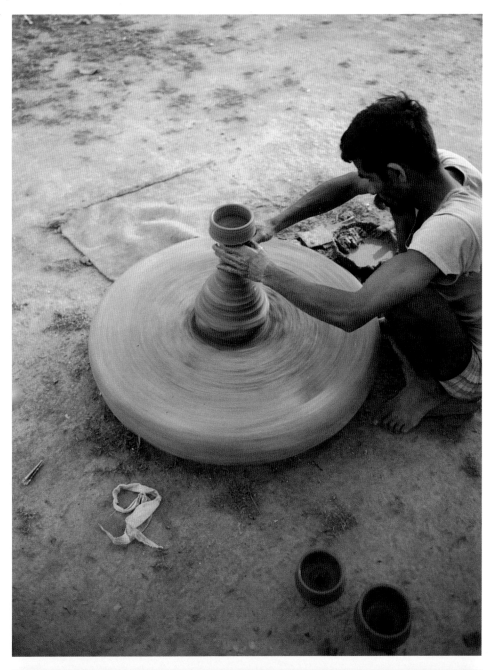

Above: Utensils are made of clay in a variety of shapes. A potter from a village near Misarwala, Uttar Pradesh, throws clay bowls for the tops of huqqa pipes on his hand-propelled stone wheel

Below: Terracotta horses are made by potters throughout Tamil Nadu and dedicated to Ayyanar shrines to protect the boundaries of the village. It is commonly believed that the god and his soldiers ride the horses at night and protect the villages. These examples are from Velangambadi, South Arcot District, and are 30–36″ high

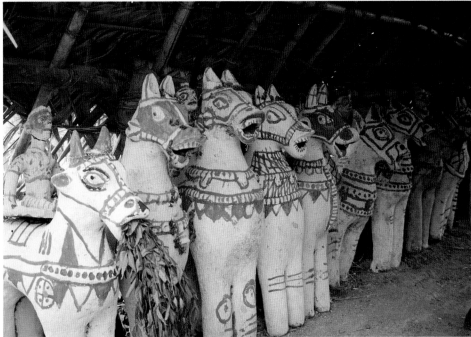

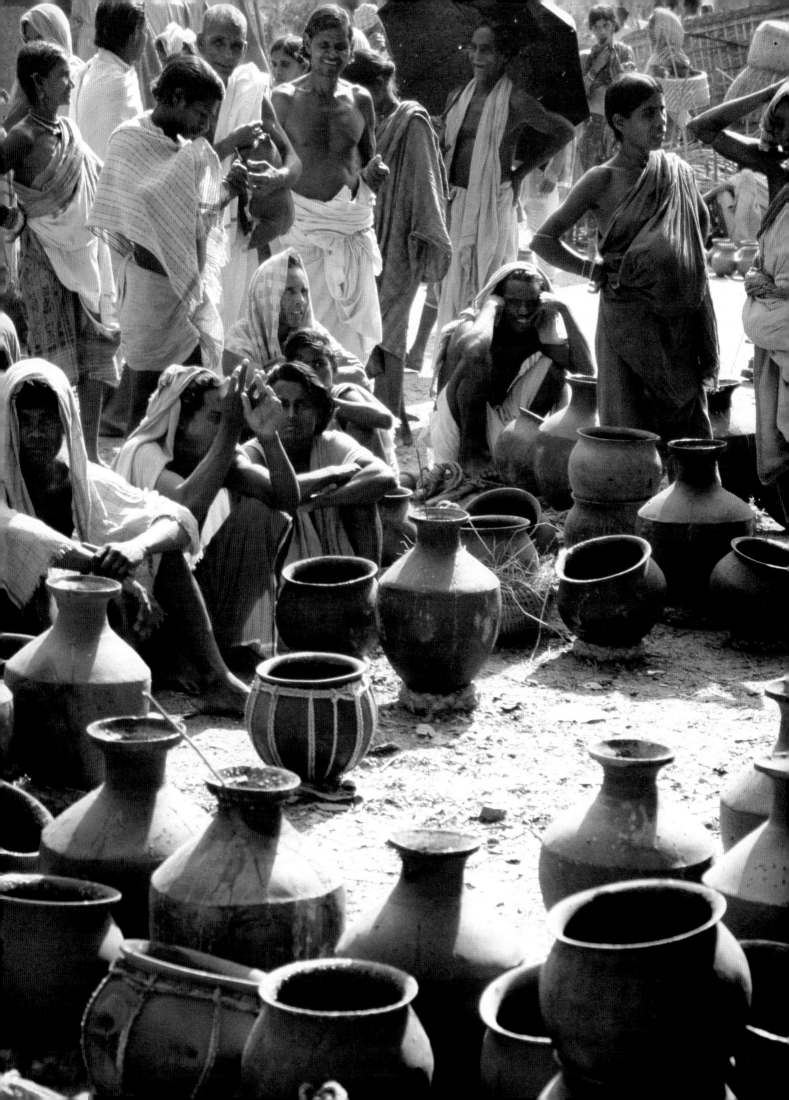

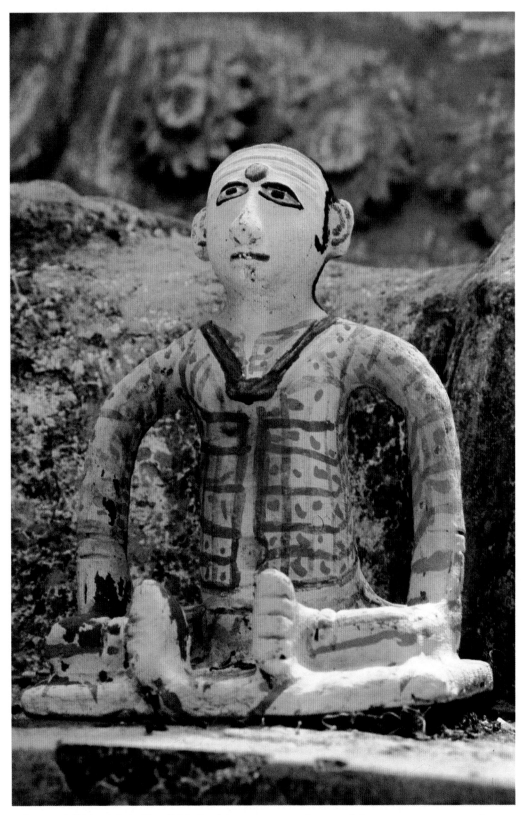

When a child is sick in Tamil Nadu, his parents purchase and donate a terracotta sculpture representing him to a shrine of Ayyanar, the local god of fertility and health. This image (12″ high) was photographed on the roof of a small temple in Elumedu, South Arcot District

Opposite: Pots for sale in a village market in Deogaon, Bolangir District, Orissa, display a variety of shapes and uses. The black color of the pottery is achieved by restricting the oxygen flow during firing

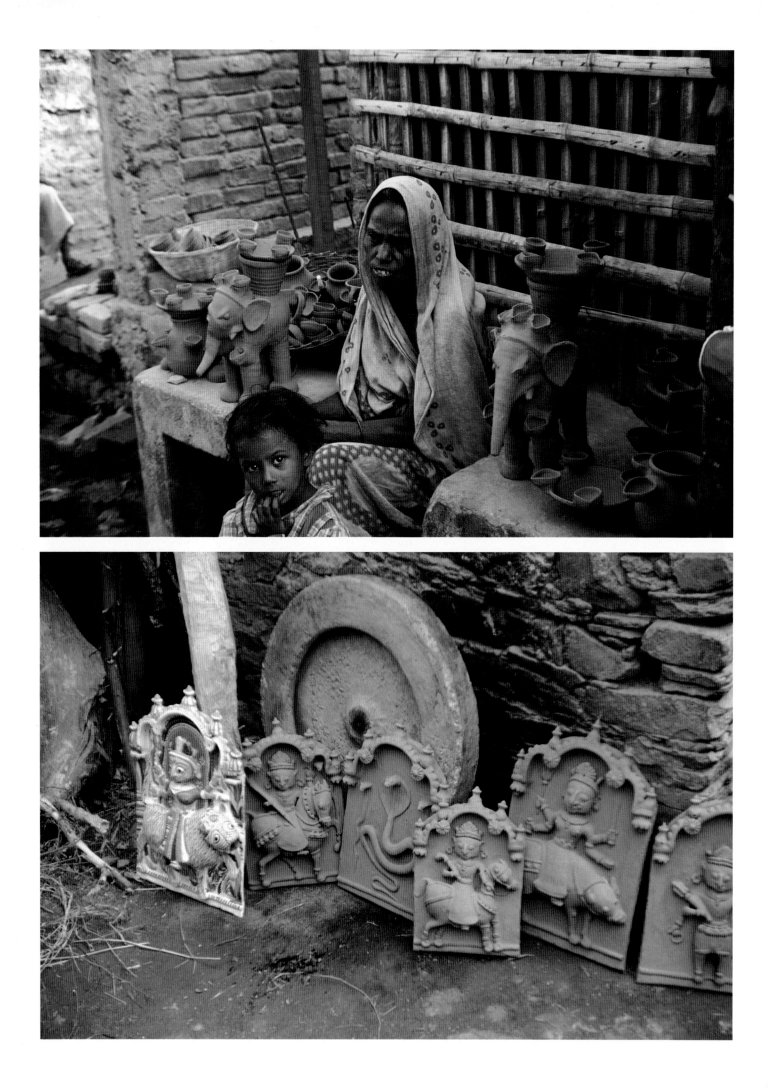

Elephants such as this one from Chota Udayapur, Baroda District, Gujarat (about 36″ high), are given each year to the spirits of malevolent ancestors who are believed to cause most misfortunes in the family. The open hole at its chest is the opening of the large pot that comprises its torso. While most of its components have been created on the wheel, smaller details have been added by hand

Opposite, above: In Bihar, clay elephants placed on rooftops indicate an impending household wedding. During Chhattra, the Sun Festival, terracotta elephants are ritually given to the Ganges in return for the god's favor. In this photograph, elephants in a market in Patna have been adorned with lamp dishes, which are filled with oil and lit on festive occasions

Opposite, below: Images of gods are sculpted in relief and affixed to plaques in Molela, Udaipur District, Rajasthan (average height 14″). As with most Indian terracottas, they are fired before being painted with bright polychrome colors

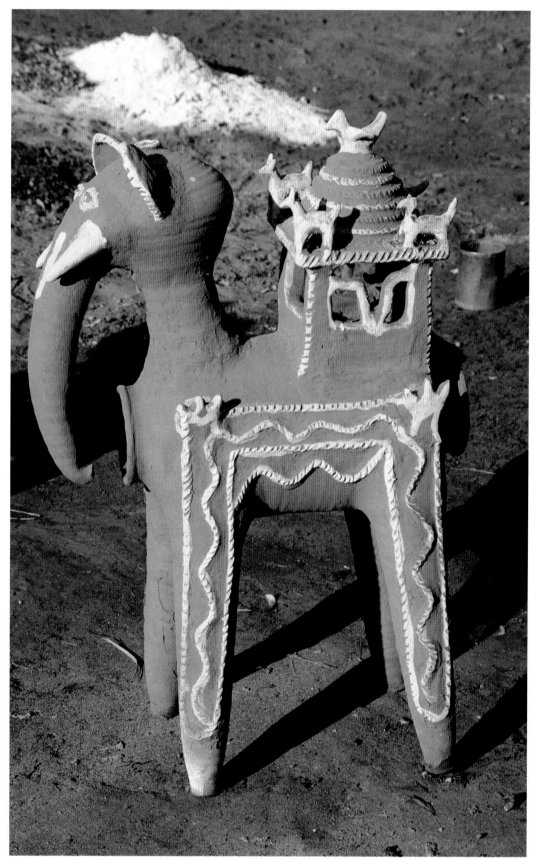

they have disregarded many of India's less obvious arts. While other crafts have long been extolled in India, terracottas have received little attention. Haku Shah's 1983 exhibition in New Delhi brought contemporary terracottas to the attention of a broad, educated Indian audience for the first time.

Archaeological excavations of India's earliest civilizations have yielded numerous terracottas, both vessels and sculptures. Historical research indicates that potters were honored craftsmen in ancient India and their products integral to classical societies. Though relatively little comparative documentation has been carried out, it is obvious that many of the techniques, styles, and purposes of contemporary terracottas parallel closely those of archaeological relics. The character within Indian terracotta sculpture, whether of magnificence, power, mystery, agelessness, whimsy, or humor, expresses an artistic vitality unique to India. In showing that stimulating diversity for the first time in the West, this exhibition opens the door to a broader understanding of a fundamental rural Indian craft.

The photographs that accompany this text portray contemporary terracottas in their natural settings. Prominent among them are images of horses and elephants. Rural Hinduism teaches that misfortune, disease, and infertility are caused by malevolent spirits and displeased gods. Throughout India, in villages and towns, the anger of these deities and demons is placated by the donation of terracotta images, the most common form being humans, horses, and elephants, to specific shrines. To quote the exhibition's honorary curator/designer Haku Shah: "These objects and figures are used and offered with utmost sincerity. Even to offer a small terracotta at harvest time or for fertility, people have to undergo intense rituals which include music, dances, trances, sacrifices, feasts, and the hoisting of flags. During the offering they say: 'We offer this terracotta to you, the God, and from today our safety is guaranteed. Be good to us; may your good wishes prevail and may our generations grow.' In these rituals the many forms of Mother Clay remain alive even today. Even though modern technology is trying to replace [terracotta], it will never become obsolete."

STEPHEN P. HUYLER

The Golden Eye

Over the centuries, "the golden eye" of Indian culture has defined and refined this ancient civilization's vast vocabulary of handicraft skills. Time-honored methods of working with stone, metal, wood, glass, ceramics, paper, lacquer, enamel, leather, and textiles have been passed down from generation to generation, from father to son and from mother to daughter. Until recently, artisans in villages throughout the country labored to supply the nation with the goods required for daily life. The steelworker forged the sword for battle; the handloom weaver provided the cloth for *saris*; the brass worker fashioned water jugs. Primarily these craftsmen were engaged in the production of functional objects, although not infrequently they lavished their creations with the care, the attention—the craftsmanship—that made them beautiful as well.

Today, modern technology has introduced new techniques of manufacture to India; it has also removed the demand for many traditional objects. The damascened sword that once would have been carried into battle has been replaced, and the steelworker who continues to embellish sword handles with decorative inlay work is now engaged in producing an object that will probably be sold as a souvenir. There is danger that when this tourist market dries up, skills acquired over the millenniums will also vanish.

In an attempt to bridge the gap between India's ancient heritage and the future, the Cooper-Hewitt Museum invited an impressive roster of world-famous designers and architects to visit India to discover craft traditions that could be used to realize their own work. The designers Frei Otto from Germany; Hans Hollein from Austria; Sir Hugh Casson from England; Ettore Sottsass and Mario Bellini from Italy; Isamu Noguchi, Jack Lenor Larsen, Mary McFadden, Milton Glaser, Bernard Rudofsky, Charles Moore, I. M. Pei, and Ivan Chermayeff from the United States; and others, working hand in hand with Indian artisans, searched for ways to apply the age-old methods and techniques of India's native crafts to the creation of objects that meet today's needs.

To document this historic cross-cultural endeavor, the Cooper-Hewitt Museum organized an exhibition of the prototypes that grew out of this experiment. Examples of the finest traditions in Indian craftsmanship—those that embody the inspirations and standards that the Western designers discovered in their personal explorations of India's past and present—were also incorporated into the exhibition.

It is the museum's hope that this experimental collaboration will ultimately provide Indian craftsmen with the freedom to practice their crafts on new designs in a way that will at the same time enrich the world with beautiful objects and benefit India's future in the world market.

Cooper-Hewitt Museum, The Smithsonian Institution's National Museum of Design, New York

Above: A design by graphic designer Milton Glaser for a toy box to be made of wood and papier-mâché

Below: Designs by Ivan Chermayeff for zippered cloth fish, which will employ various types of embroidery and embellishment techniques used in India

Opposite: Men caning in the Juneja Workshop, Delhi

Tiger, Tiger Burning Bright
An Indian Wildlife Portfolio

From earliest times to the present, animals have been subjects of interest for painters, sculptors, and other artists. It is good to be reminded periodically that the worlds of art and science are connected. This exhibition on wildlife in India does that, and makes us more aware of the many threads that connect East and West. These bonds find roots in both worlds.

Many in the West think of efforts to conserve endangered species and to preserve rapidly diminishing natural environments as lesser concerns for non-Western nations. Nothing could be further from the truth in India, where the Department of Environment plays a key role in administering and developing a system of nature preserves. As Indira Gandhi said: "Our ancient books teach that Dharma or obligation is always mutual. The earth will protect us only if we ourselves protect it." Part of the present photographic exhibition was mounted at the National Museum of Natural History, New Delhi, prior to coming to the United States.

The great Indian subcontinent still is home to a remarkably diverse assemblage of animals that includes almost five hundred species of mammals and more than two thousand species of birds. India is the only country that has both the lion and the tiger, at least twelve other species of cats, and the now well-established mutant white tiger. There still exist rhinoceros, elephant, and several species of wild cattle. India has six wild members of the dog family, eight species of deer, four of antelope, and four of bears. It has apes—even a species of panda. Although more than fifty species of mammals and birds are today considered endangered—mostly because of habitat destruction—India still represents one of the world's great zoological strongholds.

The title of this exhibition, "Tiger, Tiger Burning Bright," focuses on one species that has intrigued writers and artists as well as lay people for generations. To be truthful, however, the tiger is a "hook" designed to capture public interest. The exhibition as a whole is concerned with all of India's species of flora and fauna. There are several dozen species of mammals, birds, and reptiles represented in the photographs, and even these constitute only a minute fraction of the life forms at stake.

There are nine photographers whose works are represented in the sixty-four photographs: Rajesh Bedi, Ashish Chandola, H. S. Panwar, A. S. Parihar, K. S. Sankhala, S. P. Shahi, Brijendra Singh, Valmik Thapar, and Joanna Van Gruisen.

The government of India and many state governments of that country together have developed a system of preserves, parks, and sanctuaries, which are linked in

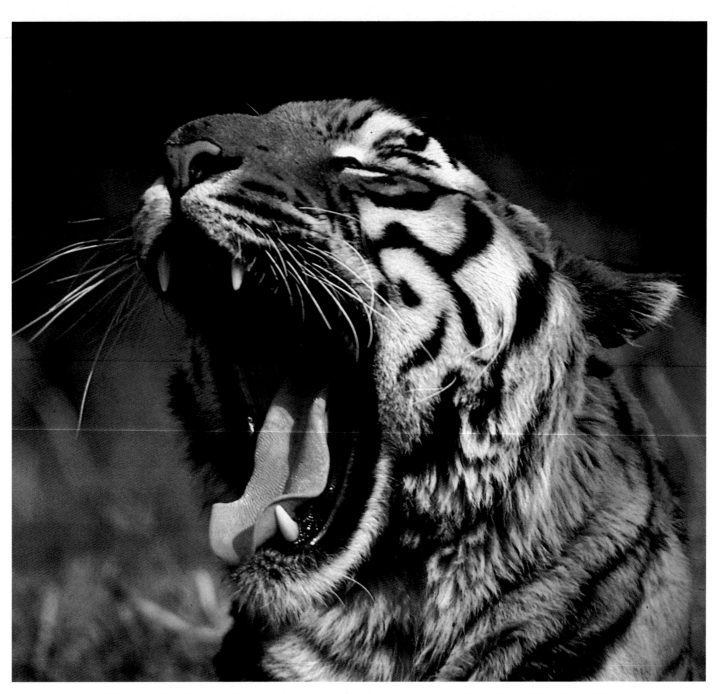

The tiger (*Panthera tigris*) is mainly nocturnal and, except for courting pairs and females with young, essentially solitary. About 4,000 remain in India

spirit to those in the United States. Both nations face the inevitable question of establishing priorities and deciding how to allocate scarce funds. Both are striving to heighten the consciousness of citizens to the need for preserving natural habitats for aesthetic, historic, and scientific reasons.

The presence of this handsome exhibition in the United States, like many of the other achievements recorded in this volume, is an expression of what shared interests and a cooperative spirit can produce.

MALCOLM ARTH and KENNETH CHAMBERS
Department of Education, American Museum of Natural History, New York

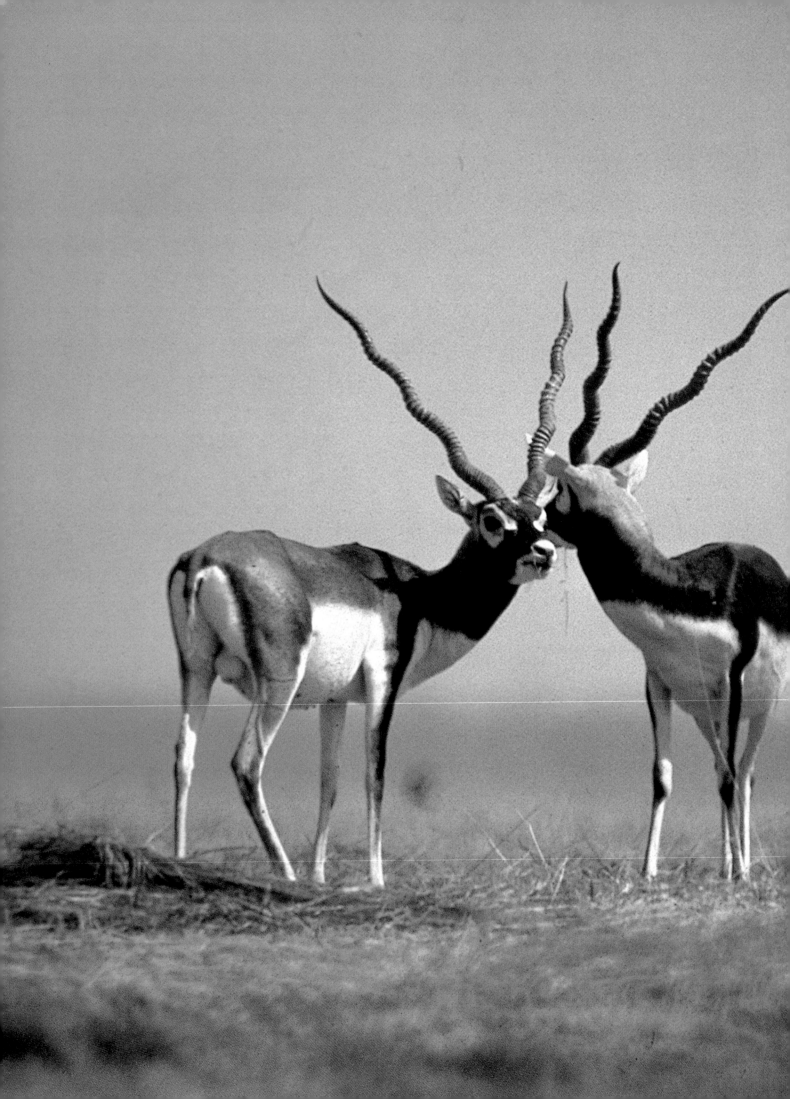

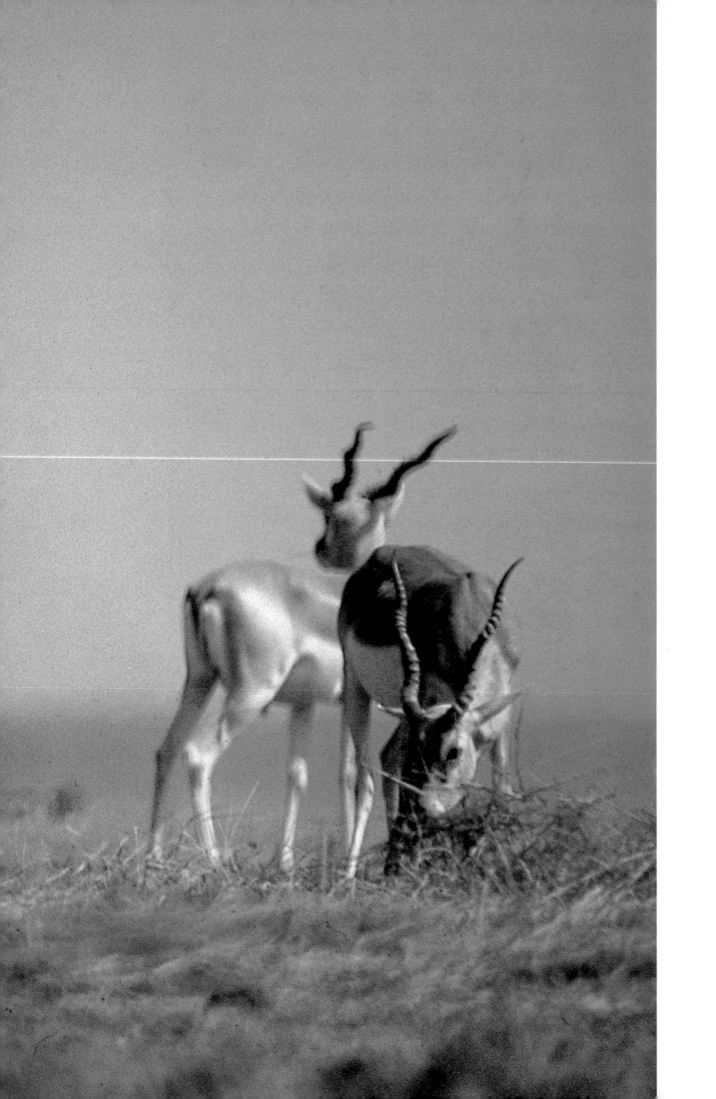

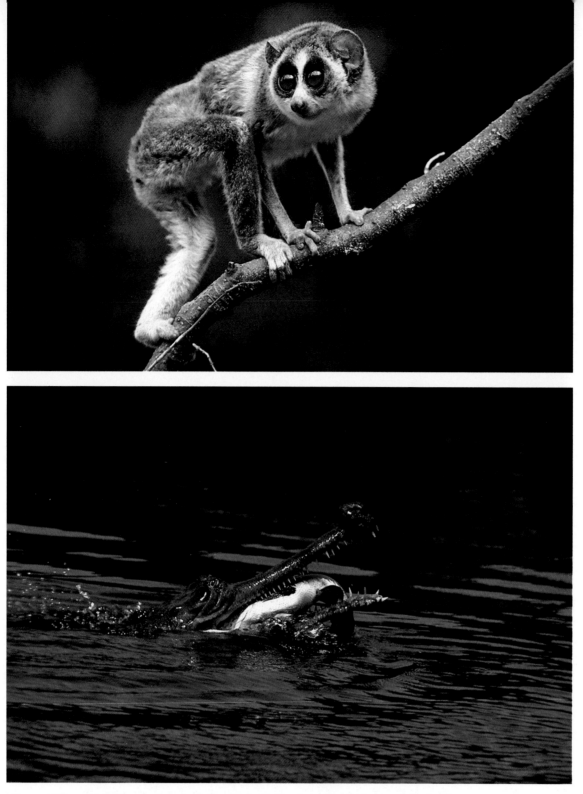

Above: The arboreal and nocturnal slender loris (*Loris tardigradus*) occurs in the forested areas of southern India and Sri Lanka. When climbing it uses its great toes and thumbs for grasping

Below: This crocodilian, called the gavial (*Gavialis gangeticus*), is found only in India and Burma. Its narrow snout is an adaptation for eating fish, which it catches with a sudden sidewise sweep of the head

Opposite: The wild ass (*Equus hemionus khur*) is found in areas of open plains in western India, where it occurs in small groups. It is now endangered by over-hunting, habitat deterioration, and interbreeding with the domestic donkey

Preceding pages: The blackbuck (*Antilope cernicapra*) is one of the very few mammal species in which the male is colored differently from the female. It is found mostly on open plains, but it also inhabits dry forested areas. Once the most abundant hoofed mammal in India, it is now much reduced in number

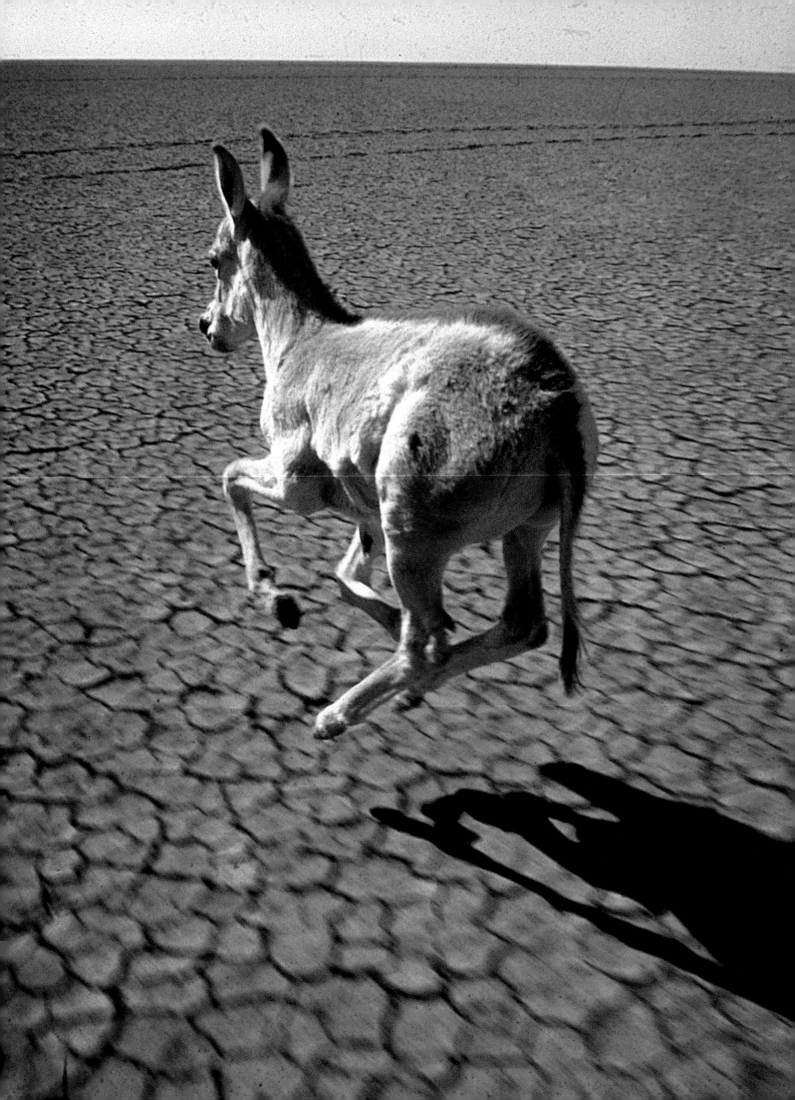

Rosalind Solomon: India

Rosalind Solomon's photographs are not the pictures of India one normally sees. Neither picturesque nor sentimental in subject matter or vision, they are direct, vivid images that evoke the emotional flavor—the nontangible substance—of India more effectively than any other photographs I know. They are the products of a unique and compassionate artistic sensibility, one that is able to translate a profound personal experience into graphically compelling, visceral images that stir their viewers.

In a very real sense, Rosalind Solomon's photographs communicate fundamental universal truths about the human condition. They depict aspects of those beliefs and rituals that order and regulate people's lives and, as she has written, "provide them with a means of dealing with struggle, chaos and inconsistency in their lives." In India—as in the United States and Latin America, where Rosalind Solomon has also photographed—these beliefs and rituals are inseparably integrated into daily life and are the essential matrix of India's culture and experience. They exert a fascination that cannot be articulated verbally.

Rosalind Solomon has described herself as "an explorer" who travels "to learn about life." Her photographs are both the instrument and the expression of this very personal voyage of discovery. She believes that "through their sacred objects people reveal their inner lives and key elements of their culture." These photographs are the documents of that revelation. They represent moments of insight and intuition. They are profoundly beautiful images—not because of the physical grandeur or splendor of what they depict (quite the contrary!), but because of their graphic power and raw emotional force. They are the creation of a sensitive eye that discerns compelling beauty within the typical and of a heart that comprehends the universal emotions that underlie traditional beliefs and are manifested in ritual.

In short, these photographs are not mere records (idealized or otherwise) of India's physical appearance. They are complex images, just as India is complex, and they arouse complex emotions, just as any encounter with India does. At the same time, they reveal a sympathy and affection that is deep and sincere.

Rosalind Solomon's photographs do not comprise a travelogue of India and they should not be looked at with that expectation. They are, rather, evocations of an experience that is at once private and to be shared. They are works of art.

WILLIAM F. STAPP
Curator of Photographs, National Portrait Gallery, Washington, D.C.

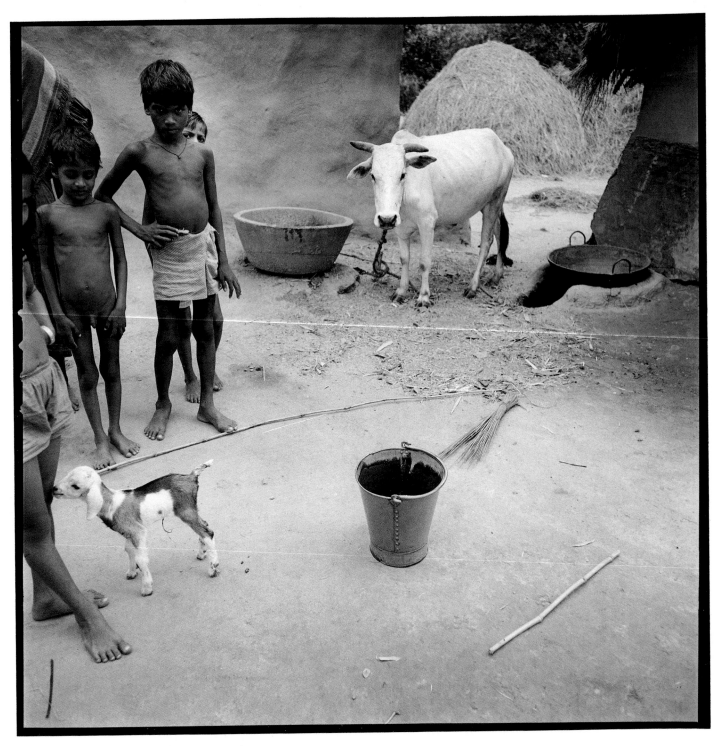

Farmyard, Orissa. 1981
This is a typical farm scene in a village in the state of Orissa

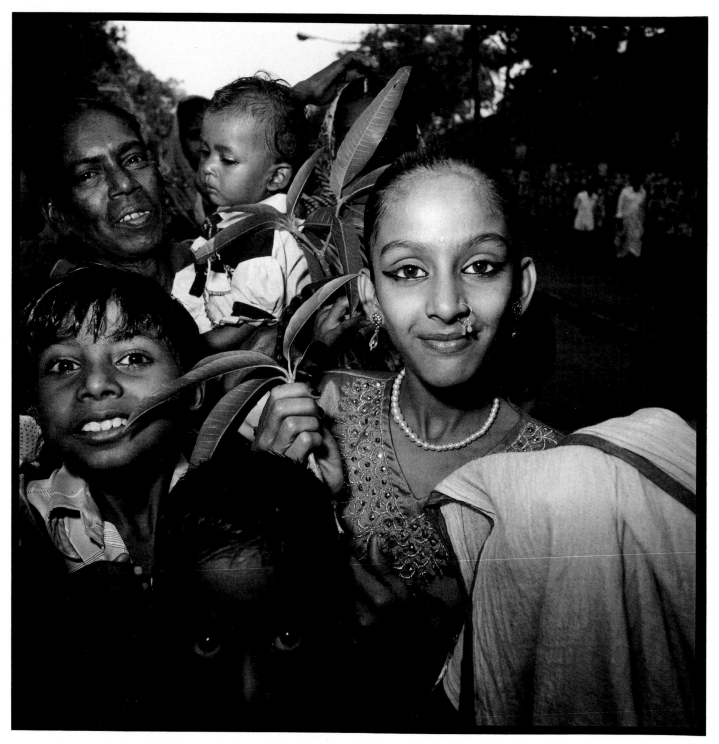

Young Girl Holding a Mango Twig, Festival of Chat. Calcutta, 1982
The mango is one of the most prized of trees and is often used in worship

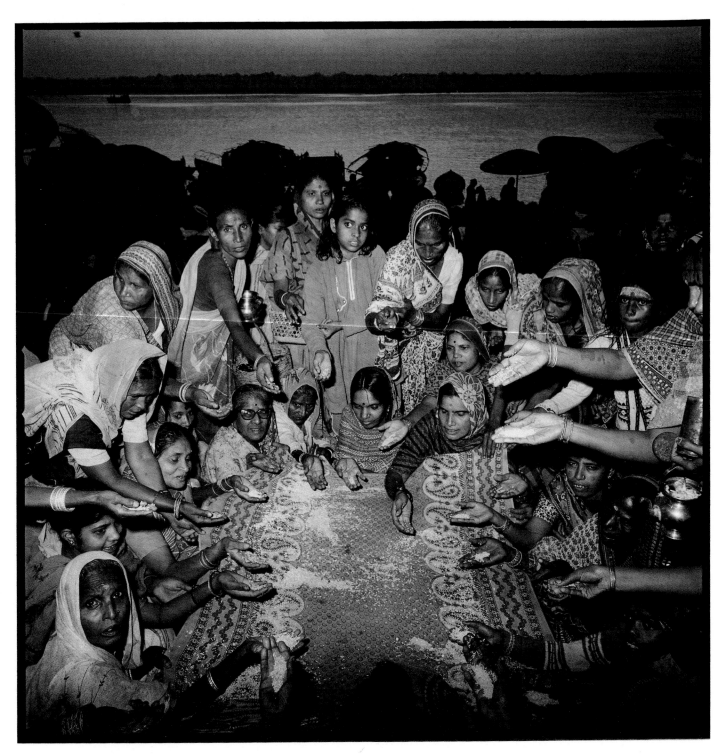

Women's Ritual on the Banks of the Ganges at Sunrise. Banaras, 1982

There are many religious rituals in India that are performed only by women. The use of rice is associated with fertility and good fortune

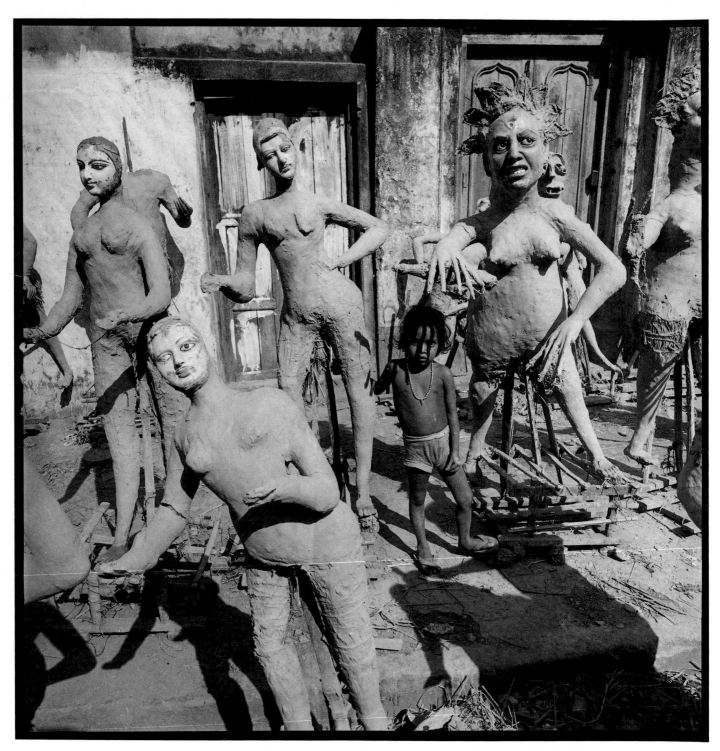

Images of Attendants of the Goddess Kali. Calcutta, 1981
The great goddess Kali is escorted by demon-attendants. These are some of the forms the demons take

Photographs by Raghubir Singh

The contribution of the University Art Museum, University of California at Berkeley, to the Festival of India is "Photographs by Raghubir Singh," an exhibition of thirty-five dye-transfer color photographs. Photographer Raghubir Singh was born in 1942 to a wealthy family in Jaipur whose lives were changed by Indian independence and land reforms. The horses, the servants, the sheltered existence disappeared, and Singh began bicycling to school, where, for the first time, he came in contact with the outside world. Attracted by the West, he finally left India; he has lived in Paris for many years, often returning to India in order to photograph.

In his work Singh combines the color, composition, and attention to detail that characterize traditional Indian painting with the viewpoint and technique of the modern street photographer. The results, said Max Kozloff in *Artforum*, manage to "fuse the soul of a Rajput miniaturist with the outlook of a Henri Cartier-Bresson." Singh often juxtaposes old and new: in one photograph, a turbaned Indian stands in an ox-drawn cart on the left, while on the right a casual young man in sneakers leans against a parked red-topped jeep.

In referring to *Rajasthan: India's Enchanted Land*, Singh's 1981 publication, Vicki Goldberg, in *American Photographer*, wrote: "Singh's program is complex, taking a whole state for his theme and letting his invention loose on it. . . . Singh courts color at the turn of the day, when the sun is low and level—not, however, for the propensity of colors to slide off the scale at these hours, but for the theatrical quality of the light, which spreads like filtered spotlights or the warm glow of a thousand lanterns."

The work of this subtle and sensitive interpreter of Indian life illuminates several facets of the complex and fascinating land of India.

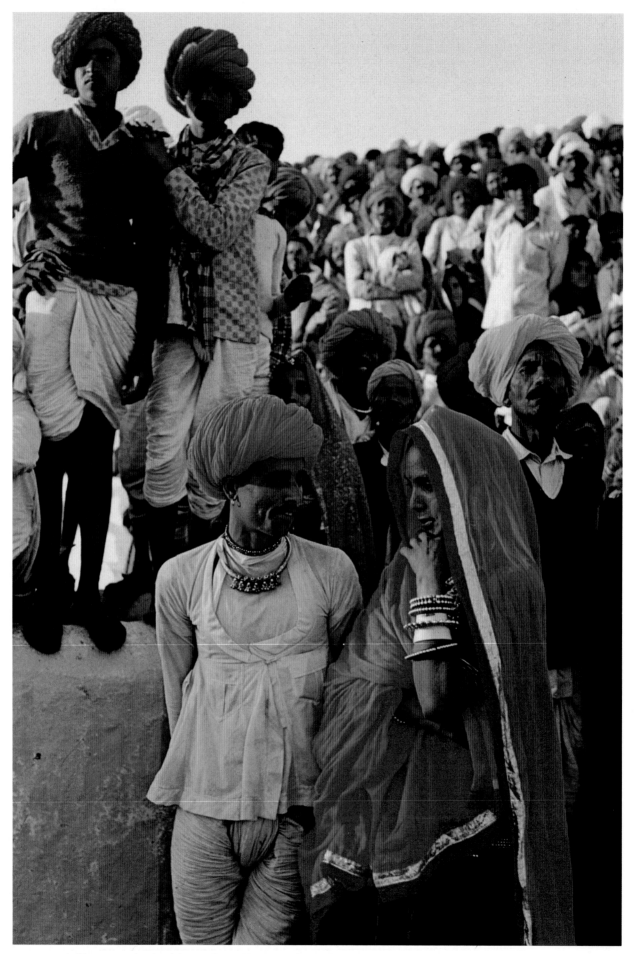

Villagers at the Pushkar Fair, 1983

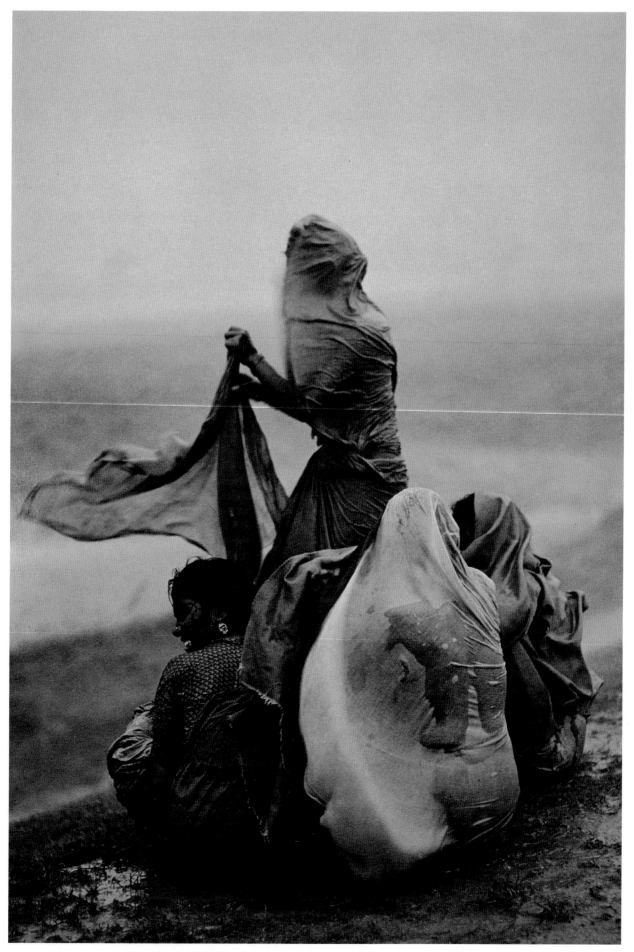

Women in a monsoon, Bihar, 1981

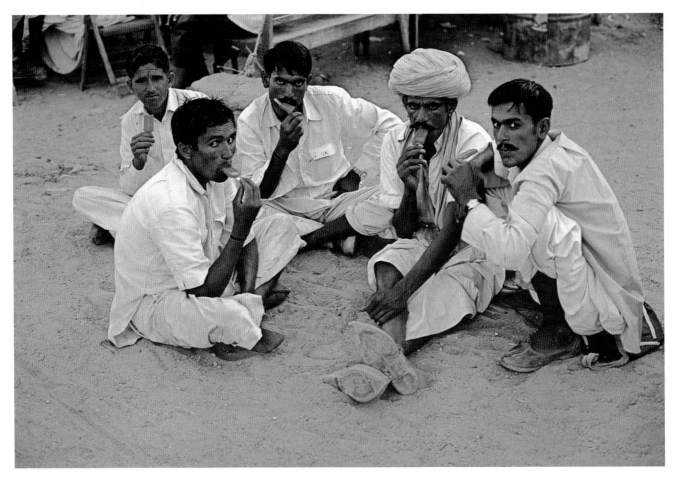

Above: Villagers enjoy iced sweets, Jodhpur, 1981

Below: Bullocks for sale, Pushkar Fair, 1981

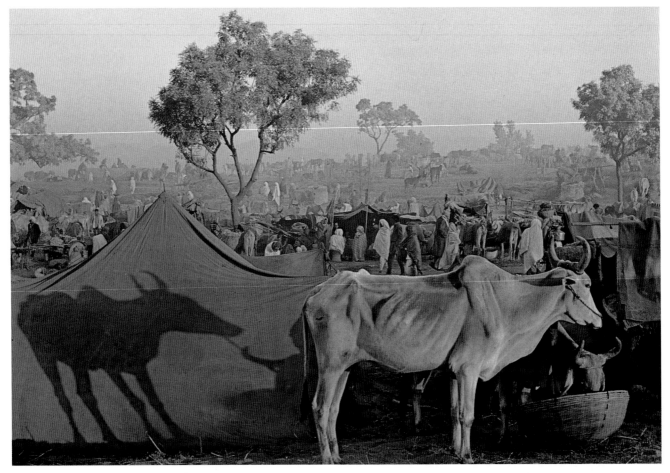

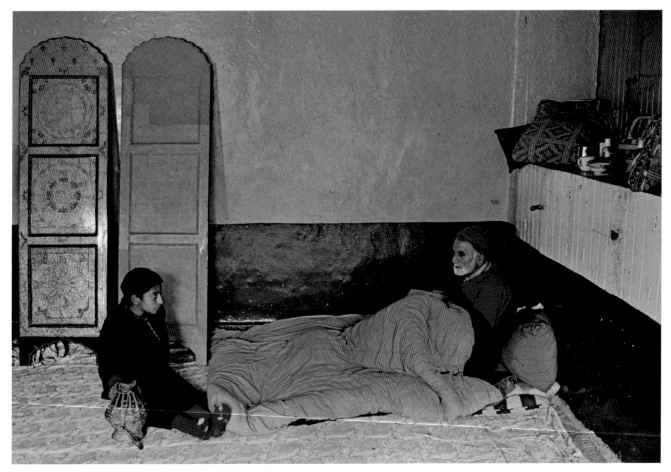

Above: Papier-mâché master, Srinagar, 1983

Below: A villager before a cardboard cutout of a happy farmer, Pushkar, 1981

Nek Chand's Rock Garden

Nek Chand, age fifty-eight, was born in northern India. He resettled in Chandigarh in 1951 shortly after it was erected according to a plan by the French architect Le Corbusier.

Nek Chand had no formal training and supported himself as a road construction worker. He spent idle moments making rock sculpture out of scrap from various work sites. In 1958, he found an unused site on the outskirts of Chandigarh. Transporting materials on his bicycle, he slowly created a fantasy world. Visitors came to look and returned with recycled materials for his creations. Chand's fame spread; in 1966, the public helped him keep the government from taking back its land. Today the government supports the project and two hundred people are employed to care for and enlarge the Rock Garden.

The Garden India

Nek Chand sculpts space as well as art in the Rock Garden. It consists of twelve acres of sculpture, streams and waterfalls, plants, a stage, work areas, nursery stock, and storage. The entry contains several small courtyards with abstract sculpture, winding, narrow passageways, and subtle patterns. A five-hundred-seat performance area appears. More pathways open onto a series of scenes—a mountain village, the kingdom of heaven, fields of animals, a court of judgment, a waterway, and more.

A new five-acre section will flow from the old, tied together by the stream bed. The river banks are barrels covered in stone. Each area slowly takes a form that speaks to its function, and its surface is covered to bring it to life and make it beautiful.

There are few new materials aside from concrete and two 50,000-gallon water tanks, part of the system that runs the waterfalls and streams. Vast work areas contain recycled materials organized into neat piles—wooden spools, carpet scraps, carbon paper, broken dishes, old furniture, building stone, glass, costume jewelry, fabric, marbles, wood, plumbing fixtures, ceramics, and more.

The nursery shows the same organization. It is large, smells of alyssum, and sparkles with nasturtiums and marigolds. Fifteen full-time gardeners tend it.

As a tour of the garden suggests, Nek Chand's style has matured over the years. His new work is more bold and colorful. It evolved from abstract to stylized—a style distinctly his and firmly rooted in Indian culture. The newest work is housed

Sculptor Nek Chand and a mosaic Garden of Eden

in storage, since his production outstrips the workers' ability to make new space. It awaits the opening of the new section, or exhibits like the one held at the Pompidou Center in Paris in 1980, or the garden soon to be built by Nek Chand at the Capital Children's Museum.

Chand at the Capital Children's Museum

The Capital Children's Museum in Washington, D.C., will be the site of the first garden that Nek Chand creates outside India. Construction of Nek Chand's garden and all materials will be provided by Sigal Construction Corporation of Washington, D.C. Nek Chand will select sculptures from his collection, which the government of India will ship to inhabit the space at the museum.

While the garden will open officially during the inauguration of the Festival of India in Washington, D.C., in June 1985, it will remain long after the festival runs its course—it will be a permanent part of the museum, a tribute to the spirit of its creator, a secret world that will speak to the heart of every visitor, and a treasure in Washington's children's museum.

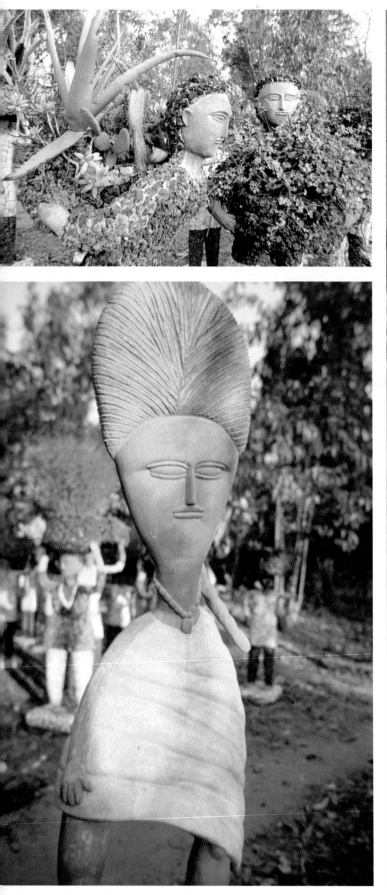

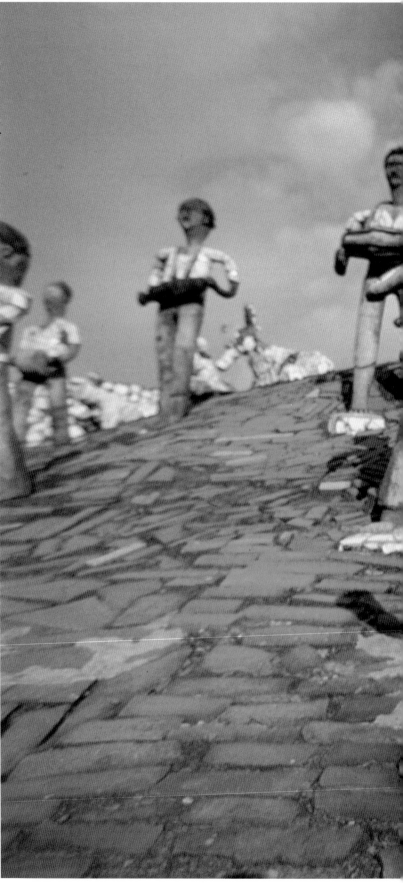

Above: "Rock people" become planters in this extraordinary fantasy garden. The figures are the creations of Nek Chand, a rare folk artist who tends plants with the same love he bestows on his figures

Below: Images of stone are Nek Chand's interpretation of traditional Indian custom—headdress, costume, bearing, and attitude

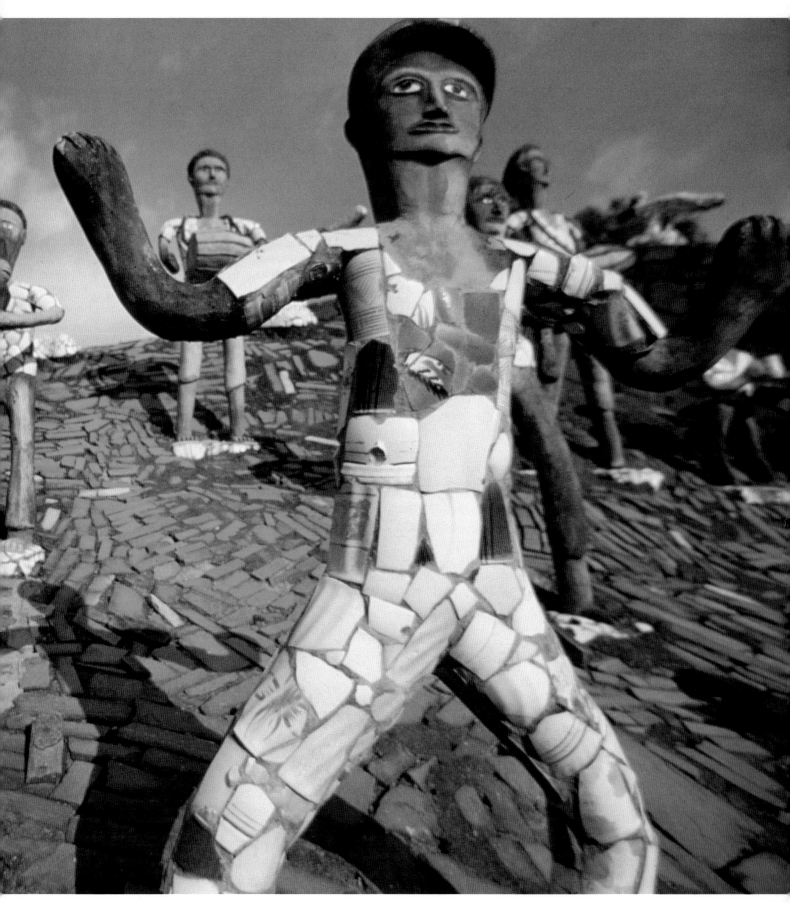

Above: Wooden men outfitted in broken pieces of bathroom tiles; the face, position, and details of each are different

Overleaf: Vibrant creatures roam the landscape that Nek Chand creates for them

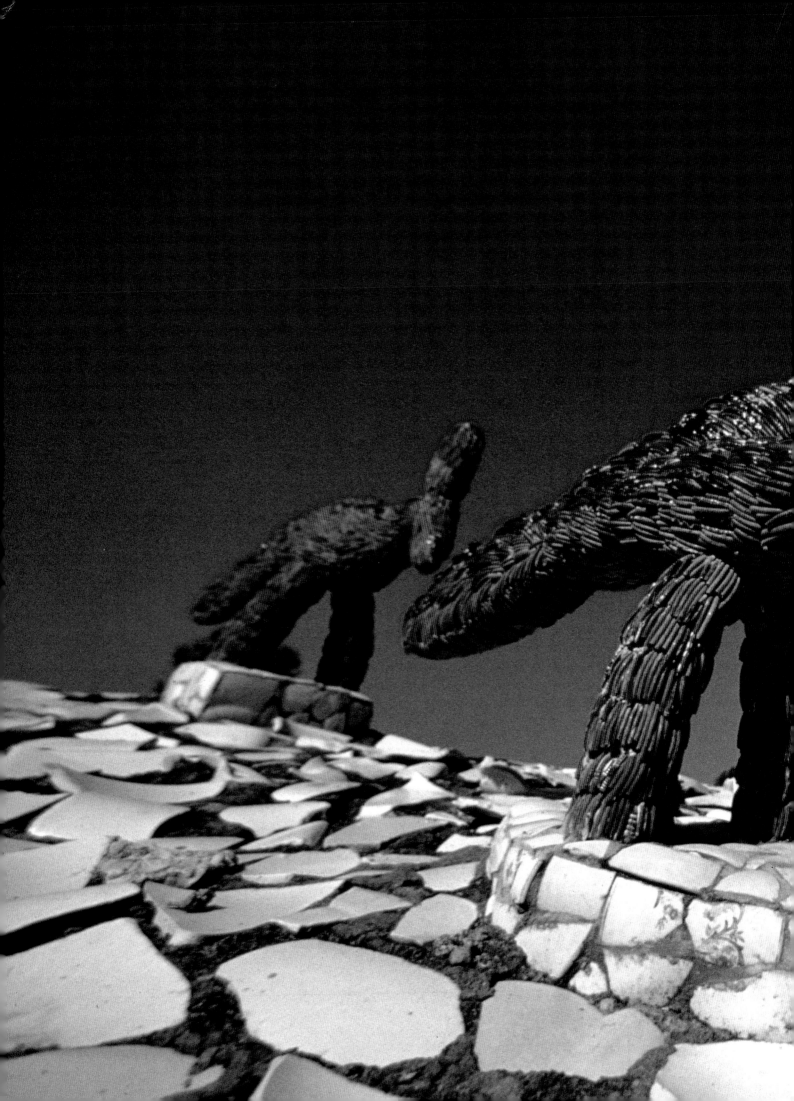

Once Upon a Time in India
The Adventures of Lord Rama

Bala Books, a nonprofit educational publisher of India's traditional stories for young people, chose the epic *Ramayana* as its theme for the Festival of India. The story was portrayed through puppetry, dance, music, and narration at the New York Public Library's Performing Arts Auditorium at Lincoln Center.

Pervading Indian culture for thousands of years, the *Ramayana* by the sage Valmiki has had a cultural impact comparable to that of the Bible. In the labyrinthine passages of this six-hundred-chapter work are contained the social, moral, and religious beliefs of one-sixth of the world's population.

By textual reference, the story dates back more than 800,000 years to the Treta-yuga or Silver Age of the Vedic period, when a lifetime spanned a thousand years and the world was ruled by a godly monarchy. In order to defeat the armies of demons led by the ten-headed King Ravana and reestablish divine law, the Supreme Lord appeared as Ramachandra, ideal king and standard-bearer of the righteous life.

Young Prince Rama proves his prowess by breaking the reputedly immovable bow of Shiva. In so doing, he wins the hand of the beautiful princess Sita. Rama's father, King Dasaratha, announces his intention of installing Rama as the future king but is tricked into exiling his son through the intrigues of an ambitious maidservant. Rama, his wife Sita, and his adoring brother Laksmana enjoy the simple pleasures of forest life until one day when the wicked Ravana kidnaps Sita and takes her to his golden kingdom of Lanka. Rama joins forces with an army of mystically endowed monkeys—led by the resourceful and devoted Hanuman—and attacks Lanka, slays Ravana and his demonic forces, and returns with Sita for a glorious installation on the throne of Ayodhya.

The story carries a universal theistic message: all living beings are eternal souls, temporarily trapped in this world by their material desires. The soul's original state of eternity, bliss, and knowledge can be regained through devotional works and meditation (for devotees of Rama, this is done by chanting sacred *mantras*, such as Hare Krishna, Hare Krishna, Krishna Krishna, Hare Hare, Hare Rama, Hare Rama, Rama Rama, Hare Hare). Ravana symbolizes the materially conditioned soul who tries to replace God (Rama) by stealing his energies (Sita) for his own enjoyment. The mission of the devotee (Hanuman) is to return Sita to Rama. In so doing, he performs a sacred duty and provides an example of devotional life for all mankind. The heroes of the *Ramayana* also set a standard by their reverence for life and their

ఐయుద్ధనానామష్మిగళిందిస్థరశ్రయసుపతంఖ్రూఖిత్రూకావనష్ఖుళరదు
ఖొందుళూఖాగలుఖుఐిఖిత్రూకావనద్ధిర్రయేసుస్త్రయరహుద్రద్ఐయుద్ద
ఖూదెవియెప్రూఘుగళయెద్రద్ఐయెద్రమణెహూళయెంతిఖిఖూదెవి
యెఖ్రంతుయెతూశదిందఐలిగిఖుశ్రిదుద్రెయెంతిముఖాం
తిగుండఐెంయెంశరవాదల్రత్రయెల్లరాఖ్రసత్రయెశందఐెంయెపళి
వఖూరిఖ్రెతంఖ్రుగుండతూశఖాంశెయెఖిఐంఖపతియెఐరూమస్రామి
యెనతంశయెష్రద్రెవపెందుద్ధ్రసమాదూతిత్రద్రలియెఐశఖ్రఐ్రుత్రంఖప
స్త్రుపళ్శిమునిర్ఖరమళుఖిలపరిగనిరూపంగూదుత్రద్రధరాఐ్రూ ఖ్రో
మద్రామాయెనాదఐిరంఖ్రెశండద్ధ్రరావణాసురమళిఖూదెవియెను
ఐిఖూకావనశెశ్రుళిఖదెంఐెళ్రద్రఖ్రపంగద్రవిచామరయెత్రిఐిలాసుద
ఐ్రిఖఖ్రనయెఐెశ్ల్రసఖ్శిమంగనమళూఖ్రిఖిత్రి ఖిత్రిత్రి

Sita pines for her beloved Rama in Lanka's Ashoka garden. Page from a Mysore *Ramayana* manuscript of the 18th century

Ravana leads an attack against Rama. Page from a Mysore *Ramayana* manuscript of the 18th century

ಬ್ರಂಹ್ಮಾ(ಸ್ತ್ರ)ಕೆಯುಲಕಾಶವೆ ಎಂದುಶ್ರೀಕರಿವಾಣಿಯ ಹಾಡು (ಬ್ರಂಹ್ಮಾ(ಸ್ತ್ರ)ದಸಂ
ವಿಯ್ಯ ಮಂದರಕರಿವರ್ತ ಮೆರುಬವತ್ಕಳಿಗೆ ಇವಗಾನವಾಣಿಯಹಾಡು ಸುವ
ನ್ವರುಯದಾದ ಬಾಳು ಕಿನಂದಡೆದ್ವ್ಯವಾನವಾಣಿಹೊಳೆಯಕಿಹಾಡು (ಇವಣ್ಣ
ಪ್ರಾಣಸ್ಕಳಿಗು ಸಾಂಬ್ಬವಂಡಲದಕಾಂಶಿಯಂಶ್ರೀಕೊರು ಪ್ರಿಹಾಡು ಪಿಸೊಗೆ
ಸುಪ್ರಿದ(ಪ್ರ)ಳಯಕಾಲನ್ಶಿಯಂತ್ರಿಜ್ವರಿಸುಪ್ರಿಹಾಡು ವಿಷ್ಮಿಜ್ವಾಲೆಯಸುಕುಳ್ಳಶಿತ್ರ
ಇವನೆಗಾವಿಡ ಯಲ್ಲಿಯ ದರಥಾದ್ರು ಶತ್ರುಬಲದನ್ಶಿ ಯತಿನೆಸೆದುಕೆಳಪಡು
ರಿಯಶಿಕ್ಷವಂಥಾದ್ರು ಇವತ್ರ(ಪ್ರಾಣಸ್ಕಳಿ ಶೂಸಿಯಯವನಂಹುವಾದುವಂತ್ರಾ
ಪ್ಪು ನಿಂಸಪಕ್ಷವಾದಕಬಿಬಲಕ್ಷೆ ಇಂತ್ರಿಷವಮಾಡುವಂಥಾದ್ರು ನಿಂಸಶತ್ರುಕಳಲೊ
ದಕ್ಷಾಕ್ಷಸರಥಿ ಇಯು ಧವನೆಗಾಯಸವಂಥಾದ್ರು ಯಲ್ಲೆರಾಪಸ್ಥಾಪಿಯಂಥಾ(ಬ್ರಂ

Rama shoots a celestial arrow that kills Ravana. Page from a Mysore *Ramayana* manuscript
of the 18th century

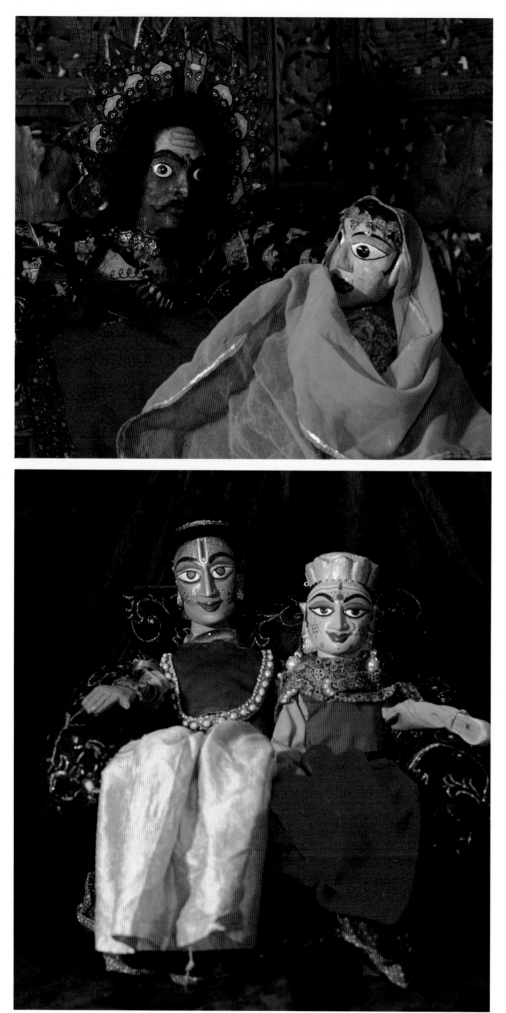

Above: Ravana, the demon king, amuses himself with a dancing girl in the Bala Books presentation of the *Ramayana*. Puppeteers Gary and Mavis Gewant created the puppets in the Kathputli style of Rajasthan

Below: After twelve years of hardship in the forest, Queen Sita and King Rama are at last installed on their royal throne

Opposite: Indrani, one of India's foremost classical dancers, strikes a pose in her performance for "Children's Day India." Daughter of Ragini Devi, a pioneer in Indian dance revival, Indrani began her studies at age five. She later followed her mother's example by introducing *Kuchipudi* and *Orissi* dance outside India

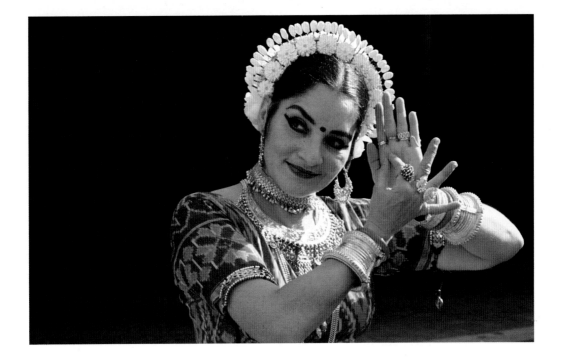

adherence to the Brahmanical qualities of chastity, truthfulness, and scriptural wisdom.

Followers of the Vedic tradition accept the *Ramayana* not just as literature but as literal history and incorporate its precepts—including vegetarianism, karma, and reincarnation—into their daily lives. So popular is the work that it represents a phenomenon of major proportions in dozens of countries, with hundreds of published editions and numerous presentations as folk drama, song, dance, and communal celebrations.

As a work for children's audiences the *Ramayana* is ideal, for it embodies characters and themes that pervade storytelling the world over: the heroes and heroines of virtue, the comedians of foolishness and pride, the villains of treachery and deceit. In India, *slokidhara* (itinerant storytellers) recount one or more chapters under a tree or at some other accessible gathering spot. The presentation sometimes includes the use of a story cloth—a large tapestry that depicts chronologically the highlights of the adventure in simple drawings.

Troupes of children performers periodically stage the saga against simple cloth backdrops and to the accompaniment of a chanter who tells the story as the actors move silently about the stage.

The audiences are not limited to children. Rama pageants are staged throughout India, especially at Diwali, the Hindu new year, which commemorates Rama's return to his capital of Ayodhya, where he is welcomed with a festival of lights. It is in fact significant to a deeper understanding of India's traditional culture that the world of adults and that of children so effectively overlap: temple ceremonies, theatrical productions, and religious celebrations join the generations and reinforce the transmission of traditional morals and beliefs. No single story has ever served so effectively for this transmission as the *Ramayana*, the ideal introduction for Western young people to the artistic, cultural, and spiritual treasures of India.

JOSHUA M. GREENE
Director, Bala Books

Theater
The Little Clay Cart

Produced by the Theatre and Dance Department. Directed by Balwant Gargi

The classical Sanskrit drama has ten types, but its principal categories are *Nataka*, a play dealing with kings and mythological heroes in an exalted format, and *Prahasna*, a social play dealing with ordinary people. *The Little Clay Cart* is of the latter type, a delicious plot of love and intrigue, jealousy and passion, and of earthy humor and refined sentiments.

Nowhere do we find such a galaxy of crooks, gamblers, lechers, sycophants, and villains as in the classical Sanskrit drama *The Little Clay Cart*, ascribed to King Shudraka of the fourth century A.D. The virtues of the poor merchant Charudatta and the beautiful courtesan Vasantasena glow through these people.

The play is immune from the usual mythological heroes and gods. The characters are full-blooded. A corrupt judge, an honest thief, a barber-turned-Buddhist monk, a stuttering, lustful brother-in-law of the king, a blundering, gluttonous Brahman, cart drivers, elephant tamers, maidservants, bastards, and executioners inhabit the theatrical stable of the royal playwright.

The Little Clay Cart has been staged all over the world. Its maiden American production was at the New York Neighborhood Playhouse by the National Theatre Conference in 1924. A Mughal-style latticed set was used, dividing the stage into two main acting areas—Charudatta's poor house and Vasantasena's mansion, with a path connecting the two. Instead of depicting the bullocks through mime, the director yoked two actors to create the four-footed animals. In the current production, the dancers' movements and acting art conjure up the reality.

A team of twenty-eight actors, dancers, and singers have rehearsed for six weeks, and the play opens on the thrust stage of the Goodwin Theatre, Trinity College, Hartford, Connecticut, on April 24, 1985. The players move, gallop, dance, kick; they create palaces, temples, gardens, streets, gambling dens, towers, and the seven courtyards of the gilded mansion of the courtesan through stylized movements and sculptural freezes. The production is designed to be a visual experience.

A *rangapatti* (hand-held curtain), as used in folk dramas and dance forms, opens the play. Two dancers, representing proscenium pillars, glide in rhythmic steps while holding the richly textured curtain. Some characters are introduced from behind this curtain to make their entry more effective.

The musicians, drummers, and chanters sit in view onstage in the tradition of an Indian folk play. Many of the actors perform double and triple roles. Those play-

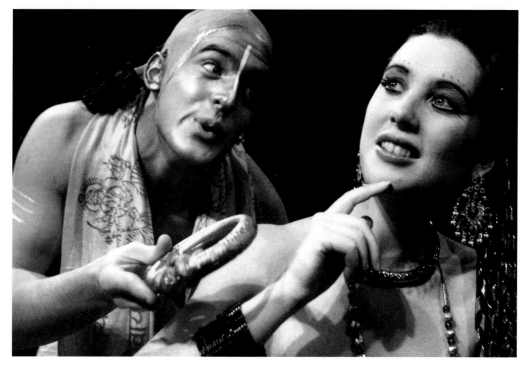

A rehearsal scene from *The Little Clay Cart*. The beautiful courtesan Vasantasena (Gretchen Schoppert) wonders at the foolish Brahman Maitreya (Paul Renaud), who offers her a jeweled bracelet

ing the principal characters take on no other parts, but those playing subsidiary characters, with a change of costume and makeup, become totally different, sometimes their opposites. For example, the two gamblers of Act Two change into cart drivers in Act Six, and become executioners in Act Ten. A penniless derelict is transformed into a judge and the stage manager into a thief.

There is multiple action on the stage—inside the house and in the brightly lit "dark street" where the king's brother-in-law and his retainers chase Vasantasena. In white light, the actors create the illusion of pitch darkness by their groping actions and stretched-open eyes.

The geometrically and mathematically worked-out movements melt into logical rhythms and are believable, natural, and stunningly spectacular. It is a theater of wild movement, color, masks, ceremonials, music, dance, flaming oil torches, fragrant flowers, incense fumes, and "close-up" action. Special costumes, masks, silks, jewelry, folk motifs, and instruments have been flown from India to provide an authentic atmosphere and color.

The American spectator, familiar with the use of half-masks, dummies, song, dance, stylized makeup, the double, will find all these elements and much more in this classical Sanskrit masterpiece. Contemporary Western masters have borrowed from Asian techniques. It will be of some interest for the viewer to go to the roots and see these exciting forms from the other end of the telescope.

The ancient sage Bharata, in his two-thousand-year-old exhaustive treatise on dance and drama, *The Natyasastra*, says, "Drama gives wisdom to fools, courage to cowards, peace to ruffled minds, diversion to kings, and entertainment to all." *The Little Clay Cart* ideally stands this test.

BALWANT GARGI
Director-in-Residence, Trinity College, Hartford, Connecticut

Film
Festival of Indian Cinema

Geoffrey Gilmore of the UCLA Film Archives and Adrienne Mancia of the Department of Film of the Museum of Modern Art are co-coordinators of a series on Indian film that will tour the United States after being shown at UCLA, the Museum of Modern Art, and the Pacific Film Archive. The series will consist of two parts, one focusing on the classic film traditions, the other on contemporary Indian cinema. Part I includes selected films from three of the greatest names in the history of Indian cinema: V. Shantaram, Guru Dutt, and Raj Kapoor. The second part includes miniretrospectives of the films of the late Bengali filmmaker Ritwik Ghatak, an equally brief series of the films of Mrinal Sen, and fifteen to eighteen films made in India in the last three years. There are about forty films in the traveling program. Also included in the tour will be a visiting filmmaker program, as approximately twelve Indian filmmakers and critics are expected to tour the United States over the period during which the films will circulate.

Left: The director Mrinal Sen

Opposite, above: A scene from *Jhanak Jhanak Payal Baje* directed by V. Shantaram

Opposite, below: A scene from *Shri 420* directed by Raj Kapoor, starring Nargis and Raj Kapoor

Museum of Modern Art, New York, and UCLA Film Archives

226

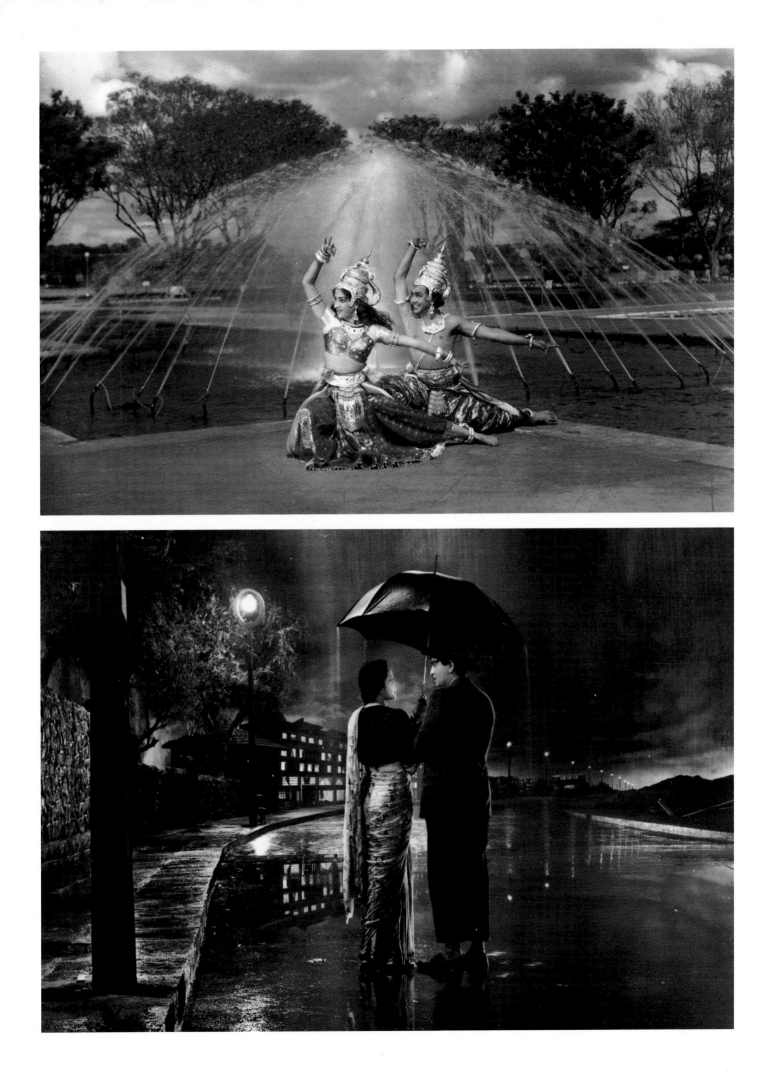

The India Festival of Music and Dance at Lincoln Center

Lincoln Center for the Performing Arts will present seven performances of India's lively dance, music, and dramatic arts as part of the nationwide Festival of India. The colorful shows at Alice Tully Hall will celebrate a wide range of Indian performance traditions through an assembly of costumed dancers, singers, and musicians, the country's foremost exponents of their arts, gathered from all over India.

Each of the groups selected to participate at "The India Festival of Music and Dance at Lincoln Center" represents a different type of traditional performing art form, displaying old and new cultural customs that range from masked dancers conveying ancient legendary tales to a popular ensemble of folk singers.

The New York Philharmonic will present a "Celebration of India" program as its contribution to the Festival of India, and the New York City Opera will stage Philip Glass's *Satyagraha*, an opera about Mahatma Gandhi.

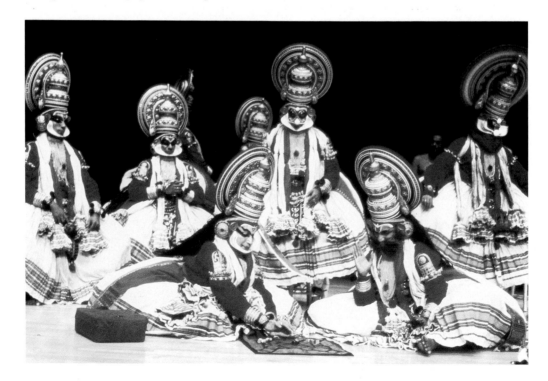

Lincoln Center for the Performing Arts, New York

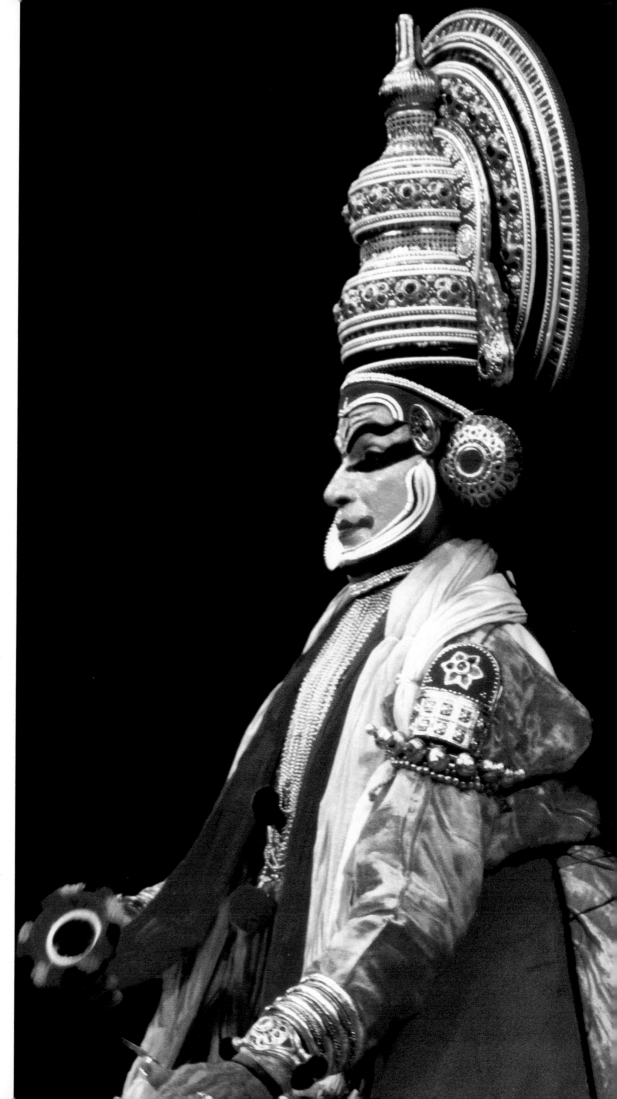

Opposite and right:
Kerala Kalamanda-
lam, dressed in elabo-
rate and colorful
costumes, will per-
form a section of the
Ramayana. In this art
form, *Kathakali*, men
play the female roles

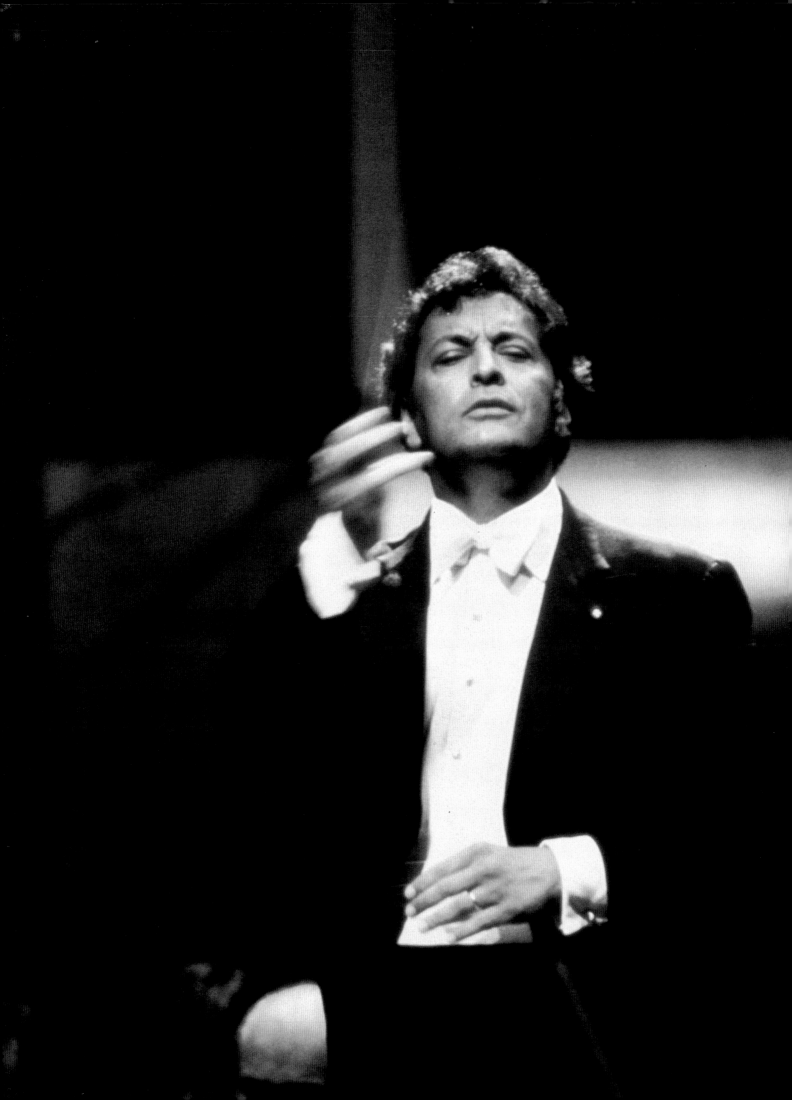

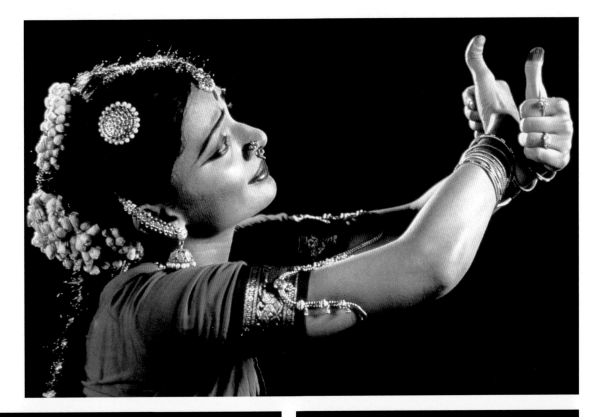

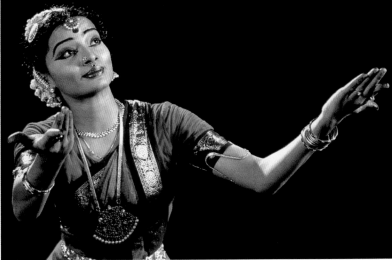

Malavika Sarukkai is a young star of the ancient art form *Bharata Natyam*, a composite art that combines drama, music, poetry, color, and rhythm. Its keynote is the dance, which includes all the arts but whose message is not merely to the senses but to the soul of the dancer and of the spectator

Opposite: Zubin Mehta will conduct the New York Philharmonic in a program of Indian music for the Festival of India

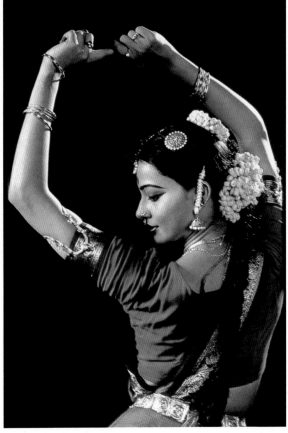

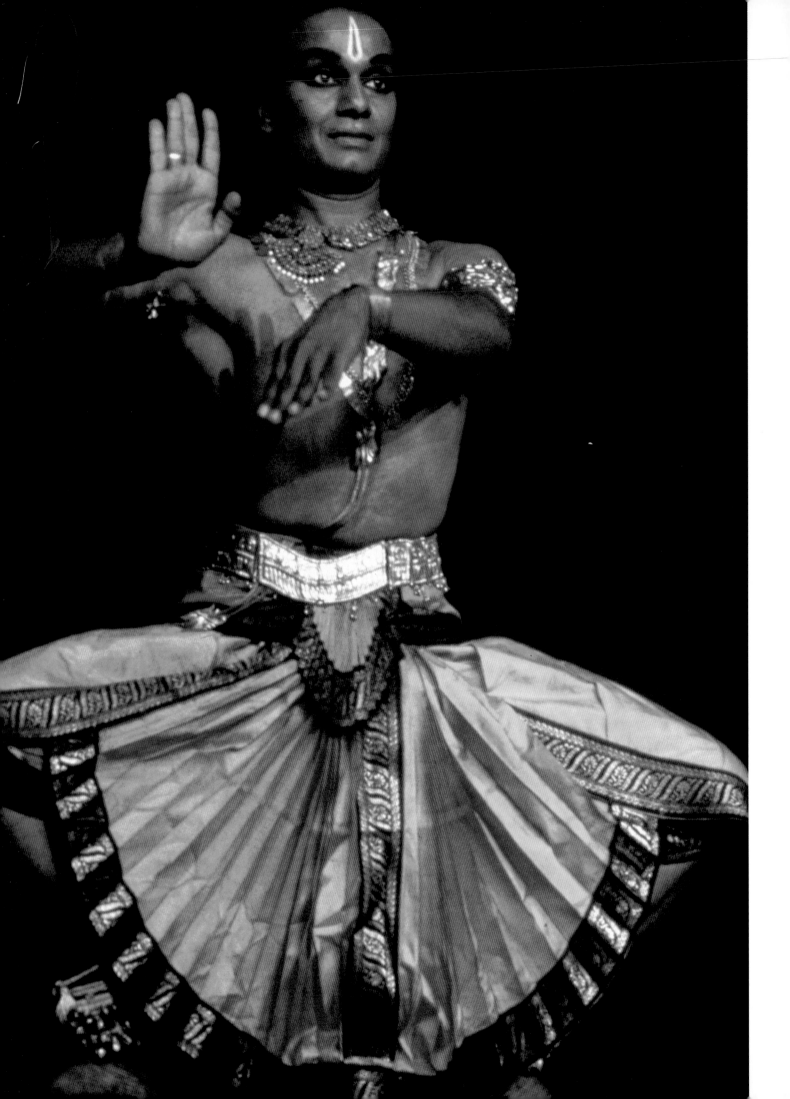

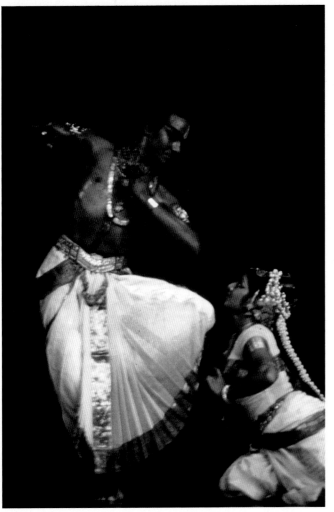

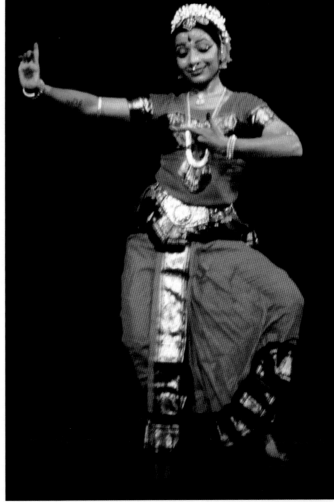

Opposite, above, left, and above, right: Radha and Raja Reddy perform *Kuchipudi*, a dance form similar to *Bharata Natyam* but involving a man and a woman. In its use of both solos and duets it resembles a classical *pas de deux*

Below, right: Birju Maharaj is the foremost exponent of *Kathak*, a dance form based on complex rhythms that involves clapping, stamping, and bell-ringing in dialogue with an ensemble of percussionists

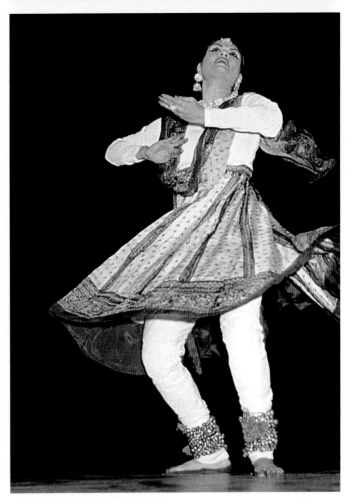

Performing Artists of India

Several outstanding performing troupes of India have been invited to tour the United States as part of the Festival of India celebration. Each group exemplifies a tradition rarely seen outside of India.

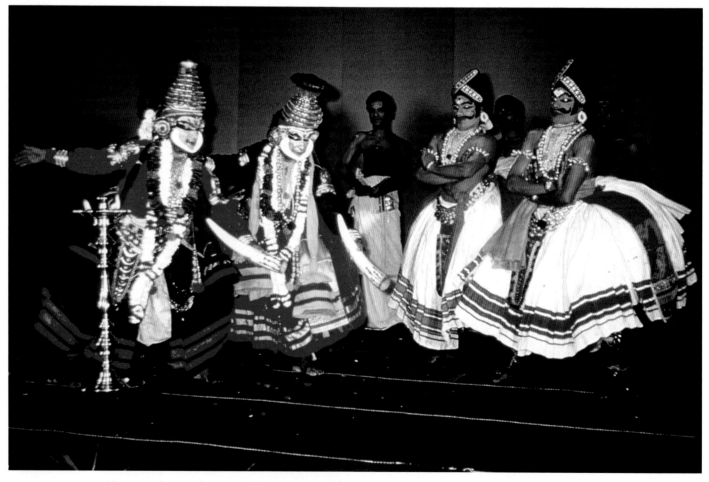

Above and opposite: For 400 years a sacred royal treasure of Kerala, *Krishnattam* is making its first appearance in the United States. Stories of Lord Krishna are told in a captivating mix of dance, mime, and hand-language, embellished with spectacular makeup, masks, and costumes. The company consists of four musicians and seven dancers, all males

American Institute of Indian Studies, Committee on Performing Arts for the Festival of India

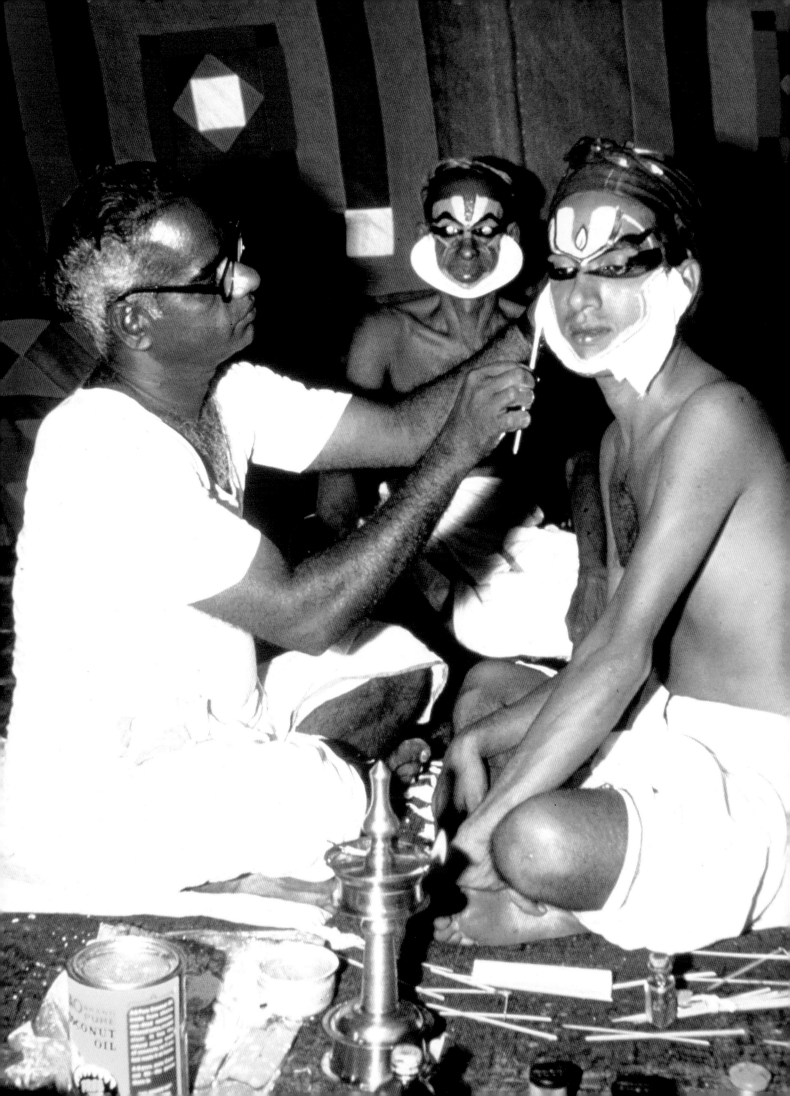

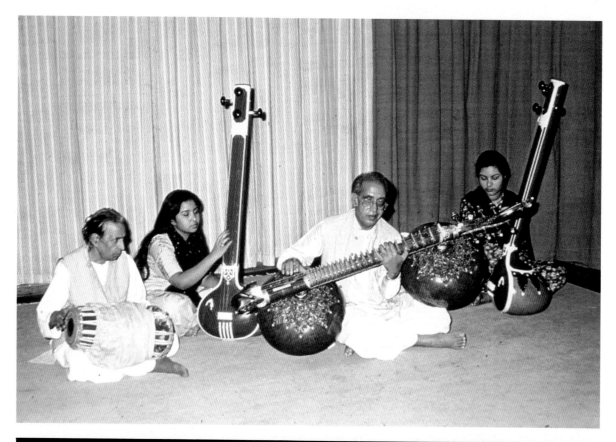

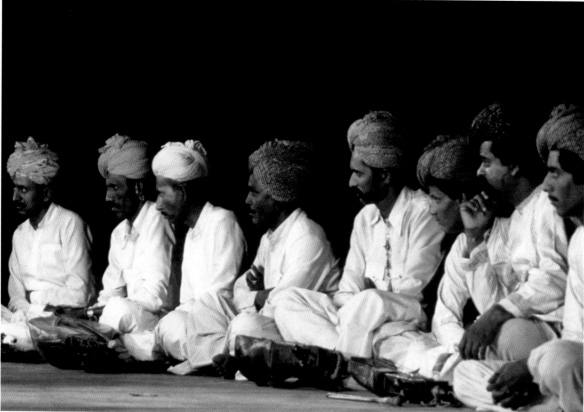

Above: *Dhrupad* is the oldest classical music in India. Ustad Zia Mohiuddin Dagar is a member of the distinguished Dagar family of *dhrupad* specialists, the only musicians today performing the original ensemble of voice and *rudra veena* (a string instrument). Rhythmic accompaniment is provided by *pakhawaj* (a barrel drum)

Below: From the desert regions of Rajasthan come the colorfully turbaned *Langas*. Traditionally, their rich-voiced renditions of love and heroic ballads—accompanied by *sarangi* (the Indian fiddle), wooden clappers, and drum—garnished festive occasions such as weddings and birthdays

Index

PHOTO CREDITS

Air India Slide Library, 11, 13 all; © Rajesh Bedi, New Delhi, 152 top; © Rajesh Bedi, New Delhi, Courtesy American Museum of Natural History, New York, 197–201; W. E. Begley, 37–41; © Beth Hatefutsoth, the Nahum Goldmann Museum of the Jewish Diaspora, Tel Aviv, 113 both; Joan Broderick, Philadelphia Museum of Art, 73 both; Carolyn Henning Brown, 157; © 1984 Sheldan Collins, Weehawken, N.J., 69 both; Federico Diaz, Courtesy Lincoln Center for the Performing Arts, New York, 230; © Mark Edwards, London, 146 top right; Balwant Gargi, 225; John Gollings, 44–47; Government of India Tourist Office, Los Angeles, 12; Robert Heiderer and Janet Kastelic, 213–17; H.H.E.C., New Delhi, 179–85; © Stephen P. Huyler, Camden, Maine, 187–91; Kulbhushan Jain, 34, 35 bottom; Uttam C. Jain, 29, 31, 33 right, 35 top; David Joyce, 158–61; David Loggie, New York, 124–29; © Antonio Martinelli, Milan, 144; © Roland and Sabrina Michaud, Paris, 151; Eric E. Mitchell, Philadelphia Museum of Art, 71, 72; Museum of Modern Art, New York, Film Stills Archive, 226, 227 both; Erik Pelham, Wallingford, England, 118–22; Courtesy the Powis Estate Trustees, 121; © Jyoti Rath, New Delhi, 145 top right, 145 bottom left, 149 top left; Bernard Rudofsky, 194; Clive Russ, Boston, 67; Sangeet Natak Akademi, New Delhi, 228, 229, 231–36; © T. S. Satyan, New Delhi, 146 bottom; Mark Sexton, Salem, Mass., 132–35; © Daphne Shuttleworth, 147; Daphne Shuttleworth/SI, 152 bottom; © Ragubir Singh, Paris, 148; © Ragubir Singh, Courtesy Fraenkel Gallery, San Francisco, and Ragubir Singh, 208–11; © Rosalind Solomon, New York, 203–6; Kartik Vora, 32–33; © J. H. C. Wilson/Robert Harding Picture Library, London, 146 top left.

Aditi was funded by the Smithsonian Institution and the Government of India, with additional support from Air India, the Indo-US Subcommission on Education and Culture, the Armand Hammer Foundation, and the Chicago Pneumatic Tool Company. Illustrations on pages 1, 145 top left, 145 bottom right, 149 top right, and 149 bottom by Chip Clark/SI from *Aditi: The Living Arts of India* (Washington, D.C.: Smithsonian Institution Press, 1984). Used by permission.

Mela was funded by the Smithsonian Institution and the Government of India, with additional support from the Handicrafts and Handlooms Exports Corporation of India, Ltd., the Ashok Group of Hotels (India Tourism Development Corporation), and Coromandel Fertilizers, Ltd.